Tobias Rehberger

flach

Plakate, Plakatkonzepte und Wandmalereien

Eva Linhart

Museum
für AngewandteKunst
Frankfurt

flat

Posters, Poster
Concepts
and Wall Paintings

Inhalt/Content

4

Vorwort

Tobias Rehberger — flach. Das klingt wie ein
Paradoxon bei einem Bildhauer, der auch in seiner
Performance eine durchaus abgerundete Erscheinung
abgibt. In der Tat aber erscheint er in der Ausstellung
im Museum für Angewandte Kunst Frankfurt mit
Wandmalerei, Tapeten, Plakaten und Plakatkonzepten.
Rehberger lässt sich eben überhaupt nicht einordnen
in die kunsthistorischen Gefäche, die heute — und
dies ist einer jungen Generation von Künstlern zu
verdanken — obsolet wirken.
Rehberger, der an der Frankfurter Städelschule
zumal bei den Professoren Thomas Bayrle und
Martin Kippenberger sehr breit angelegt ausgebildet
wurde, unterrichtet heute an dieser ebenso kleinen
wie feinen Kunsthochschule Bildhauerei und wirkt
dort auch als Prorektor. Nach vielerlei Ausstellungen
in den besten Instituten, nur das Moderna Museet
Stockholm oder das Museo Nacional Centro de Arte
Reina Sophia Madrid seien hier stellvertretend
benannt, verfügt Rehberger über eine hervorragende
internationale Visibilität. Auf gut deutsch:
Rehberger is a star.

Dies verdankt er in einer Zeit, in der Nuancen
mehr zählen als Kontraste, seiner vielseitigen
Unverwechselbarkeit. Skulpturen, Gemälde, Graphiken,
Rauminterventionen, textile Gestaltungen, all diese
Gattungen verschmelzen mit Natur und Gesellschaft
zu Gesamtkunstwerken, die sehr viel mit Öffent-
lichkeit zu tun haben.

Und so ist es geradezu selbstverständlich, dass die
Museumsausstellung in die Stadt Frankfurt ergießt,
zum Kulturprojekt der Stadt Frankfurt wird. Denn
Rehbergers Werke mischen sich fast klandestin in
die dröhnende Werbewelt des Alltags ein. Wo alle
„Stellen" schon besetzt scheinen, alle Positionen
schon vermietet, findet er noch Plätze für seine
„Ads", die damit gleichsam zu abstrakten Beiträgen
einer veröffentlichten Rehberger-Autobiographie
werden.

Diese Ausstellung, die mit einem reichen und sehr
jungen Kulturprogramm aufwartet, Club Boulle, Nacht
der Museen und Guerilla-Marketing-Symposium, ist
vielen zu verdanken: Dem Kulturdezernat der Stadt
Frankfurt, das den Auftritt in der Öffentlichkeit sehr
unterstützt, der international tätigen Anwaltssozietät
Clifford Chance, unserer langjährigen Partnerin
und Exklusivsponsorin der Ausstellung, natürlich
Tobias Rehberger und allen Mitarbeiterinnen und
Mitarbeitern der Ausstellung. Frau Dr. Eva Linhart, im
Museum für die Bereiche Graphik und Buchkunst
zuständig, hat mit großem Enthusiasmus den Puls
der Zeit getroffen und lockt damit ein Publikum ins
Haus, das echte Angewandte Kunst antrifft.

Mein weiterer Dank gilt dem Marketingfachmann und
Autor Jay Conrad Levinson, Schöpfer des Guerilla-
Marketings, Katharina Schücke für die Koordination
der Umsetzung, was den Dank an ihre Maler und
Sprayer einschließt sowie Tilo Kohl; VIER5 für Layout,
Britta Fischer und Sabine Huth für Presse, Barbara
Hassel für konservatorische Betreuung, Judith
Rosenthal für Übersetzung sowie Hana Spijkers und
Johannes Yong Boehm.
Darüber hinaus danke ich für ihre Inszenierungen
im Rahmen der Ausstellung DJ Ata, Club Robert
Johnson, und AZITA, Modestore, sowie für die
Kooperation am Guerilla-Marketing-Symposion
HORIZONT sowie Ogilvy & Mather Frankfurt.

Prof. Dr. Ulrich Schneider
Direktor des Museums für Angewandte Kunst
Frankfurt

Rehberge

aa

onzepte und

alereien

etdt Clifford Chance

Foreword

Tobias Rehberger — flat. That sounds like a paradox for a sculptor who makes a very rounded appearance in his performance. In fact, however, in the exhibition at the Museum für Angewandte Kunst Frankfurt he is appearing with wall paintings, wallpaper, posters and poster concepts. Rehberger completely defies classification according to art-historical categories which — thanks to the up-and-coming generation of artists — are fast becoming obsolete.

Rehberger looks back on very comprehensive training at the Frankfurt Städelschule — an art academy as sophisticated as it is small — where he studied under professors Thomas Bayrle and Martin Kippenberger. Today he teaches sculpture there himself, and serves as prorector as well. Through a wide range of exhibitions at the best institutions — the Moderna Museet Stockholm and the Museo Nacional Centro de Arte Reina Sophia Madrid being only two representative examples — Rehberger has gained outstanding visibility. In other words, to use the global vernacular: Rehberger is a star.

In an era in which nuances are worth more than contrasts, he owes this visibility to his distinctive diversity. Sculptures, paintings, prints, spatial interventions, textile designs — all of these genres merge with nature and society to form syntheses of the arts which have a lot to do with the public, public presence, the public realm.

It therefore comes as no surprise that this museum exhibition overflows into the city of Frankfurt, becoming an urban cultural project in the process. For Rehberger's works intervene almost clandestinely in the droning world of everyday advertising. Where every surface already seems occupied, every site already leased, he finds space for his "Ads", which thus virtually become abstract contributions to a "publicized" Rehberger autobiography.

This exhibition, and the diverse and very youth-oriented cultural programme accompanying it — Club Boulle, Night of the Museums and a guerrilla marketing symposium — could not have been realized without support from many sides. The municipal department of culture, which substantially supports the public presence; the international law firm Clifford Chance, our partner of many years and exclusive sponsor of the exhibition; Tobias Rehberger, naturally; and all of the staff involved in the organization of the exhibition. With her finger on the pulse of the times, Dr. Eva Linhart — head of our department of book art and graphics — has succeeded in luring into our museum a public which will encounter genuine applied art.

I would also like to extend my thanks to the marketing expert and author Jay Conrad Levinson, the creator of guerilla marketing; Katharina Schücke for the coordination of the show's realization — which includes our gratitude to her painters and sprayers as well as Tilo Kohl; VIER5 for the layout; Britta Fischer and Sabine Huth for the publicity; Barbara Hassel for the conservatorial supervision; Judith Rosenthal for the translations; Hana Spijkers and Johannes Yong Boehm.
For their contributions to the exhibition, we are moreover indebted to DJ Ata, the Robert Johnson Club, and the AZITA fashion shop, as well as HORIZONT for their cooperation on the guerrilla marketing symposium and Ogilvy & Mather Frankfurt.

Prof. Dr. Ulrich Schneider
Director of the Museum für Angewandte Kunst Frankfurt

Translation: Judith Rosenthal

Grußwort

Die Partnerschaft zwischen dem Museum für Angewandte Kunst Frankfurt und Clifford Chance geht ins zehnte Jahr. In dieser Zeit hat sich daraus eine für beide Seiten nutzbringende Kooperation entwickelt. Unsere Sozietät hilft dabei, sowohl den Besuchern aus der Region als auch den zahlreichen internationalen Gästen des Museums Ausstellungen zu präsentieren, die den Ruf von Frankfurt am Main, eine bedeutende Kulturstätte zu sein, eindrucksvoll untermauern.

In diesem Jahr sind wir besonders stolz auf unseren Unterstützungsbeitrag, der dafür sorgt, dass ein international ebenso angesehener wie erfolgreicher Künstler wie Tobias Rehberger für das Publikum erstmals sein umfassendes Plakatwerk und seine beeindruckenden Wandmalereien „enthüllt". „Tobias Rehberger — flach. Plakate, Plakatkonzepte und Wandmalereien" ist nach „almir da silva mavignier — additive poster" (2004) die zweite Plakatausstellung im Museum für Angewandte Kunst Frankfurt, die unsere Sozietät exklusiv unterstützt.

Berührungspunkte zwischen dem Künstler Tobias Rehberger und Clifford Chance gab es allerdings auch schon vor dieser Ausstellung. Tobias Rehberger ist unserer Sozietät bereits durch ein Projekt aus dem Jahr 2008 verbunden. Damals schufen Studenten der Frankfurter Städelschule unter seiner Leitung Installationen für unser Frankfurter Kasino.

Die Farben- und Bilderwelt von Tobias Rehberger hat etwas Faszinierendes. Kein Besucher der Ausstellung kann sich der Wirkung seiner Werke entziehen. Die Motive, ihre Gestaltung und ihre Farben, teilweise auch ihre Monumentalität, ziehen den Betrachter konsequent in ihren Bann und lassen ihn nicht mehr los. Diese Wirkung dehnt sich mit freien Plakatierungs- aktionen auch über die Ausstellungsräume des Museums hinaus in die gesamte Stadt Frankfurt aus. Damit werden die Plakate von Tobias Rehberger förmlich zu Kunst, der man auf Schritt und Tritt begegnet, Kunst der man gar nicht ausweichen kann. Auch Clifford Chance hat er mit einem Plakatmotiv bedacht, mit einem ironisch verkehrenden Wortspiel, aber — für uns durchaus schmeichelhaft — eingereiht in die Plakatmotive seiner Lieblings- produkte im Alltag.

Wir wünschen allen, die den Künstler Tobias Rehberger so schätzen wie wir, viel Spaß mit diesem Buch.

Dr. Hans-Josef Schneider
Geschäftsführender Partner
Clifford Chance, Frankfurt am Main

Posters, Poster Concepts and Wall Paintings

Words of Greeting

The partnership between Clifford Chance and the Museum für Angewandte Kunst Frankfurt is now entering its tenth year, with both sides having gained great benefit from it. Our firm has helped to bring exhibitions to the museum's local, national and international visitors which reinforce Frankfurt's reputation as an important cultural centre.

This year, we are particularly proud to help bring the work of the internationally renowned artist Thomas Rehberger to the public. It will be the first time that his extensive collection of poster art and his impressive mural works have been put on public display. "Tobias Rehberger – flat. Posters, Poster Concepts and Wall Paintings" will be the second poster exhibition at the Museum für Angewandte Kunst Frankfurt to be exclusively sponsored by our firm, following "almir da silva mavignier – additive posters" in 2004. Tobias and Clifford Chance also previously collaborated on a project in 2008 when a number of his students from the Städelschule art academy in Frankfurt created various installations for the canteen at our Frankfurt office.

The colours and images Tobias uses create a world of fascination and no-one will fail to be inspired by his work. Visitors will be drawn in and captivated by the motifs, with their combinations of structure and colour, and in some cases their monumentality. Posters have also been put up all round Frankfurt so that the impact of Tobias's work can be felt beyond the exhibition hall. His posters will be around every corner and the impact of his art will be impossible to avoid. There is also a nod to Clifford Chance in one poster – an ironic, but very flattering, play on words concealed in the poster motifs of his favourite everyday products.

We hope you will enjoy Tobias Rehberger's work as much as we do and that this book will prove to be an invaluable guide.

Dr. Hans-Josef Schneider
Managing Partner (Germany)
Clifford Chance, Frankfurt am Main

Translation: Clifford Chance

Flachware (...und soziale Ungerechtig- keiten stören mich ehrlich gesagt nicht besonders)

Mit dem Titel der Ausstellung „flach" bezeugt sich das Selbstverständnis eines Künstlers, der es gewohnt ist, vom Raum auszugehen. Einführend sei gleich dazu angemerkt, dass kein eingefleischter Maler oder Grafiker seine Arbeit als „flach" bezeichnet wissen möchte, so wie es im Unterschied dazu Tobias Rehberger im Frühjahr 2010 tat, als er den Titel zu der Ausstellung seiner Plakate, Tapeten und Wandmalereien sowie Buchkunst im Museum für Angewandte Kunst Frankfurt entwickelte — und zudem sei noch darauf hingewiesen, dass es doch seit Platon in der Kunst darum geht, die Fläche mit dem Prädikat „tief" als Äquivalent für „bedeutungsvoll" aufzuladen.

Tobias Rehberger ist Professor für Bildhauerei an der Städelschule Frankfurt. Dementsprechend ist seine Arbeit für künstlerische Eingriffe in den Raum bekannt. Der Raum ist für Tobias Rehberger jedoch nie eine bloß abstrakte und schon gar nicht eine nur neutrale Größe.[1] Auch stellen seine künstlerischen Eingriffe keine lediglich formalen Lösungen dar. Ausgehend von der Fragestellung des Künstlers, ab wann die Dinge Kunst sind, provozieren seine Arbeiten, die uns umgebenden Dinge neu zu bewerten — so auch die hier vorgestellten Werkgruppen. Sie als „Flachware" zu bezeichnen, also mit jenem Terminus der Kunstwelt für Druckgrafik, dem die Mischung aus Mitleid und Geringschätzung für diese sparsame

Sparte anhaftet, amüsiert den Künstler. Zugleich wird jedoch damit auch deutlich, dass er „flach" in Bezug zur Wand und die Wand als ein räumliches Element mit Potenz zur Ausdehnung versteht.

So weist denn jede Gruppe jeweils ihre eigene spezifische Strategie auf, wie sie den Raum ergreift und ihn im Sinne ihres Konzepts besetzt. Die Ursache für diese Expansion ist darin zu sehen, dass bei der Kunst Tobias Rehbergers der Entwurf die eine Sache ist, die Übersetzung in einen Ausstellungszusammenhang wieder eine andere, die Ausführung ist dann nochmals ein eigenständiger Bereich und schließlich kommt die daraus resultierende Wirkung als Synthese hinzu. Diese Zerlegung der Kunstentstehung in eigenständige Prozesse, quasi Arbeitsteilung, hat Methode und eine ihrer wesentlichen Folgen ist die Integration der Kunst im Leben.

(Ich mag keine Musik und habe auch keinen Humor...) oder (Oranges from Eden)

Ein prägnantes Merkmal der Wandmalereien von Tobias Rehberger ist ihre Flexibilität in der Konstellation von Wandgröße und Budget. Die Gleichung lautet: je größer die Wand, desto mehr Farbe, desto teuerer und umgekehrt. In einem Ausstellungszusammenhang verschieben sich die Prioritäten zugunsten einer optimalen Präsentation in Bezug auf die Wechselwirkung von Wandmalerei und Raum. In dem konkreten Fall der Ausstellung im Museum für Angewandte Kunst Frankfurt galt es auf die besondere Architektur Richard Meiers, auf seine Rundnischen, die Sockel, das zentrale Vitrinenmonument, die Säulen und das Spiel mit unterschiedlichen Deckenhöhen, einzugehen. Zudem ließ der Künstler um das Vitrinenmonument herum Wände hochziehen, die sich als Kubus mit den beiden weiteren Kuben zu einer Dreierformation komplettierten, um die gesamte Raumsituation der Ausstellung zu gliedern (siehe S. 32-35, 56/57, 60-67). Zusätzliche Impulse für die Interpretation der Wandmalereien zu gewinnen, war das Ziel. Zur Ausführung kamen acht Wandmalereien (siehe S. 8-57, 116-129). Davon spricht jede, was als Merkmal des Werks von Rehberger generell gelten darf, eine andere Sprache oder weist einen anderen Malstil auf. Es sind die für den Künstler wichtigsten Wandmalereien zusammen gestellt und sie sind hier erstmals als eine Werkgruppe mit Retrospektivcharakter zu sehen. Als besonderes Merkmal sticht dabei hervor, dass sie sich antizyklisch zu der zentralistisch-musealen Architektur anordnen: Sei es, dass eine Wandmalerei über acht Ecken verläuft („Ich mag keine Musik ich hab keinen Humor und soziale Ungerechtigkeiten stören mich ehrlich gesagt nicht besonders" Nr. 5; siehe S. 35, 38/39), sei es, dass sie sich über die gesamte Raumhöhe erstreckt (S. 24-35). Indem sich die Wandmalereien über Elemente wie Sockel oder die Breite einer Wand hinwegsetzen, bringen sie umgekehrt die Präsenz der Architektur — quasi im Negativverfahren als Irritation — zur Geltung.

Die Wandmalereien von Tobias Rehberger basieren einerseits auf der Auseinandersetzung mit Malerei sowie ihrer Tradition und andererseits auf dem Vergleich mit Tapeten. Die Überlegung, dass Tapeten unsere Wohnkultur dominieren, weil sie durch ihre massenserielle Produktion preisgünstiger als Wandmalereien sind, liefert ihm den Ausgangspunkt. Dabei setzt sich der Künstler zum Ziel, dass seine Wandmalereien so in ihrer Herstellungsweise konzipiert sein müssen, dass sich die Kosten an diejenigen von hochwertigen Tapeten angleichen. Zum anderen soll jedoch die Exklusivität der Wandmalerei — die historisch betrachtet Vorläufer der Tapete ist — in ihrer Einmaligkeit erhalten bleiben. Damit wird deutlich, dass Tobias Rehberger die Frage nach den Möglichkeiten einzigartiger Wandgestaltung für individuelles Wohnen im Zeitalter der heutigen Massenkultur stellt.

Bei den Wandmalereien von Tobias Rehberger liegen
Entwurf und Ausführung nicht in einer Hand.
Die Entwürfe dienen zugleich als digitale Vorlagen —
dem Prinzip nach Schablonen —, welche zunächst
an die Proportionen der Wand angepasst werden
müssen, um dann durch Andere realisiert zu werden.
Die hier sich abzeichnende Analogie zur Tapete, wo
Gestalter und Herstellung zweierlei sind, setzt Tobias
Rehberger in der Bildlichkeit der Wandmalerei fort.
Bei der Betrachtung seiner Wandmalereien fällt auf,
dass das Prinzip transparentartiger Überlagerung
von Farbflächen das Erscheinungsbild prägt. Dies
geht auf die Entstehung des Entwurfs zurück, den
Tobias Rehberger am Computer mit dem Programm
„Illustrator" erstellt. Es gehört zu dieser digitalen
Vorgehensweise, dass sich Farbfelder relativ mühelos
transparent überlagern lassen, um entsprechend
viele neue Nuancen zu bilden. Im Unterschied dazu
muss für die Wand jeder einzelne Farbwert eigens
definiert werden. Diese Vielzahl an Farbtönen
bedeutet eine Herausforderung an das malerische
Kalkül des Mischens und ist farbtechnischer Höchst-
aufwand. Zum anderen beinhalten die Wandmalereien
Elemente, die von erfahrenen Sprayern ausgeführt
werden müssen. Damit hält in den Wohnbereich die
Straße Einzug: die anarchische Szene der Jugend-
kultur sowie des Undergrounds vermischt sich
mit dem Poppig-Plakativen in der Anmutung einer
naiven Malerei.
Das Spiel mit Schriften und Slogans, ohne jedoch
dabei in einer sinnstiftenden Erzählung oder dem
Informationsgehalt einer Botschaft aufzugehen,
verortet die Wandbilder darüber hinaus an der Grenze
zwischen Comic, Graffiti oder großflächiger Reklame
und somit auch an der Grenze zwischen Innen- und
Außenraum als privat und öffentlich.
Dabei korrespondieren Rehbergers Strategien, wie
Wandmalereien entstehen, wirkungsvoll mit den
Motiven, die sie bestimmen. Bemerkenswert ist,
dass der Künstler gleich zweimal Henri Rousseau
(1844–1910), den Zöllner, zitiert („Horrible Flute
Player" Nr. 6 und „Oranges from Eden" Nr. 7; siehe
auch S. 32/33, 12/13, 46–49, 55): Jenen Maler-
autodidakten, den nicht nur Picasso wegen seiner
Ursprünglichkeit besonders schätzte, sondern weil
dieser Naive den Garten Eden mit Eva oder Löwen
malte, als das Zeitalter der Industrialisierung
fortschritt und das Paradies seine Unschuld zu
retten, nur noch in der authentischen Kunst der
Peinture sah. In dem Maße, wie eine Tapete durch
den Vorgang des Klebens eine nicht mehr abzu-
lösende Einheit mit der Wand bildet, gehört es zum
Konzept der Wandmalereien Tobias Rehbergers,
dass jeder erworbene Entwurf nur einmal als Wand-
gemälde in einem privaten Innenraum ausgeführt
wird. Damit werden die aktuellen Möglichkeiten der
technischen Reproduzierbarkeit bewusst unterlaufen,
um die traditionelle Identität eines Wandbildes —
die Einmaligkeit im Entwurf und Ausführung — zu
behaupten. Jedes Motiv darf nur genau so oft wie
es der Editionsgröße entspricht, reproduziert werden.
In der Folge ist damit Originalität sowie Exklusivität
eines Wandgemäldes sichergestellt. Das Konzept
triumphiert über die Machbarkeit, durch serielle
Produktion die Einzigartigkeit eines Kunstwerks zur
Auflagenarbeit zu nivellieren.

Inside (UP On 1–5)

Dass die Tapete eine reproduzierbare Bebilderung
für das Innenleben ist, stellt den thematisch-
formalen Ausgangspunkt für diese Wandarbeit dar.
Von hier aus entwickelt Tobias Rehberger Bezüge,
die er zu einer komplexen Wechselwirkung steigert.
Er wählt als technisches Medium eine Fototapete
(Nr. 9, siehe auch S. 8, 10, 54, 56/57, 58/59, 61,
84). Das, was abgebildet ist, sind medizinische
Aufnahmen: Spiegelungen der Innenorgane des
Künstlers von der Lunge durch den Magen.
Diese vermitteln sich als abstrakt-ornamentale
röhrenförmige Verschlingungen seines Innenlebens,
deren rot-tonige Farbigkeit pulsierende Energie
ausstrahlt. Diese Thematik setzt Tobias Rehberger

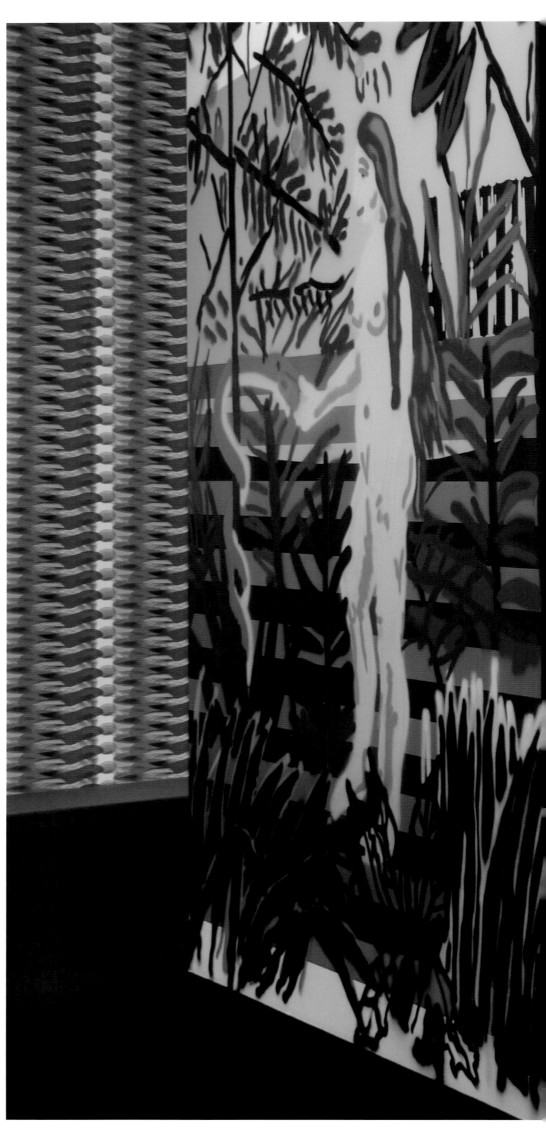

mit der Präsentation in der Museumsarchitektur fort. Denn die Tapete umschließt denjenigen Zentralschacht, indem die technische Innenversorgung des Museums unsichtbar fließt: der Aufzug, die Stromkabel, die Lichtschalter, das Telefon, der Feuerlöscher, der Abstellraum für Reinigungsutensilien und der Aufbewahrungsort für die persönlichen Sachen des Aufsichtspersonals. Dieser von der Tapete Tobias Rehbergers umschlossene Raumkubus betont zugleich seine Funktion, Durchgänge zwischen zwei Ausstellungsräumen zu bilden (S. 56/57). Tapete in Verbindung mit den Themen Innenleben, abstrakte Bildlichkeit und Passagencharakter setzt ihrerseits das kunsthistorische Faktum frei, das etwa Immanuel Kant (1724-1804)[2] dieser Kunstform zubilligte: die Mittlerfunktion zwischen Kunst und Leben. Entlang der Tapete und ihrer Ornamentik exemplifizierte Kant die Vorstellung, dass die Kunst sich als das Bessere in die Lebensverhältnisse hinein zu verlängern habe. Er reflektiert damit die Ansprüche früher bürgerlicher Ästhetik, die besonders der deutsche Klassizismus mit seinen Skulpturen und seiner ganzheitlichen Inszenierung[3] zu verkörpern sich bemühte, und ihrer Fragestellung, wie die Kunst als das Bessere (das Wahre, Gute und Schöne) auf die hässliche Realität positiv einzuwirken vermöge.[4] Was der Klassizismus bis in die Moderne hinein und darüber hinaus an methodischen Strukturen freisetzte, ist das Spiel mit Grenzen. Dabei kam Elementen wie Rahmen, Sockel, Tapeten, Wandtäfelungen oder Vasen die Funktion zu, die Grenze zwischen Kunstwerk und Realität zu markieren und zu ziehen. Galten diese Elemente wegen ihrer Verbindung zum Ornamentalen zunächst als untergeordnete Künste, avancierten sie in der Folgezeit gerade wegen ihres Bezugs zu den Ornamenten zu Grenzhütern der Autonomie.[5] Denn die Ornamente, da sie frei von der Nachahmung äußerer Wirklichkeit seien, wurden zu jenem Thema, entlang dessen die abstrakte Kunst angedacht wurde mit dem Ziel, das Innenleben des Subjekts und seine schöpferisch-genialischen Kräfte als angeborene Anlagen unmittelbar zum Ausdruck zu bringen. Diesen kleinen Exkurs hier einzuschieben, sei darum erlaubt, weil er deutlich machen soll, wo sich die künstlerischen Strategien von Tobias Rehberger samt seiner Fragestellung, ab wann die Dinge Kunst sind, historisch verorten lassen, und wie sehr sein Spiel entlang der Grenzen autonomer und angewandter Kunst zugunsten einer „Verbesserung der Realität" einem emanzipatorischen Impetus untersteht. Bis heute legitimiert und bestimmt dieser die gesellschaftliche Rolle der Kunst und unsere Ansprüche an sie. Im Zusammenhang mit der Plakatgruppe „Ads" von Tobias Rehberger, auf die noch eingegangen wird, verdeutlicht sich dies noch nachhaltiger. Indem Tobias Rehberger in der Ausstellung „flach" die hintere Wand der Tapete für die Präsentation von Plakaten nutzt (S. 58/59, 61), und dies zugleich derjenige Raum ist, der sich mit breiten Fensterfronten nach außen zur Stadt Frankfurt hin öffnet, gewinnt die Mittlerrolle der Tapete als ein Grenzgänger zwischen Kunst und Leben zusätzlichen Nachdruck. Im Unterschied zu der im idealistischen Pathos sich ergehenden „Denke" der Klassizisten hat jedoch Tobias Rehbergers Tapete und ihre Inszenierung den Vorteil von Humor und Pragmatik.

(bitte danke) offset

Die Plakate von Tobias Rehberger lassen sich in fünf Gruppen gliedern und sind erstmals komplett hier vorgestellt.
Eine Gruppe umfasst solche Plakate, die der Künstler als klassisches Medium angewandter Kunst nutzt, um für eigene Ausstellungen, Kunstprojekte oder für Fußball – eine Leidenschaft des Künstlers – zu werben (Nr. 10-26). Jedes Plakat weist eine eigene solitäre Handschrift auf und gewährt Einblicke bis in die Anfangszeit seiner Karriere: „Hochhäuser, Felsen,

Rudis" das erste Plakat von 1990 im Siebdruck-
verfahren von ihm selbst, noch als Student an der
Städelschule, gedruckt (Nr. 10, S. 86; 58/59, 61)
oder „Cancelled Projects", das die Ausstellung im
Museum Fridericianum Kassel von 1995 ankündigt
(Nr. 11; S. 88; 60, 63). Etwa zeitgleich kam es zu
einer Kooperation mit seinem Bruder Chris Rehberger,
dem Designer, bei der Plakatserie Kunst-Gespräche
Leipziger Messe (Nr. 23-26; S. 87, 89-91).
Die immer gleiche grafische Struktur der Plakate
variiert in ihrer Farbigkeit, um den jeweils neuen
Termin zu kennzeichnen.

(Tobias Rehberger — COPyBrAIN)

In Korrespondenz zu den Ausstellungsplakaten
entwirft Tobias Rehberger Kataloge zu seinen
Ausstellungen. Unabhängig von der Tatsache,
dass sie parallel zu seinem Bekanntheitsgrad
umfangreicher und aufwendiger werden (Nr. 75-97;
S. 184-187), verraten sie vor allem als Buchkunst
den Anspruch, substantieller Teil der jeweiligen
Ausstellung und Kunst zu sein. Auch hier lässt sich
das Phänomen, für jeden Zusammenhang und
entsprechend zum jeweiligen Kunstkonzept eine
eigene Form finden zu wollen, erneut verfolgen.
Darüber hinaus zeigen die Kataloge ein deutliches
Interesse daran, mit dem Buch und seinen komplexen
Möglichkeiten aus Einband, Vorsatz, Seitenfolge,
Papier, Buchblock, Bindung, Layout, Druck, Vakatseiten
oder Lesebändchen und in Wechselwirkung zum
Thema der jeweiligen künstlerischen Arbeit zu
experimentieren. So steht weniger der Katalog als
Informationsmedium im Mittelpunkt des Interesses,
als er vielmehr eine künstlerische Ausdrucksform
darstellt, die als eine Übersetzung der Kunst in
das Buch gelten muss. Sei es, dass er für die
Ausstellung Frankfurter Positionen 2001 im Portikus,
welche die „First Ads" zeigte, einen Katalog
konzipierte, dessen Seiten unmittelbar aus den
Plakaten selbst bestehen, wobei die Innenseiten des
Umschlags andererseits die Plakatmotive in der
Größe DIN A5 reproduzierten (Nr. 84; S. 184/185).
Für die Ausstellung „Tobias Rehberger — Artist
Book" SAMUSO Space for Contemporary Art, Seoul
2004, entwickelte der Künstler das Konzept, dass
jede Seite eine Titelseite sei und realisierte dies als
Katalog in Kooperation mit Baan Kim Sung Yeol
(Nr. 90; S. 187). 2002 benutzte der Künstler für die
Fundação Serralves im Rahmen der Ausstellung
„Tobias Rehberger — presçrições, descrições, receitas
e recibos" als Seitenmaterial Selbstklebefolien, die
so bedruckt und gestanzt sind, dass sich die
grafischen Elemente vom Untergrund loslösen
lassen (Nr. 88; S. 184). Etwa zeitgleich zu Arbeiten
für die Kunstbiennale in Venedig in 2009 beginnt
Tobias Rehberger das Künstlerbuch COPyBrAIN zu
entwickeln (Nr. 96; S. 185). Die 336 Seiten des
Buches basieren auf einer Arbeit, die der Künstler
im Hans-Thoma-Museum in Bernau/Schwarzwald
im Zusammenhang mit der Verleihung des Hans-
Thoma-Preises realisiert hat: „The GREAT disarray
swindel". Hierbei greift Rehberger — ähnlich wie
bei der Cafeteria der Giardini in Venedig — formal
jedoch deutlich unterschieden —, das Thema
„Verwirrung" auf. Mehrere Kilometer Kabel, die sich
durch den Raum wanden, verwirrten und verknoteten,
waren mit einer Vielzahl von Lampen kombiniert.
Das sich dabei ergebende Bildmaterial wurde für
das Künstlerbuch mit Neonpapier unterlegt, einzelne
Seiten als Collage konzipiert und in Kooperation mit
v.e.r.y. Frankfurt am Main gestaltet. Ein besonderer
Reiz besteht zwischen dem geschlossenen Buchblock
und seinem Öffnen. Einer Schnittverzierung gleich
befindet sich der Titel des Künstlerbuches auf den
Buchschnittflächen. Wird der nüchterne Buchblock
in Bewegung versetzt, beginnen sich die Seiten
aufzufächern und das von Neonfarben getragene
Innenleben kommt überraschend zum Vorschein.

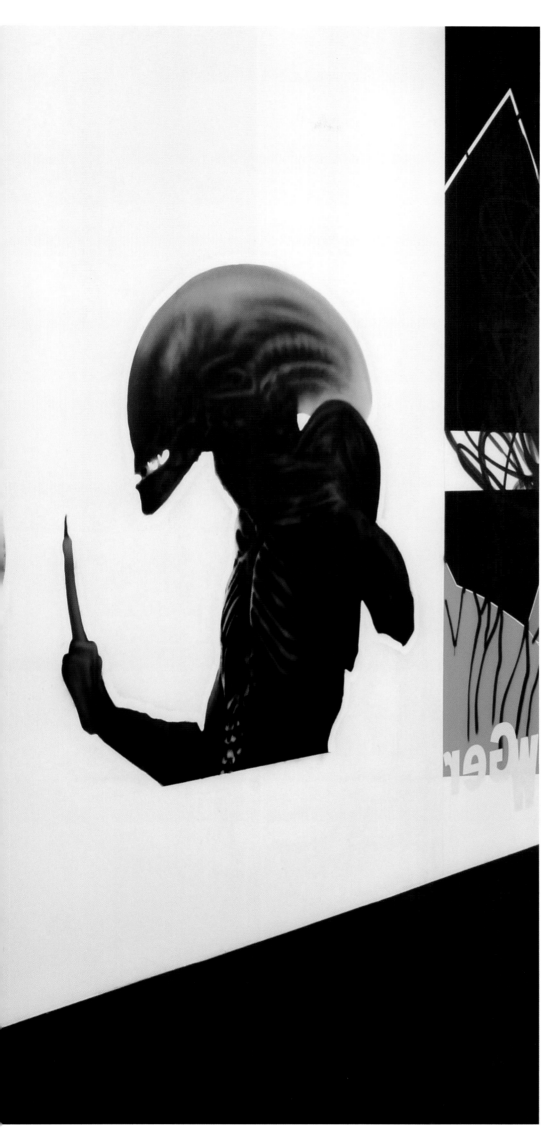

Die Plakate für die Venedig-Kunstbiennale 2009/Bar Cafeteria — Palazzo delle Esposizioni Giardini sind Bestandteil der Arbeit „Was Du liebst, bringt dich auch zum Weinen", für die Tobias Rehberger mit dem Goldenen Löwen ausgezeichnet wurde (Nr. 39-47; S. 134-140/141; 82-85). Diese auf dem Prinzip der Collage basierenden Plakate mit Motiven des legendären New Yorker Punk Clubs CBGB korrespondieren mit dem Gestaltungskonzept der Bar Cafeteria, das sich auf jene „Durcheinander-Malerei" bezieht, die im England des Ersten Weltkriegs unter dem Namen „Razzle-Dazzle-Painting" zum Zweck der Täuschung, Verunsicherung und Desinformation des Feindes entstanden ist.

Indem zwar die Motive der Plakate mehrheitlich die Underground-Musikszene erkennen lassen, jedoch offensichtlich keine zielgerichtete Botschaft herauslesbar ist, unterwandern sie die Informationsfunktionalität, die das Plakat als Werbemedium ausmacht. Mit ihrer Bildlichkeit aus grob vergrößerten Druckrastern auf unterschiedlich farbigen Neonpapieren bilden diese Plakate in Bezug auf die präzis-geometrische Wandmalerei der Biennale-Inneneinrichtung einen sich abhebenden, quasi störenden und damit eigenständigen Akzent. Die Wirkungsweise ihrer Desinformation bindet sie denn auch stärker an die Wandgestaltung der Graffitikunst als an die Werbeintention eines Plakats. Ihre Präsentation in dem sonst stark geometrisierten Gestaltungskontext der Cafeteria hat die Anmutung ungeordnet, zufällig und schnell aufgeklebt worden zu sein. Damit spielen sie auf die Gegenbewegungen des Undergrounds oder auf das wilde Plakatieren an. Der Eindruck, dass Tobias Rehberger an Gegenbewegungen als künstlerischer Methode für Neuentwicklungen interessiert ist, stellt sich ein.

Fine-Art-Prints

Die Plakate „On Otto" sind Bestandteil des gleichnamigen Kunstprojekts, das die Idee verfolgt, einen Film von seinem Ende her anzufangen. Dabei steht das Kinoplakat am Anfang (Nr. 27, S. 131; 68, 70). Die komplexe Teamarbeit, die für eine Filmproduktion notwendig ist, zerlegte Tobias Rehberger in die jeweiligen Kompetenzen und rollte die Arbeitsschritte rückwärts auf. Als Ausstellung wurden die einzelnen Sequenzen von „On Otto" 2007 in vier labyrinthischen Pavillons in der Mailänder Fondazione Prada gezeigt.[6] Daraus entwickelte Tobias Rehberger 2009 die Plakatserie, die er in Kooperation mit Florian Markl gestaltete. In der exklusiven Auflage von nur sechs Abzügen ließ sie Edition Schellmann bei Druck Recom Art/Ostfildern in hochwertigem Digitaldruck auf Photo Rag, dessen Eigenschaft eine sehr feine, weiche Oberflächenstruktur und Haptik ist, produzieren. Die grafisch vielschichtigen Arbeiten lehnen sich an die Gattung des Kinoplakats an und würdigen die verschiedenen Produktionskompetenzen: Zehn Plakate repräsentieren jeweils einen Bereich der Filmproduktion:
Titles (Titel), Sound, Music (Musik), Editing (Schnitt), Cinematography (Kamera), Actors (Schauspieler), Production Design (Szenenbild), Costume Design (Kostümbild), Story Board und Script (Nr. 29-38). Der Umstand, dass die Plakatserie im Anschluss an das Kunstprojekt entstanden ist, um die jeweiligen Kompetenzen, die sonst von der Öffentlichkeit — bis auf die Schauspieler — unbeachtet bleiben, zu würdigen und das in Verbindung mit der hohen Qualität in Grafik, Druck und Papier, bringt diese Werkgruppe in die Nähe des Denkmals.

**Marker, Kugelschreiber, Tipp-Ex, Klebeband
auf Papier im Glas**

Die neuesten Plakate von Tobias Rehberger
bestehen aus einsilbigen handgeschriebenen Aus-
rufen wie „Nö!" oder „Ah!" (Nr. 68-74; S. 80/81,
115). Dabei handelt es sich um keine Druck-
erzeugnisse mehr, sondern um einmalige Schrift-
zeichnungen auf Affichen-Papier. Sie sind darüber
hinaus vom Künstler durch Eingriffe, indem er
das Papier den Spuren von Vorbeigehenden in
seinem Studio aussetzte, in und auf das Papier zu
dreidimensionalen Plakatobjekten geformt.
Die lautmalerische Kurzbotschaft dieser Unikate als
Mitteilung oder Reaktion auf etwas, was sich nicht
erschließt, lässt an das Plakatmedium in seiner
Minimalintention denken: Der Wille, sich grafisch laut-
stark Gehör zu verschaffen.
Bemerkenswert ist ihre Präsentation. Sie sind über-
wiegend von neon-farbigen Klebebändern eingefasst
und in jeweils auf das Format individuell angepassten
Ganzglasrahmen versiegelt. Dies sieht nicht nur
äußerst elegant aus, sondern es entsteht eine
Polarität zwischen Verewigung und Vergänglichkeit,
welche an die christliche Praxis des Reliquiars
denken lässt. Die sich damit abzeichnende Tendenz
zur Einmaligkeit, Individualisierung und einer quasi
sakralisierenden Überhöhung konterkariert — auf ihre
Konsequenz hin weitergedacht — die übliche Schnell-
lebigkeit des massenseriellen Druckerzeugnisses
Plakat und neigt sich zum Kunstwerk als Original.

Mykita, Margiela, Maserati

Auch wenn die Plakate der Werkgruppe „Ads" in der
Ausstellung in Ganzglasrahmen präsentiert und zu
dreidimensionalen Objekten geformt sind (S. 66, 69,
72-79), so leitet sich die Begründung für ihre
Erscheinung aus sehr anderen Zusammenhängen
als den eben besprochenen Unikatplakaten her.
Die Gruppe der „Ads" umfasst Plakate, die sich mit
der Gattung des Werbeplakats auseinandersetzen.
Ihr Konzept ist es, dass Tobias Rehberger sie in
eigenem Auftrag für Produkte oder Brands wegen
ihres Stellenwerts in seiner persönlichen Lebenswelt
entwirft und in der Form wilder Plakatierung im
öffentlichen Raum ausstellt. Auf eben dieses Faktum
geht die Verformung der Plakate in der Frankfurter
Ausstellung zurück. Sie ist der künstlerischen Vor-
stellung geschuldet, dass die Plakate im Stadtraum
plakatiert worden sind, danach vom Untergrund
abgenommen oder abgerissen wurden, sich schließ-
lich nach Beendigung ihres Wirkungsprozesses im
Straßenterrain in den Zustand eines repräsentativen
Kunstwerks verwandeln, um nach Abschluss all
dieser Transformationsprozesse für das Museum im
Glas verschweißt konserviert zu werden.
Die „Flachware" gewinnt im Zuge des Prozesses,
im öffentlichen Raum zu wirken, an Volumen und
Gewicht.

Bei den Motiven der Plakate „Ads" handelt es sich
um Produkte, die Tobias Rehberger mag, schätzt
und manche sogar selbst benutzt: Unterwäschen-,
Brillen-, Auto- oder Getränkemarken, sei es Coca
Cola, Margiela, Advil, Bach Rescue Cream, Zimmerli
und andere (Nr. 48-67). Indem der Landwirt Bauer
Mann aus der Frankfurter Kleinmarkthalle genauso
gleichwertig mit einem Entwurf bedacht wird wie
etwa der weltweit agierende Computerhersteller
Apple, wird deutlich, dass der Bekanntheitsgrad der
Marke eine untergeordnete Rolle spielt und dass
tatsächlich allein persönliches Goutieren des Künstlers
das Kriterium ist. Dabei geht Tobias Rehberger
insbesondere bei der Serie der „First Ads" in der
Weise vor, dass er seine positive Bewertung des
Produkts bis in eine Verbesserung oder einen Neu-
entwurf des Corporate Designs der jeweiligen Marke
nach seinen ästhetischen Vorstellungen fortsetzt.
Der Künstler als Verbraucher wird zum Designer, der
sich am Erscheinungsbild beteiligt beziehungsweise

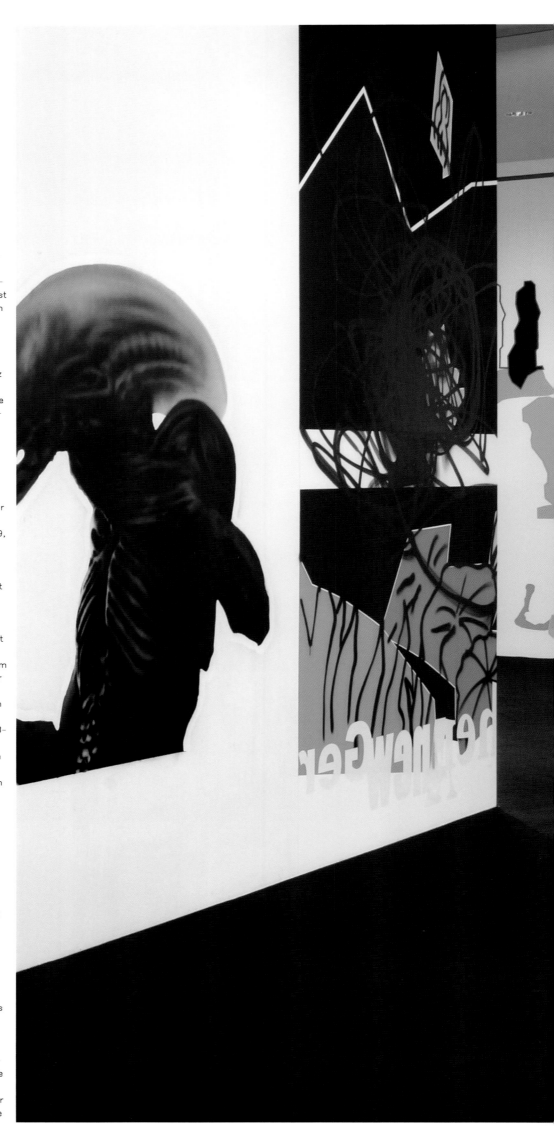

es im eigenen Auftrag und nach seinem Dafürhalten optimiert. Im Fall des Plakats „adidas" (Nr. 53, S. 101; 66, 69, 72) kombiniert Tobias Rehberger das Performance-Logo des deutschen Sportartikel-Herstellers mit dem Titel eines Leitfadens für Teenager und ihrer Charakterbildung von Barbara A. Lewis („what do you stand for ...")[7] sowie „Cipla". Dieses ist ein Pharmazie-unternehmen aus Indien und ist für Generika, also wirkstoffgleiche Kopien eines bereits unter einem Markennamen auf dem Markt befindlichen Medikaments bekannt. Es bietet dieses deutlich günstiger an und sorgt so für eine medizinische Versorgung zum Beispiel in Bezug auf AIDS.

Das Vereinen von Marken in einem Plakat erinnert an das Fusion-Marketing als Unterkategorie des Guerilla-Marketings.[8] Im Fall dieses Plakats sind jedoch Elemente aus so verschiedenen Bereichen gewählt, dass ihre Zusammenführung sich als eine Strategie erweist, die jenseits des üblichen Kooperationseffekts beim Werben liegt. Vielmehr verkehrt sich das, was aus der Sicht des Marketings als absurd gelten muss, aus der Perspektive von Kunst zu einem Statement, das soziale Verantwortung, Kopieren oder Lifestyle für gleichwertige Lebens-äußerungen erklärt, oder anders gewendet: Das Plakat als Kunstwerk entzieht sich der Ideologisierung.

Für die Ausstellung im Museum für Angewandte Kunst Frankfurt hat Tobias Rehberger Plakate entworfen (Nr. 62-67), die in der Innenstadt Frankfurts frei plakatiert sind (S. 164-183). Der Künstler verlängert die Ausstellung in den öffentlichen Raum, der so zum Ausstellungsraum wird und der Konsument eine Erweiterung um die Rolle des Ausstellungsbesuchers erfährt. Eine der Folgen dieser Umwertungsstrategie ist, dass Frankfurt als Kulturmetropole in Dialog mit Frankfurt als kreativer Wirtschaftsmetropole tritt und seine Tradition des kritischen Diskurses mit Mitteln der Kunst erneuert.[9]

Die für die Frankfurter Ausstellung entworfenen Plakate „Ads 3" lassen uns wissen, welche Brillen der Künstler trägt, welchen Cocktail er gerne wo und in welcher Sportkleidung trinkt, welches Auto er fährt, mit welchem Mundwasser er den Tag beginnt und in welchem Club er feiert. Es handelt sich also bei diesen Plakaten auch um Selbstporträts. Dabei erfahren wir nicht nur, dass Tobias Rehberger gerne gut lebt,[10] sondern auch, dass er als Künstler einer von uns in Frankfurt ist, wo – wie es Max Beckmann formuliert hat „[...] alles schön nah beieinander [liegt]"[11] – und dass er als international anerkannter Künstler natürlich häufig auch weltweit unterwegs ist.

Die Werbeplakate als Selbstporträt repräsentieren demnach seine Kaufentscheidungen: Der Künstler als Verbraucher wirbt nicht dafür, was wir kaufen sollen – wie es die Werbeindustrie für gewöhnlich tut –, sondern dafür, was er gerne kauft. Und das Selbstporträt des Künstlers als Werbeplakat im öffentlichen Raum plakatiert, hat die Aussage zur Konsequenz: Ich wähle; ich wähle als Bürger und Verbraucher dieses und jenes Produkt nach meinem Geschmack und nach meinen sozio-ökonomischen Möglichkeiten, und diese Wahlentscheidung setze ich als Künstler ins Bild in der Form von Werbeplakaten und bin auf der Suche nach Mehrheiten für meinen Lifestyle als Kunst.

Dieses Werben für Produkte seiner Wahl als sein Lifestyle veranlasst uns, unsere Rolle als Bürger im öffentlichen Raum zu hinterfragen, zu bewerten und neue Gestaltungsmöglichkeiten anzudenken: als Konsumenten, als Ausstellungsbesucher und als Bürger.

Dabei wird deutlich, dass das Plakat, das Werbeplakat, immer noch das politische Medium ist, um eine Mehrheit der Bürger, jenseits der heutigen Tendenz zur Zersplitterung in verschiedene „communities" und jenseits der ephemeren Präsenz digitaler Botschaften, anzusprechen. Denn das Plakat samt seiner analogen Konstanz wird von Allen auf öffentlichen Plätzen einer Stadt gesehen, und zwar ohne Unterschied zu welcher

Gruppe von Bürgern sie gehören: Wir alle sehen die Plakate. Das Plakat — und insbesondere das Werbeplakat — ist dasjenige Instrument, vielleicht das einzige, das heute noch die Öffentlichkeit im Sinne des Allgemeinheitsbegriffs herzustellen vermag.

Mit den „Ads" geht Tobias Rehberger also über die gewohnten Grenzen visueller Kommunikation hinaus. Er leistet eine Umwertung der Hierarchien zwischen dem Plakat als funktionalem Werbemedium und dem Plakat als attraktivem Bildmedium. Mit der Eigeninitiative im Entwerfen von Plakaten für Markenprodukte, fortgesetzt durch die Hängung im öffentlichen Raum, wird das Medium aus dem Zweck der Profitsteigerung einer Marketingstrategie losgelöst und in die offene Situation eines Kunstprojekts gebracht. Profitanspruch der Unternehmen, die mit Werbung den öffentlichen Raum besetzen und die Bürger zu Konsumenten erklären, transformiert Tobias Rehberger durch die Plakate und ihre Inszenierung zu einem gesamtgesellschaftlichen Ereignis, das ein Mehr an Wahlentscheidung in Bezug auf die Rolle der Teilnehmer im öffentlichen Raum und ihren Gestaltungswillen freisetzt.

Der Künstler beharrt auf dem Recht, das er traditionell hat. Er ist der Autor wirksamer Bildlichkeit und er entscheidet, welche Motive er für bildwürdig erachtet. Dem aktuellen Hoheitsrecht von Wirtschaftsunternehmen auf Bildpräsenz in der Öffentlichkeit setzt er dasjenige der Kunst und dem dazugehörigen Spiel mit Konventionen und ihren Grenzen entgegen. Im Endeffekt stellt er die Frage, wer in welcher Form am öffentlichen Raum beteiligt ist und was „Öffentlichkeit" aus heutiger Sicht sein kann. Die Vorstellung, welche die ursprüngliche Konzeption des Genies bedingt, nämlich ein Modell für den Bürger zu sein, der auf seine schöpferischen Kräfte vertraut,[12] ist immer noch aktuell.

Eva Linhart leitet die Abteilung Buchkunst und Graphik des Museums für Angewandte Kunst Frankfurt und ist Kuratorin der Ausstellung „Tobias Rehberger — flach".

Anmerkungen

1. Vgl. Ulrike Lorenz, „Rehbergerst...im öffentlichen Raum", in: „Public — Tobias Rehberger 1997-2009", Köln 2009.

2. Immanuel Kant, „Kritik der Urteilskraft", Darmstadt 1963, s 16, S. 70f; vgl. auch: Günter Österle, „Vorbegriffe zu einer Theorie der Ornamente, kontroverse Formprobleme zwischen Aufklärung, Klassizismus und Romantik am Beispiel der Arabeske", in: „Ideal und Wirklichkeit der bildenden Kunst im späten 18. Jahrhundert", Berlin 1984, S. 123.

3. Vgl. Ellen Kemp, „Die Entstehung des Werks und seine Präsentation", in: „Ariadne auf dem Panther", Katalog Liebieghaus, Museum alter Plastik, Frankfurt am Main, 1979, S. 11-24.

4. Günter Österle , a.a.o. (siehe Anm. 2), S. 119-139.

5. Ebenda, S. 125-129.

6. Germano Celant (Hg.), „Tobias Rehberger — OnSolo", Milano 2007.

7. Barbara A. Lewis, „What do you stand for? For Teens. A Guide to Building Character", Minneapolis 1999.

8. Siehe hiesigen Beitrag von Jay Conrad Lewinson, „Die Wahrheit über Guerilla-Marketing", Nr. 9.

9. Die Ausstellung „Tobias Rehberger — flach" realisiert den Dialog in der Form eines Symposions zum Guerilla-Marketing am 30. April 2010 im Museum für Angewandte Kunst Frankfurt.

10. Vgl. Maria Lind, in: „Tobias Rehberger — Kunsthalle Basel", Peter Pakesch (Hg.), Katalog zur Ausstellung, Basel 1998.

11. Zitiert nach: „Max Beckmann in Frankfurt", Klaus Gallwitz (Hg.), Frankfurt 1984, S. 42.

12. Jochen Schmidt, „Die Geschichte des Geniegedankens in der deutschen Literatur, Philosophie und Politik 1750-1945", Bd. 1 und 2, Darmstadt 1985, Bd. 1, S. 4 ff.

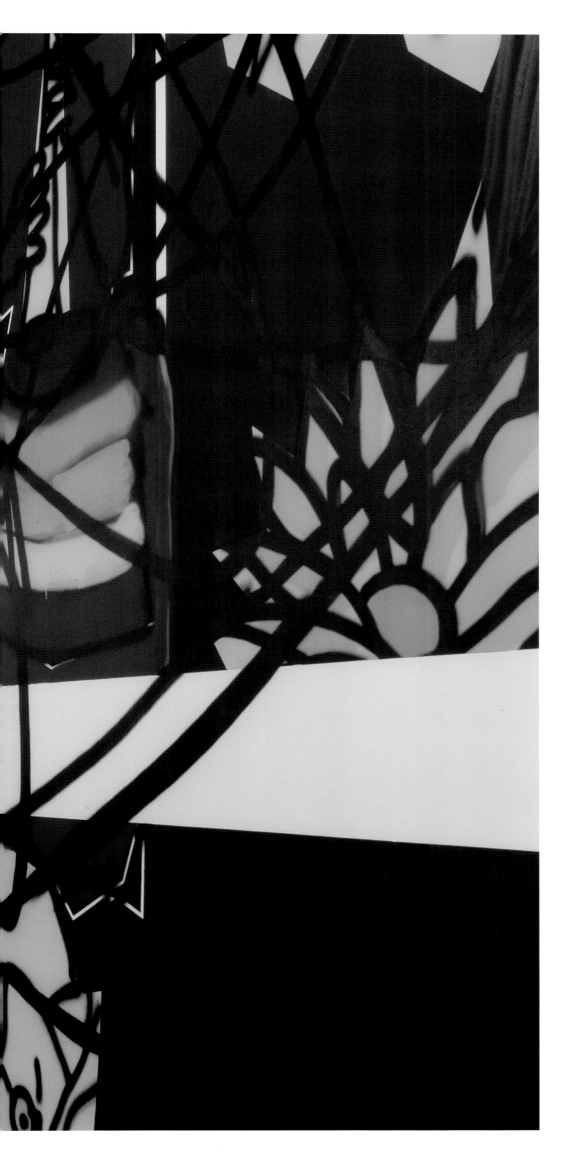

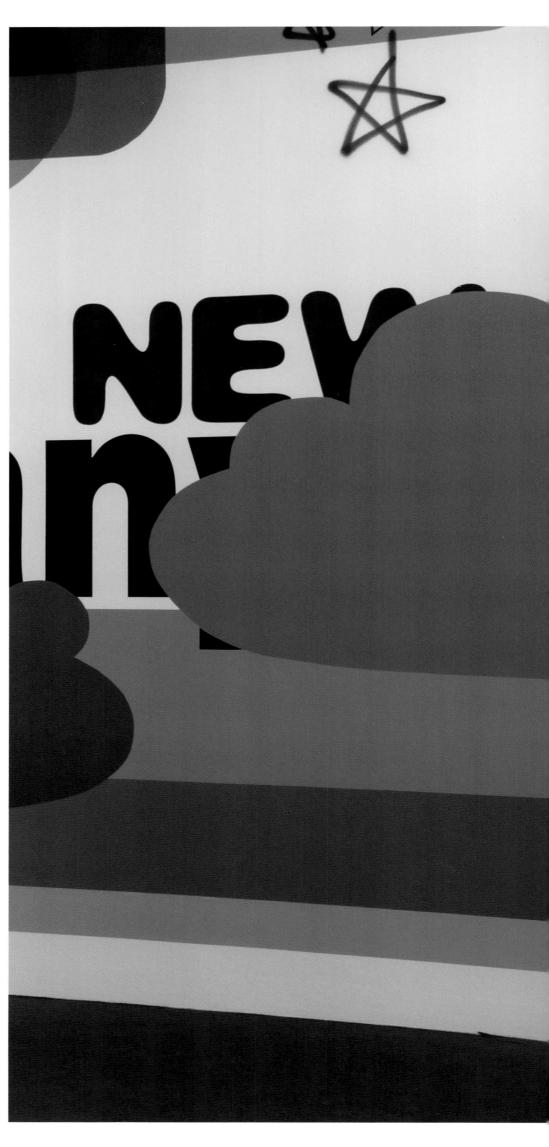

Flachware (... to be honest social injustices don't particularly bother me)

The title of the exhibition "flat" testifies to the self-conception of an artist accustomed to space as his point of departure. Let it be pointed out here, by way of introduction, that no dyed-in-the-wool painter or printmaker wants his work described as "flat" — as, in contrast, Tobias Rehberger did in the spring of 2010 when developing the title of the show of his posters, wallpaper, wall paintings and book art at the Museum für Angewandte Kunst Frankfurt. And let it furthermore be remarked that, since Plato, art has endeavoured to charge the surface with the attribute "deep" as an equivalent to "meaningful". Tobias Rehberger is a professor of sculpture at the Frankfurt Städelschule. His work is accordingly known for artistic interventions in space. For Tobias Rehberger, however, space is never merely an abstract factor, much less a neutral one.[1] Nor do his artistic interventions represent mere formal solutions. Based on the artist's query as to when an object can be considered art, his works provoke a re-evaluation of the things around us — and that also applies to the workgroups presented here.

The reference to them as "Flachware" (literally: "flatware"), i.e. the term used in the German-speaking art world for printmaking — and connoted with a mixture of sympathy and disdain for this moneysaving medium —, amuses the artist. At the same time, however, it also thus becomes clear that he relates "flat" to the wall, and conceives of the wall as a spatial element with potential for expansion. Each of the workgroups displays a different specific strategy for how it embraces space and occupies it in keeping with its concept. The cause of this expansion is to be found in the fact that, in Tobias Rehberger's art, the idea/design is the one thing, its translation into an exhibition context another; the execution a third — quite independent — area and, finally, a fourth aspect is constituted by the resulting effect as a synthesis. There is method to this breaking down of art's development into independent processes — virtually a form of labour division —, and one of its chief consequences is the integration of art into life.

(I don't like music and have no sense of humour ...) or (Oranges from Eden)

A distinctive feature of Tobias Rehberger's wall paintings is their flexibility in the constellation of wall size and budget. The equation is quite simply: the bigger the wall, the more paint, the more expensive and vice versa. In an exhibition setting, the priorities shift in favour of an optimal presentation with regard to the interplay between wall painting and room. In the specific case of the show at the Museum für Angewandte Kunst Frankfurt, a chief concern was to respond to Richard Meier's special architectural design, his round niches, bases, the central glass-case monument, columns and playful differences in ceiling heights. The artist moreover had walls put up around the glass-case monument, creating a cube which joins the other two cubes to complete a tripartite formation and thus to structure the overall spatial situation of the exhibition (see pp. 32-35, 56/57, 60-67). The aim was to create additional impulses for the interpretation of the wall paintings. Eight of the latter works were executed (see pp. 8-57 and 116-129). Of the eight — and this is a feature which holds true for Rehberger's œuvre in general — each speaks a different language or exhibits a different painting style. The wall paintings which are of greatest significance for the artist have been brought together on this occasion, and are being shown here as a workgroup with retrospective character for the first time. In this context, their arrangement in a manner anti-cyclical with regard to the centralistic museum architecture is particularly conspicuous: whether because a wall painting continues across eight corners ("I Don't Like Music I Have No Sense of Humour and To Be Honest Social Injustices Don't Particularly Bother Me" No. 5, see pp. 35 and 38/39), or whether it extends upward to the height of the room itself (pp. 24-35). By spreading themselves out across the surfaces of elements such as bases or the width of a wall, they conversely highlight the presence of the architecture — by a virtual negative method, causing a kind of visual irritation. On the one hand, Tobias Rehberger's wall paintings are based on an exploration of painting and its tradition; on the other hand on the comparison with wallpaper. The simple fact that wallpaper dominates our home decor because, thanks to its mass production, it is cheaper than wall paintings serves him as a point of departure. And in response to that fact, the artist sets himself the goal of conceiving his wall paintings and their production in such a way that the costs approximate those of high-quality wallpaper.

At the same time, however, the exclusive status of wall painting — historically speaking the forerunner to wallpaper — is to remain intact. In other words, Tobias Rehberger raises the question as to how unique wall decoration for individual interiors can be achieved in the present-day age of mass culture. The design and execution of Tobias Rehberger's wall paintings are not the job of one and the same person. The designs double-function as digital patterns — essentially a kind of stencil — which, in the first stage of the process, have to be adapted to the wall's proportions before then being realized by persons other than the artist himself. An analogy to wallpaper becomes apparent here in the sense that, in the case of wallpaper, the design and the production are also separate processes. Tobias Rehberger carries this analogy further in the pictoriality of his wall paintings. Contemplating them, we notice that the principle of overlapping semi-transparent fields of colour dominate their overall appearance. This can be retraced to the design, which Tobias Rehberger carries out on the computer using a program called "Illustrator". One of the features of this digital procedure is that it allows transparent colours to be overlapped with relatively little effort as a means of attaining an accordingly wide range of new nuances. For the wall, on the other hand, each individual colour value has to be defined separately. The great number of shades used represents a challenge to the painterly task of colour-mixing and requires extreme technical skill. On the other hand, the wall paintings contain elements which have to be carried out by experienced sprayers. The street thus gains entry into the private interior: the anarchistic scene of youth culture as well as the underground merges here with a loud pop aesthetic in a style reminiscent of naïve painting. The images play with lettering and slogans, without going so far as to make narrative sense or convey actual information, but serving to position the wall paintings on the border between the comic book, graffiti and large-scale billboard advertisements — and thus on that between the interior and the exterior, the private and the public.

Within this process, Rehberger's strategies for the production of wall paintings correspond with the motifs those strategies dictate. Remarkably, the artist quotes Henri Rousseau (1844–1910), "Le Douanier", twice ("Horrible Flute Player" No. 6 and "Oranges from Eden" No. 7, see pp. 32/33, 12/13, 46-49, 55): that self-taught painter much appreciated — not only by Picasso — for his originality, but also because he painted the Garden of Eden with Eve or lions at a time when the age of industrialization progressed, seeing the authentic art of "peinture" as the last remaining means of saving the paradise of his innocence. Due to the pasting process, wallpaper enters into permanent union with the wall; in comparable manner, an aspect of Tobias Rehberger's wall-painting concept is that every design sold is realized only once as a wall painting in a private interior. The current possibilities of technical reproducibility are thus deliberately undermined in order to assert the traditional identity of a wall painting, which is constituted by uniqueness of design and execution. A given motif can be reproduced only as often as is dictated by the size of the edition. The originality and exclusivity of a wall painting is thus guaranteed. The concept triumphs over the feasibility of reducing the uniqueness of an artwork by means of serial production in an edition.

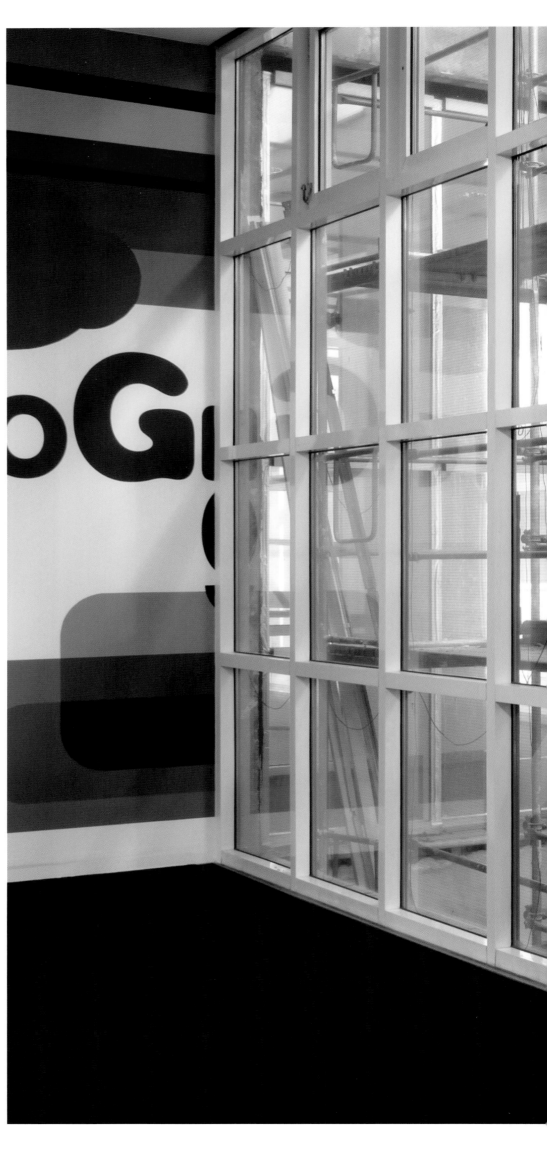

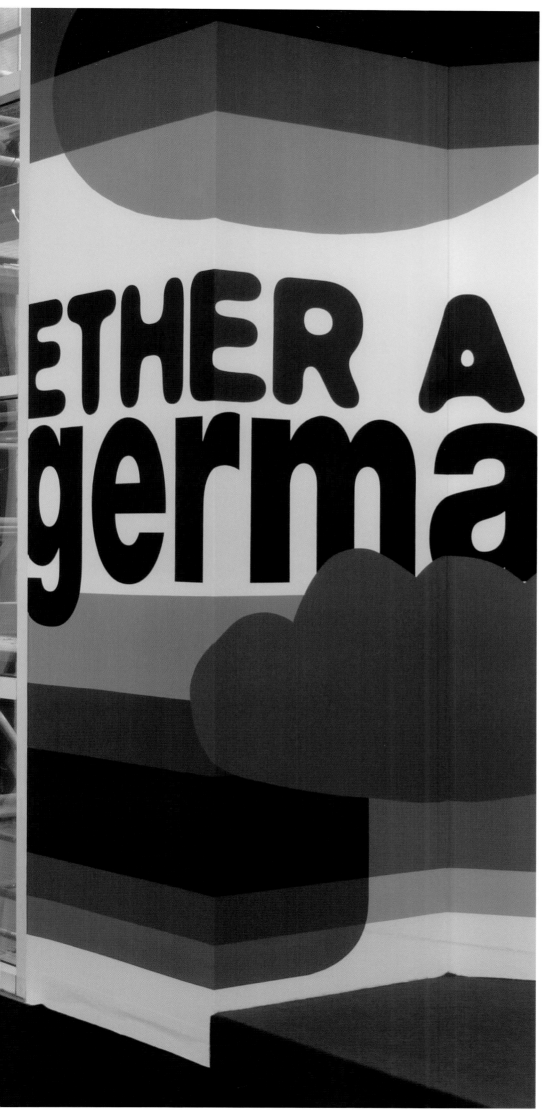

Inside (UP On 1-5)

The underlying thematic-formal principle for this wall work is the circumstance that wallpaper is a reproducible means of providing interior living spaces — or "inner life" — with pictorial imagery. On this basis, Tobias Rehberger develops a complex of interrelated references.

As his technical medium he has chosen photo wallpaper (No. 9; see pp. 8, 10, 54, 56/57, 58/59, 61, 84). What they illustrate are medical photographs: endoscopies of his own bodily organs from the lung through the stomach. They convey themselves as abstract-ornamental, tube-shaped convolutions of his "inner life", whose colouration in shades of red radiates pulsating energy. Tobias Rehberger picks up on this theme again in the manner of presentation within the museum architecture: the wallpaper surrounds the central duct containing the museum's inner workings and concealing them from view: the lift, the power cables, the light switches, the telephone, the fire extinguisher, the storeroom for cleaning equipment and the cloakroom for the guards' personal belongings. At the same time, the application of Tobias Rehberger's wallpaper to this spatial cube emphasizes the latter's function of forming passages between two exhibition rooms (pp. 56/57).

Wallpaper associated with the themes of inner life, abstract pictoriality and passage bring us in turn to the art-historical role attributed to this art form for instance by Immanuel Kant (1724–1804):[2] that of mediator between art and life. Citing the example of wallpaper and its ornamentation, Kant voiced the thought that art's function is to extend itself into life as "something better". He was thus contemplating the standards of the early bourgeois aesthetic, which especially German Neoclassicism endeavoured to embody with its sculptures and holistic stagings,[3] and its inquiry into how art, as something better (the true, good and beautiful) could have a positive influence on unsightly reality.[4] What Neoclassicism achieved in the way of methodological structures for all later periods up to and beyond the modern, was the playful handling of boundaries. In this context, elements such as frames, bases, wallpaper, wall panelling or vases were assigned the function of marking and forming the boundary between the artwork and reality. Whereas — due to their relationship to ornament — these elements had initially ranked as secondary art forms, they now advanced — due to their relationship to ornament — to the rank of sentinels at the boundary to autonomy.[5] For ornamentation — independent, as it is, from the imitation of external reality — formed the basis of the initial conception of abstract art. The essential object of such deliberations was the development of an art form capable of giving direct expression to the inner life of the subject and its creative-dynamic forces as innate qualities.

The point of this brief excursus is to show where Tobias Rehberger's artistic strategies — complete with his query as to when an object can be considered art — stand in relation to history, and the extent to which his explorations of the boundaries between autonomous and applied art are guided by an emancipatory impulse in support of "improving reality". Even today, this impetus still legitimizes and determines art's role in society and the expectations we place on it — an aspect which becomes all the clearer in connection with the poster group of Tobias Rehberger's "Ads", to be discussed below. Tobias Rehberger uses the back of the wallpaper wall for the presentation of posters (pp. 58/59, 61), a circumstance which — along with the fact that this is also the room which opens up onto the city of Frankfurt through its large windows — further emphasizes the intermediate role of wallpaper between art and life. In contrast to the idealistic pathos of the Neoclassicist mentality, however, Tobias Rehberger's wallpaper and its staging has the advantage of humour as well as pragmatism.

(please thank you) offset

The posters of Tobias Rehberger can be divided into five groups and are being presented here in their entirety for the first time.

One group comprises those posters which the artists uses as a classical medium of applied art, to advertise his own exhibitions, art projects, or even football — one of the artist's passions (Nos. 10-26). Every one of them exhibits its own solitary style and provides insight into his career all the way back to its beginnings: "Highrises, Rocks, Rudis", the first poster of 1990, a silkscreen printed by the artist himself during his student years at the Städelschule (No. 10, pp. 86; 58/59, 61), or "Cancelled Projects" announcing the 1995 exhibition at the Museum Fridericianum in Kassel (No. 11, pp. 88; 60, 63). At around the same time, he collaborated with his brother Chris Rehberger, a designer, on the poster series "Talks on Art, Leipzig Fair" (Nos. 23-26, pp. 87, 89-91). Here the graphic structure remains the same for each poster, their varied colouration serving the function of identifying each new discussion date.

(Tobias Rehberger — COPyBrAIN)

In correspondence with his exhibition posters, Tobias Rehberger designs catalogues to accompany his exhibitions. Apart from the fact that they are becoming more extensive and more elaborate as the artist gains renown (Nos. 75-97; see pp. 184-187), as works of book art they reveal the claim to contribute substantially to the corresponding exhibition, and to be art. Here again, the ambition to find a new and unique form for every context in keeping with the respective artistic concept can once again be discerned. What is more, the catalogues indicate a distinct interest in experimenting with the book and its complex facets — cover, endpaper, page sequence, paper, innerbook, binding, layout, printing, blank page and ribbon — as well as with the interplay between the publication and the theme of the artistic work it is accompanying. It is thus not so much the catalogue as an information medium which is the chief object of interest; rather, the catalogue represents a form of artistic expression which must be defined as a translation of art into the book. This is already true, for example, in the case of the catalogue conceived by the artist in 2001 for the exhibition "Frankfurter Positionen" at the Portikus, where the "First Ads" were shown. The pages of the publication consist of the posters themselves, while the inside covers, on the other hand, reproduce the poster motifs in DIN A5 size (No. 84; p. 184/185). For the 2004 show "Tobias Rehberger — Artist Book" at the SAMUSO Space for Contemporary Art in Seoul, the artist developed the concept of every page being a cover page, realized as a catalogue in cooperation with Baan Kim Sung Yeol (No. 90; p. 187). In 2002, within the framework of the exhibition "Tobias Rehberger — presçriçðes, descriçðes, receitas e recibos" at the Fundaçāo Serralves, the artist had the pages consist of self-adhesive foils printed and punched in such a way that the graphic elements can be detached from the background (No. 88; p. 184). At around the time he was executing works for the Venice Biennale in 2009, Tobias Rehberger began developing the artist's book COPyBrAIN (No. 96; p. 185). The 336 pages of the book are based on a work carried out by the artist at the Hans-Thoma-Museum in Bernau, Black Forest, in conjunction with the award of the Hans Thoma Prize: "The GREAT disarray swindle". Here Rehberger addresses the theme of "confusion", and the work accordingly bears a resemblance to the Giardini cafeteria in Venice, although there are substantial formal differences. Several kilometres of cable, winding, tangling and knotting its way through the room were combined with a large number of light bulbs. For the artist's book, the resulting pictorial material was underlaid with neon paper, some of the pages conceived as collages and designed in cooperation with v.e.r.y. of Frankfurt am Main. There is a special irritation between the closed book block and the act of opening it. The title of the artist's book is to be found on the surface created by the cut edges of the pages

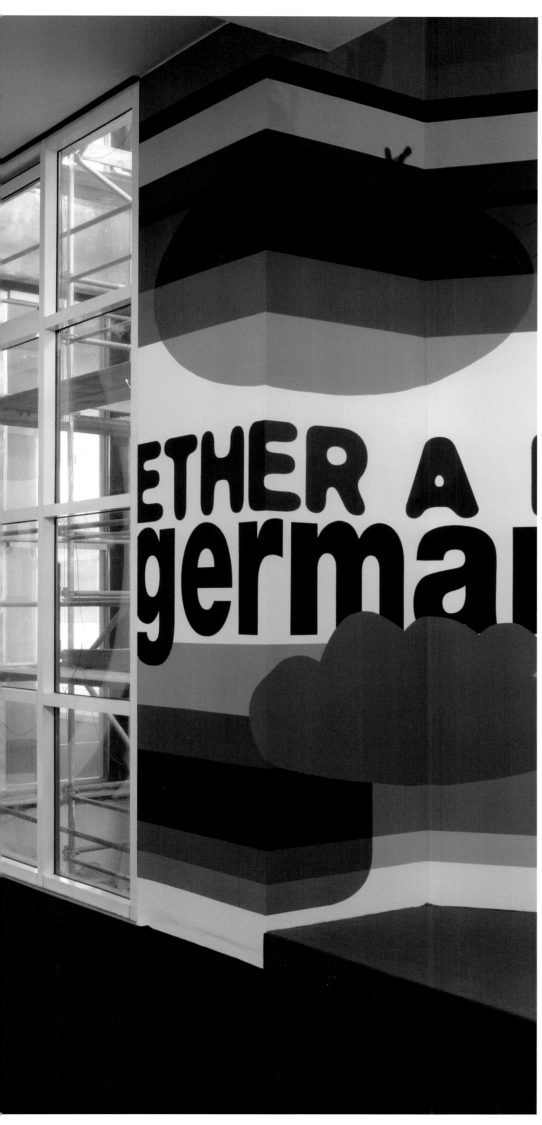

otherwise often used for some kind of ornamentation.
When the subdued book block is set into motion, so
to speak, the pages begin to fan out, and the book's
inner life, borne by a spectrum of neon colours,
surprisingly comes into view.

...

The posters for the Bar Cafeteria Palazzo delle
Esposizioni Giardini at the 2009 Venice Art Biennale
are an integral element of the work "What You Love
Also Makes You Cry", for which Tobias Rehberger was
awarded the Golden Lion (Nos. 39-47; pp. 134-140/141;
82-85). Based on the collage principle and employing
views of the legendary New York punk club CBGB,
these posters correspond with the design concept for
the Bar Cafeteria, which in turn makes reference to
a painting style referred to as "Razzle Dazzle Painting"
developed in England during World War I as a means
of deceiving, confusing and misinforming the enemy.
The poster motifs can be discerned for the most part
to be depictions of the underground music scene.
Yet because they do not convey any targeted
message, these images undermine the information
function which constitutes the poster as an advertising
medium. With their pictoriality of coarsely enlarged
print rasters, these posters contrast — in a sense
even interfere — with the precisely geometric wall
painting of the Biennale interior decoration, thus
introducing an accent of their own into that context.
The manner in which their "non-informativeness"
works is more closely related to graffiti art as a form
of wall design than to the advertising intention of the
poster. Their presentation in the otherwise strongly
geometricized design context of the cafeteria lends
them the character of having been posted in no
particular order, at random, and hastily. They thus
allude to the counter-movements of the underground
or of illegal postings. In this context it becomes
apparent that Tobias Rehberger is interested in
counter-movements as an artistic method for new
developments.

Fine-Art Prints

The "On Otto" posters are part of the art project by
the same name which pursues the idea of beginning
a film at its end, the cinema poster forming the
beginning (No. 27; pp. 131; 68, 70). Tobias Rehberger
broke down the complex teamwork necessary for the
production of a film into its separate areas of expertise,
and unfurled the working steps backwards. The
individual sequences of "On Otto" were shown as an
exhibition in four labyrinthine pavilions at the Fondazione
Prada in Milan in 2007.[6] On that basis, in 2009
Tobias Rehberger developed the poster series, designed
in cooperation with Florian Markl. In an exclusive
edition of a mere six, Edition Schellmann had them
produced by Druck Recom Art in Ostfildern as high-
quality digital prints on photo rag, a paper which
features a very fine, soft surface structure/ texture.
These graphically complex works draw from the genre
of the cinema poster and pay tribute to the various
professions involved in film production, devoting each
of the ten posters to one profession: titles, sound,
music, editing, cinematography, actors, production
design, costume design, story board and script (Nos.
29-38). The fact that the poster series was carried
out subsequently to the art project as a means of
honouring the various areas of expertise which
(aside from the actors) normally go unnoticed by the
public, in combination with the high quality of the
graphic design, the printing and the paper, lend this
workgroup the quality of a monument.

Marker, Pen, White-Out, Tape on Paper in Glass

Tobias Rehberger's most recent posters consist of
one-syllable handwritten exclamations such as "Nö!"
or "Ah!" (Nos. 68–74; pp. 80/81; 115). They are no
longer products of a printing process, but unique
"writings" on poster paper. Due to interventions in and
on the paper — he exposed it to the influence
of persons passing through his studio — they have
moreover been formed into three-dimensional
poster objects. The minimal onomatopoeic reaction
to something whose identity is not revealed to us
is reminiscent of the poster medium's minimum
intention: the will to make itself heard by loud
graphic means.
What is remarkable is their presentation. For the
most part they are masked with neon-coloured tape
and sealed in full glass frames individually adapted
to the respective format. The result is not only
extremely elegant; it also introduces a polarity
between perpetuation and impermanence reminiscent
of the Christian practise of the reliquary. The works
thus exhibit a tendency toward uniqueness,
individualization and virtually sacral heightening
which — in logical consequence — counters the
usual short-lived quality of the poster as a product
of mass serial printing and leans in the direction of
an artwork in the sense of an original.

Mykita, Margiela, Maserati

Even if the posters of the workgroup "Ads" are
presented in the exhibition in full glass frames and
formed into three-dimensional objects (pp. 66, 69,
72–79), the reason for their appearance derives
from a context very different from the single-copy
posters just discussed.
The "Ads" group comprises posters which address
the genre of the advertising poster. What is unique
about their concept is that Tobias Rehberger designs
them as advertisements for products or brands
completely of his own accord, because of their
importance in his personal life environment, and
exhibits them in the form of illegal postings in the
public realm. It is precisely this fact that is at the
root of the posters' deformation in the Frankfurt
show: the posters owe their distortions to the
artistic conception of their having been posted in
the urban realm, then taken or torn down by the
underground, and finally, once their impact in the
terrain of the streets has ended, their transformation
into a representative artwork, in which condition
they — following all these many transmutations —
are preserved for the museum by sealing in glass.
In the course of their function/impact in the public
realm, the "Flachware" takes on volume and weight.

The motifs of the "Ads" posters are constituted by
products which Tobias Rehberger likes, appreciates,
even uses himself in many cases: underwear,
eyeglasses, car, or beverage brands such as Coca
Cola, Margiela, Advil, Bach Rescue Cream, Zimmerli
and others (Nos. 48–67). The fact that the produce
farmer "Bauer Mann" of the Frankfurt Kleinmarkthalle
is featured in this range, and thus placed on an
equal footing with such multinational enterprises
as the computer manufacturer Apple, is a clear
indication that the degree of "brand awareness"
plays a secondary role, and that the sole criterion
for inclusion really is the artist's personal predilection.
Here, and particularly in the "First Ads" series, Tobias
Rehberger proceeds in such a way as to extend his
positive evaluation of the product to the point of
offering an improvement or entirely new proposal for
the corporate design of the respective brand
according to his own aesthetic ideas. The artist as
consumer becomes a designer who participates in
the visual product identity, even optimizes it of his
own accord and as he sees fit. In the case of the

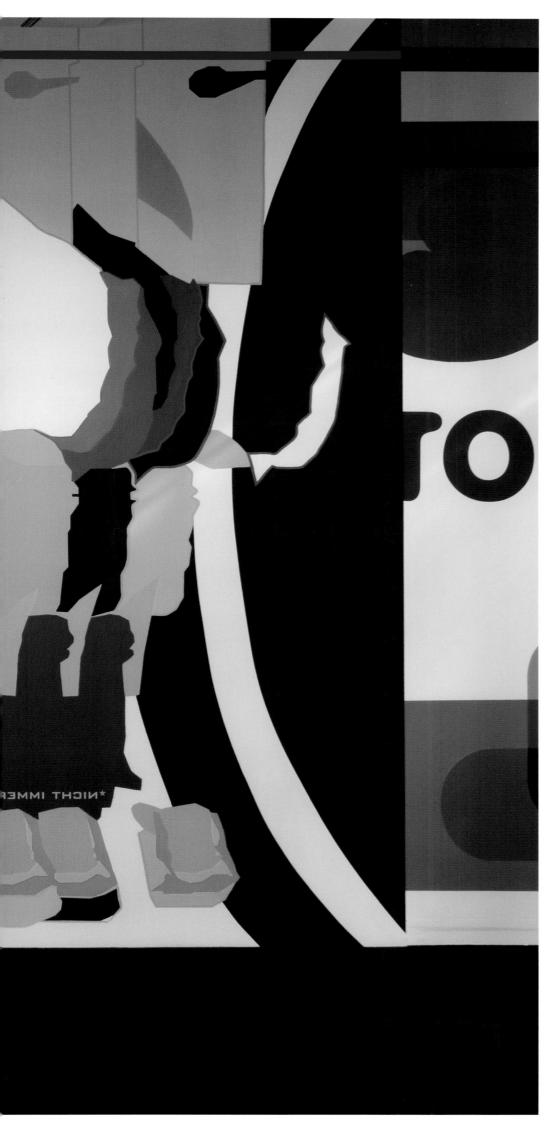

"adidas" poster (No. 53; pp. 101; 66, 69, 72), Tobias Rehberger combines the performance logo of the German sports-goods manufacturer with the title of a guide for teenagers and their character formation by Barbara A. Lewis ("what do you stand for ...")[7] as well as "Cipla". The latter is an Indian pharmaceutical company known for generic drugs, i.e. no-name copies containing the same active ingredients as medications already to be found on the market under brand names, which it sells at a much lower price, thus guaranteeing the medical treatment of, for example, persons afflicted with AIDS.

The uniting of brands in a single poster is reminiscent of "fusion marketing" as a sub-category of "guerrilla marketing".[8] In the case of this poster, however, elements have been chosen from such widely differing areas that their combination proves to be a strategy that goes beyond the usual cooperation effect in advertising. On the contrary, that which must be considered absurd from the marketing standpoint, transforms in the art perspective into a statement declaring social responsibility, copying and lifestyle to be expressions of equal validity. In other words: the poster as artwork evades appropriation for any specific ideology.

For the show at the Museum für Angewandte Kunst Frankfurt, Tobias Rehberger designed posters (Nos. 62- 67) posted at random in the city (pp. 164-183). The artist extends the exhibition into the public space, which thus becomes an exhibition space, and the consumer undergoes an expansion of his/her consumer's existence to include the role of exhibition visitor. One of the consequences of this revaluation strategy is that Frankfurt in its role as cultural metropolis enters into dialogue with the business metropolis Frankfurt, and renews its tradition of critical public discussion with the media offered by art.[9]

The "Ads 3" poster series designed specifically for the Frankfurt exhibition tell us what glasses the artist wears, what cocktail he likes to drink, where, and dressed in what sportswear, what car he drives, what mouthwash he starts his day with, and what clubs he socializes in. These posters thus essentially serve as self-portraits. We not only learn from them that Tobias Rehberger likes to live well,[10] but also that, as an artist, he's one of us here in Frankfurt, where — as Max Beckmann once remarked — "... everything is so nice and close together"[11] — and that, as an internationally acknowledged artist, he is naturally often out and about in the world.

The advertising-poster-self-portraits thus represent his purchasing decisions: the artist as consumer is not advertising what we should buy — as the advertising industry usually does — but what he likes to buy. And the self-portrait of the artist posted in the public realm as an advertising poster results in the following statement: I choose; as a citizen and consumer, I choose this or that product according to my taste and socio-economic means, and as an artist I carry this decision over into imagery in the form of advertising posters and am in search of majorities for my lifestyle as art.

This advertisement for products of his choice as his lifestyle leads us to question and re-evaluate our own roles as citizens in the public realm, and perhaps to come up with new ways of shaping these aspects of our existence: as consumers, as exhibition visitors, and as citizens.

In the process, it becomes apparent that the poster, the advertising poster, is still the political medium for addressing a majority of citizens despite the present-day tendency toward fragmentation into various "communities", and despite the ephemeral presence of digital information/communication. Because the poster — complete with its analogue constancy — is seen in all of the public streets and squares of a city, regardless of the group a given passer-by belongs to: we all see the posters. The poster — and in particular the advertising poster — is the instrument, perhaps the only instrument, still capable today of creating "the public" in the sense of commonality or community.

With the "Ads", Tobias Rehberger thus exceeds the usual boundaries of visual communication. He achieves a re-evaluation of the hierarchies between the poster as a functional advertising medium and the poster as an attractive pictorial medium. In designing posters for brand products on his own initiative and posting them freely in the public realm, the medium is detached from the profit-increasing function of a marketing strategy and introduced to the open situation of an art project. With his posters and their staging, Tobias Rehberger transforms the profit claims of companies — which occupy the public realm with advertisements and define the citizens as consumers — into a pan-societal event which brings about greater awareness and greater freedom of decision with regard to the role of the participants in the public realm and how they actively shape that role.

The artist insists on the right that is traditionally his: he is the author of striking pictoriality, and he decides what motifs he considers worthy of depiction. The sovereign right of business enterprises to visual presence in public is countered here with that of art — and art's means of playing with conventions and its own boundaries. Ultimately, Tobias Rehberger poses the question as to who participates in the public realm, and how, and what constitutes "public" from the present-day point of view. The notion at the root of the original conception of the genius — i.e. to be a model for the citizen to trust in his/her own creative powers[12] — has lost nothing of its validity.

Eva Linhart is the head of the Department of Book Art and Graphics at the Museum für Angewandte Kunst Frankfurt, and curator of the exhibition "Tobias Rehberger — flat".

Translation: Judith Rosenthal

Notes

[1] See Ulrike Lorenz, "Rehbergerst…in public spaces", in "Public — Tobias Rehberger 1997—2009" (Cologne, 2009).
[2] Immanuel Kant, "Kritik der Urteilskraft" (Darmstadt, 1963), sect. 16, pp. 70—71; also see Günter Österle, "Vorbegriffe zu einer Theorie der Ornamente, kontroverse Formprobleme zwischen Aufklärung, Klassizismus und Romantik am Beispiel der Arabeske", in "Ideal und Wirklichkeit der bildenden Kunst im späten 18. Jahrhundert" (Berlin, 1984), p. 123.
[3] See Ellen Kemp, "Die Entstehung des Werks und seine Präsentation", in: "Ariadne auf dem Panther", cat. Liebieghaus, Museum alter Plastik (Frankfurt, 1979), pp. 11—24.
[4] Österle 1984 (see note 2), pp. 119—39.
[5] Ibid., pp. 125—29.
[6] Germano Celant, ed., "Tobias Rehberger — OnSolo" (Milan, 2007).
[7] Barbara A. Lewis, "What do you stand for? For Teens. A Guide to Building Character". (Minneapolis, 1999).
[8] See contribution by Jay Conrad Lewinson in this catalogue: "The Truth About Guerrilla Marketing", No. 9.
[9] The exhibition "Tobias Rehberger — flat" will realize this dialogue in the form of a symposium on guerrilla marketing on 30 April 2010 at the Museum für Angewandte Kunst Frankfurt.
[10] See Maria Lind, in Peter Pakesch, ed., "Tobias Rehberger — Kunsthalle Basel", exh. cat., Kunsthalle Basel (Basel, 1998).
[11] Quoted in Klaus Gallwitz, ed., "Max Beckmann in Frankfurt" (Frankfurt, 1984), p. 42.
[12] Jochen Schmidt, "Die Geschichte des Geniegedankens in der deutschen Literatur, Philosophie und Politik 1750—1945", vols. 1 and 2 (Darmstadt, 1985), vol. 1, pp. 4 ff.

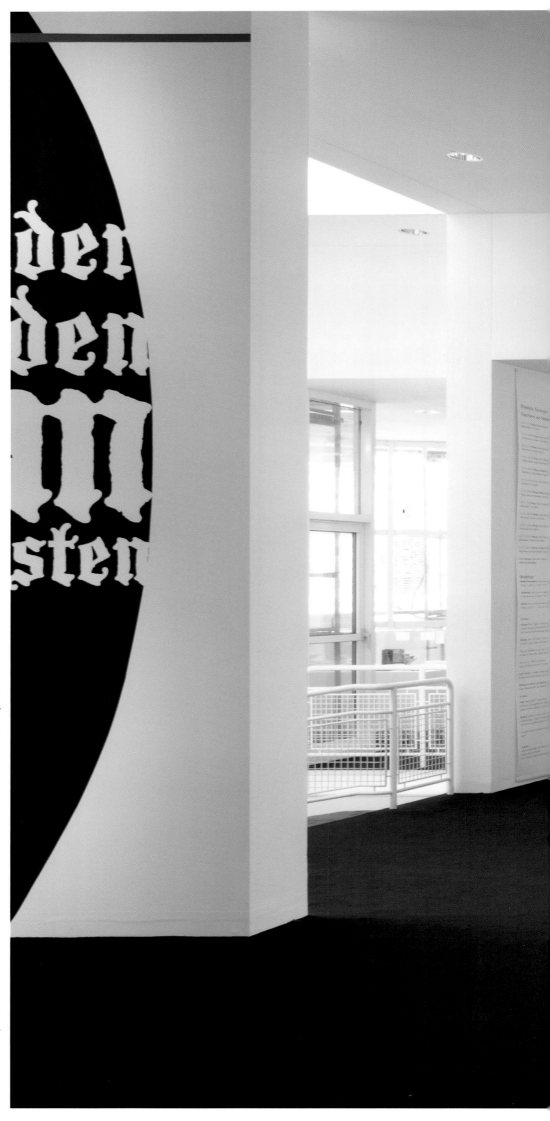

Jay Conrad Levinson

Papst und Schöpfer des Guerilla-Marketings

Die Wahrheit über das Guerilla-Marketing

Dass der deutsche Künstler Tobias Rehberger mich um einen Beitrag zum Guerilla-Marketing bat, finde ich einen sehr interessanten Schritt. Zumal die Verbindung aus Kunst und Marketing in Frankfurt am Main zur Ausstellung kommt; in einer Stadt wo die großen Werbe- und Marketingagenturen ihren Sitz haben. Für einige war ich selbst tätig.
Nachdem durch Tobias Rehberger das Thema Guerilla-Marketing nun Eingang in die Welt der Kunst findet, scheint mir vor allem die Klärung wichtig zu sein, was Guerilla-Marketing in Wahrheit ist. Das ist die Basis für die Diskussion, ob und wie Guerilla-Marketing für die Kunst taugt.

Guerilla-Marketing ist die einfachste, zugleich jedoch die am häufigsten missverstandene Schule des Marketings. Guerilla-Marketing bedeutet weder ein übergriffiges, noch hinterhältiges, unethisches oder anstößiges Marketing. Mit über 21 Millionen verkauften Titeln in 62 Sprachen ist Guerilla-Marketing das am schnellsten wachsende Segment der Branche. Erfolgreich ist es aus zwei Gründen: Es ist erstens unglaublich einfach und zweitens, wenn man es richtig anwendet, funktioniert es immer. Um die Wahrheit über das Guerilla-Marketing zu erfahren, muss man zunächst begreifen, was Marketing eigentlich ist. Marketing ist der Kontakt zwischen denjenigen, die zu Ihrer Firma gehören, und denjenigen, die nicht zu Ihrer Firma gehören. Wie das Telefon abgenommen wird, ist ebenso Teil des Marketings wie die Kleidung, die von den Repräsentanten Ihrer Firma getragen wird oder die Ordnung in Ihren Räumlichkeiten. Insgesamt geht es darum, Ihren Kunden Aufmerksamkeit zu schenken — selbst nach dem Kauf.
Marketing ist ein Prozess und kein Event. Es hat einen Anfang und einen Mittelteil. Wenn Sie es jedoch richtig angehen, so nimmt es kein Ende. Es fängt mit einem einfach geschriebenen kurzen Plan an, der dann aufgeht, wenn Sie sich an ihn halten. Der Erfolg stellt sich nicht sofort ein, aber mit dem angemessenen Engagement funktioniert es immer. Guerilla-Marketing bedeutet nicht „werde schnell reich", sondern „werde schließlich reich". Guerilla-Marketing ist eine Möglichkeit, Ihren Perspektiven näher zu kommen und Ihren Kunden dabei zu helfen ihre Ziele zu erreichen — sei dies nun mehr Geld zu verdienen, ein Unternehmen aufzubauen, abzunehmen, einen Partner zu finden oder besser Tennis spielen zu lernen. Als ein „Guerilla" stellen Sie Informationen, Dienstleistungen und Produkte zur Verfügung, die Ihrer Klientel dabei

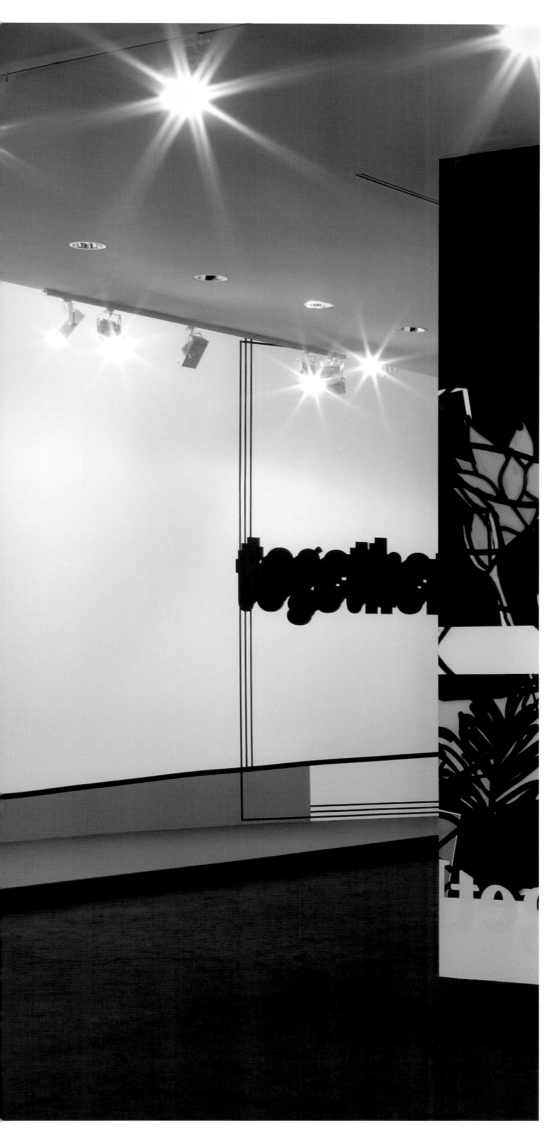

helfen, ihre Ziele zu erreichen. Wenn Sie dies geschafft haben, so haben Sie die Effizienz Ihres Unternehmens unter Beweis gestellt. Der Erfolg eines Marketings misst sich an dem Potential Profit zu generieren. Viele Unternehmen messen dagegen ihre Leistung an Verkäufen oder Besucherzahlen im Internet oder in ihren Verkaufsräumen. Andere Unternehmen wiederum brechen Umsatzrekorde und verlieren dennoch bei jeder Transaktion Geld. All dies sind folglich die falschen Indikatoren.

Der einzig wahre Maßstab ist der Profit. Es lässt sich zwar sagen, dass Marketing eine Kunst ist, weil es alle Kunstarten umfasst, die Ziele sind jedoch grundverschieden: Schreiben ist eine Kunst. Design ist eine Kunst. Tanzen ist eine Kunst. Schauspiel ist eine Kunst. Audio- und Videoproduktionen sind auch Künste. Das Ziel all dieser Künste ist aber nicht der Profit. Die primäre Kunst im Marketing ist das Können, Menschen dazu zu bringen, ihre Meinung zu ändern — so dass sie von dem, was sie schon immer kauften, zu dem, was Sie verkaufen, wechseln. Genau darum geht es und dies leistet Guerilla-Marketing.
Aber was ist es, das Guerilla-Marketing von dem traditionellen Marketing trennt? Die Unterschiede gegenüber gewöhnlichem Marketing habe ich in 22 Punkten zusammengefasst und sie verdeutlichen, warum Guerilla-Marketing so viel erfolgreicher ist. Guerilla-Marketing wird darum so genannt, weil Guerillas in der Kriegsführung zwar das Gleiche wollen, nämlich den Sieg, sie verfügen jedoch gegenüber der Konkurrenz nicht über die ausreichenden Mittel. Daher müssen sie, um effektiv sein zu können, Zuflucht zu unkonventionellen Methoden nehmen. In der Wirtschaft wollen Guerillas das Gleiche wie ihre Konkurrenten: Profit. Dies können sie aber nur erreichen, wenn sie zu ungewöhnlichen Mitteln greifen, sich etwas einfallen lassen. Die folgenden 22 Punkte geben die Vorteile des Guerillas gegenüber dem traditionellen Marketing wieder:

1. Im traditionellen Marketing galt immer die Regel, dass der richtige Marktauftritt finanzielle Investitionen erfordert. Im Guerilla-Marketing dagegen gilt, dass Geld investiert werden kann — aber nicht muss, sofern man gewillt ist stattdessen Zeit, Energie, Fantasie und Wissen einzusetzen. Je mehr Sie dies tun, desto weniger Geld werden Sie benötigen.

2. Traditionelles Marketing ist von so vielen undurch-sichtigen Geheimnissen umgeben, dass sich viele Unternehmer davon eingeschüchtert fühlen, weil nicht klar ist, ob Marketing nun den Vertrieb, den Internet-auftritt oder die PR-Abteilung betrifft. Und wer sich unsicher fühlt, hat natürlich Angst Fehler zu machen. Deshalb lässt er lieber die Finger davon. Guerilla-Marketing räumt mit der Geheimniskrämerei auf und betrachtet Marketing als das, was es tatsächlich ist — ein Prozess, der vom Menschen gesteuert wird und nicht umgekehrt.

3. Traditionelles Marketing ist auf große Unternehmen zugeschnitten. Bevor ich 1984 das erste Buch über Guerilla-Marketing schrieb, konnte ich kein einziges Fachbuch für Firmen finden, deren monatliches Marketingbudget unter 300 000 US-Dollar lag. Es stimmt zwar, dass für das Vertriebs- und Marketing-personal vieler Fortune-500-Unternehmen das Buch Guerilla-Marketing mittlerweile zur Pflichtlektüre gehört, doch es sind nach wie vor die kleinen Unternehmen, für die sich Guerilla-Marketing leiden-schaftlich einsetzt: die Kleinbetriebe mit großen Träumen und winzigen Budgets.

4. Die Effizienz des traditionellen Marketings wird an Verkaufszahlen, an der Größe der Mailing-Listen oder dem großzügigen Verschenken von Gutscheinen und einer Reihe von anderen falschen Indikatoren gemessen. Guerillas wissen jedoch, dass unterm Strich nur der Profit zählt.

5. Traditionelles Marketing basiert auf Erfahrungswerten und Urteilsvermögen, was eine höfliche Umschreibung dafür ist, ins Blaue hinein zu raten. Ein Marketing-Guerilla kann es sich jedoch nicht leisten, falsch zu raten, weshalb er sich Psychologie, die wissenschaftliche Erkenntnis über das menschliche Verhalten — so weit wie möglich — zunutze macht. 90 % aller Kaufentscheidungen werden zum Beispiel unbewusst und emotional getroffen. Heutzutage kennt man einen treffsicheren Trick, um auf die Ebene des Unbewussten vorzudringen: Wiederholung. Wenn Sie nur einmal kurz darüber nachdenken, zeichnet sich vielleicht schon ein wenig ab, wie Guerilla-Marketing funktioniert. Wiederholung versetzt Berge.

6. Die übliche Vorgehensweise im traditionellen Marketing ist das geschäftliche Wachstum voranzutreiben und anschließend das Portfolio zu diversifizieren. Dies verführte ein sonst hervorragendes Unternehmen wie Coca-Cola dazu zu glauben, dass sie mit Getränken aller Art umgehen könnten. Sie investierten in ein Weingut, nur um schließlich 90 Millionen US-Dollar zu verlieren und im Nachhinein zu begreifen, dass sie nur auf Soft-Drinks spezialisiert sind. Schon viele Unternehmen sind — nachdem sie sich von ihren Kernkompetenzen entfernt haben — in heftige Turbulenzen geraten. Das Guerilla-Marketing betrachtet Wachstum nicht als ein Muss, sondern vielmehr als eine Option, die stets dem eingeschlagenen Kurs untersteht. Schließlich hat man es genau dieser Fokussierung zu verdanken, dass man soweit gekommen ist.

7. Im traditionellen Marketing konzentriert man sich auf lineares Wachstum, was heißt, neue Zielgruppen nacheinander anzusprechen. Dies bedeutet, dass Wachstum ziemlich langsam vonstatten geht und mitunter hohe Kosten verursacht. Im Guerilla-Marketing konzentriert man sich jedoch auf geometrisches Wachstum, was bedeutet: Parallel zur traditionellen Wachstumsförderung wird jede Transaktion ausgeweitet, die Anzahl der Transaktionen pro Verkaufszyklus wird bei jedem Kunden erhöht und die äußerst wirkungsvolle Mundpropaganda wird in vollem Umfang ausgeschöpft. Und wenn das Unternehmen in vier Richtungen gleichzeitig wächst, sollte es nicht allzu schwer sein, daraus Profit zu schlagen.

8. In der irrigen Annahme, Marketing hätte mit einem Geschäftsabschluss seinen Zweck erfüllt, wird es in seiner traditionellen Variante sämtliche Munition für eben diesen Vorgang verschießen. Das Guerilla-Marketing führt dagegen das Argument ins Feld, dass 68 % aller verpassten Geschäftschancen aus demjenigen Grund verpasst wurden, dass einem Käufer nach dem Geschäftsabschluss kein Interesse mehr entgegengebracht wurde — der Kunde wurde einfach ignoriert. Die Kundenpflege — kontinuierlich Kontakt halten und zuhören — ist daher eines der am eifrigsten zu verkündenden Gebote des Guerilla-Marketings. Ein Guerilla verliert keinen einzigen Kunden aufgrund von Unaufmerksamkeit.

9. Das traditionelle Marketing empfiehlt, wachsam nach potentiellen Feinden Ausschau zu halten. Im Guerilla-Marketing dagegen wird nach potentiellen Verbündeten Ausschau gehalten, deren Zielgruppen und Standards den eigenen ähneln, um von gemeinsamen Marketingkampagnen zu profitieren. Dadurch erweitert sich die Reichweite des eigenen Marketings, während sich die erforderlichen Kosten reduzieren, da sie unter den Partnern aufgeteilt werden. Der Marketing Guerilla bezeichnet diese Taktik als Fusion-Marketing. „Fuse it or lose it" lautet das Motto. Ein typisches Beispiel für Fusion-Marketing wäre zum Beispiel ein Werbespot, in dem für McDonald's, für Coca-Cola und gleichzeitig auch für den neuesten Spielfilm von Walt Disney geworben wird. Eben diese Weltkonzerne setzen Fusion-Marketing

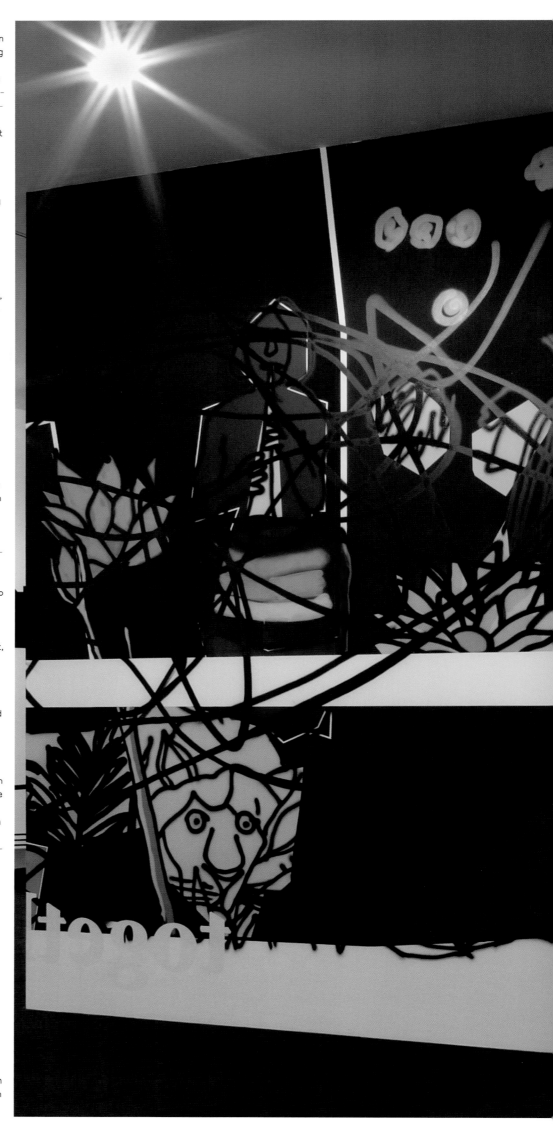

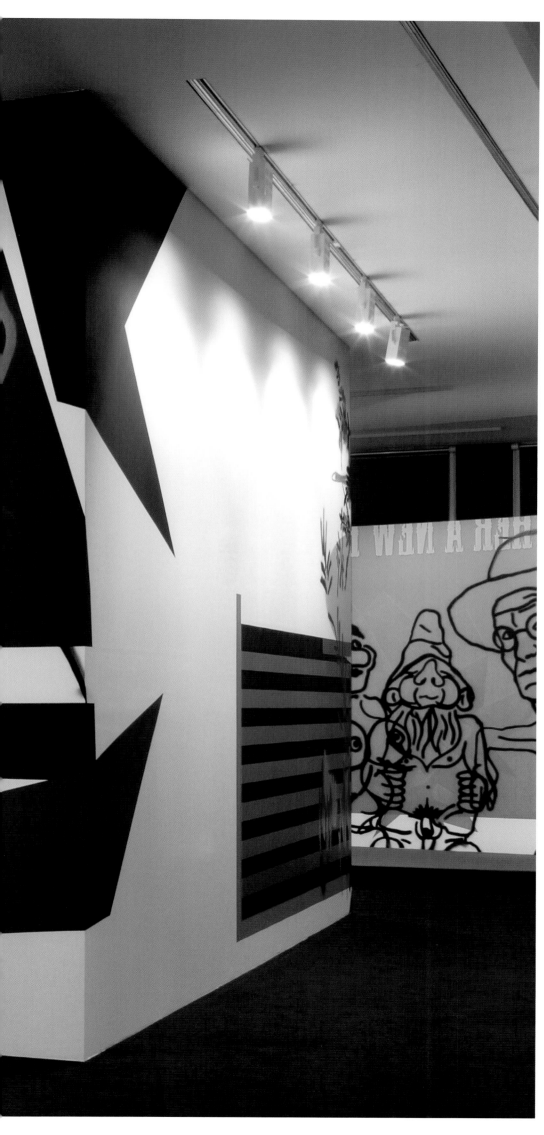

ein, wie übrigens auch FedEx und Kinkos, am weitesten verbreitet ist die Strategie jedoch unter den Klein-unternehmen, vor allem den japanischen.

10. Beim traditionellen Marketing wird dem Kunden nahe gelegt etwas zu kaufen, dessen Sinn darin liegt, nützlich zu sein. Das Guerilla-Marketing empfiehlt dagegen, dem Kunden Antworten auf Probleme anzu-bieten, da es viel leichter ist, ihm Aussichten auf die Lösung eines seiner Probleme zu verkaufen statt nur die Vorteile von Ware.

11. Im traditionellen Marketing gilt ein Firmenlogo — das Identifikationssymbol eines Unternehmens — als das absolute Muss. Visuell vermittelte Botschaften prägen sich um 78 % effektiver ein als gesprochene Worte. Im Guerilla-Marketing gilt das Firmenlogo als nicht mehr zeitgemäß, da es kaum mehr leistet, als die Verbraucher an den Firmennamen zu erinnern. Marketing-Guerillas stellen ihre Firma lieber durch ein „Mem" dar — also durch ein Symbol oder ein Wort, das mittels eines „Mem-Trägers" eine prägnante Vorstellung kommuniziert, wie es beispielsweise bei Straßenverkehrsschildern der Fall ist. In einer so hektischen Zeit wie der unseren vermittelt ein Mem in kürzester Zeit die Informationen. Vor allem für Ihre Webseite, die Interessenten möglicherweise nur für wenige Augenblicke besuchen, erweisen sich die Mems als ein Geschenk des Himmels.

12. Traditionelles Marketing war schon immer ein egozentrisches Geschäft. Auf so gut wie jeder Homepage von Firmen finden Sie Informationen über „Unser Unternehmen", „Unsere Geschichte", „Unsere Produkte", und „Unsere Konzernleitung". Glauben Sie wirklich, dass das jemanden interessiert? „Ich-Marketing" hat die Wirkung einer Schlaftablette. Marketing-Guerillas praktizieren daher das „Du-Marketing", indem es immer nur um den Kunden oder den Besucher der Homepage geht. Sie müssen bedenken, dass kein normaler Mensch sonderliches Interesse an Ihrer Firma hat. Jeder interessiert sich vor allem für sich und die eigenen Belange. Wenn Sie jedoch die Person und die Belange Ihrer Kunden ansprechen, schenken Sie ihnen die notwendige volle Aufmerksamkeit.

13. Im traditionellen Marketing zerbricht man sich darüber den Kopf, wie sich am meisten aus einem Kunden herausschlagen lässt. Guerillas ist die Bedeutung des Customer Lifetime Value (CLV) selbst-verständlich auch klar. Jedoch zerbrechen sie sich zudem darüber den Kopf, was sie einem Kunden geben könnten. Und zwar kostenlos.
Ein Apartmenthaus in Los Angeles genoss eine 100%-Belegung, während andere gleiche Gebäude nur bis zu 70 % ausgelastet waren. Daraus leitet sich die Frage ab: Wie haben es die Unternehmer geschafft eine 100 %-Belegung statt einer von nur 70 % zu erreichen? Man stellte ein Schild auf, auf dem stand: „Kostenlose Autowäsche bei Anmietung der Wohnung." Man bezahlte also jemanden für eine wöchentliche Autoreinigung. Die Differenz zwischen 100 % und 70 % deckt dessen Gehalt locker ab.

14. Das traditionelle Marketing macht Ihnen vor, dass Werbung funktioniert, sei es über Internet oder als Direktwerbung. Diesen überholten Ansichten schmettert ein Marketing-Guerilla entgegen: Unsinn, Unsinn und noch mal Unsinn! Werbung funktioniert so 2010 nicht, zumindest nicht so wie früher. Guerillas wissen, dass es nur geht, wenn verschiedene Marketing-Strategien kombiniert werden, das heißt: Anzeigen schalten in Verbindung mit einem gelungenen Internetauftritt gefolgt von der Aussendung einer Direktwerbung postalisch oder via E-Mail. Dann funk-tioniert diese Kombination nicht nur, sondern die einzelnen Komponenten verstärken sich zudem gegen-seitig. Die Zeiten, in denen das Marketing mit nur einer Waffe Siege feiern konnte, sind vorbei.

Heute ist die Kombination verschiedener Marketing-
instrumente der einzig passende Schlüssel zum Erfolg.

15. Traditionelle Marketing-Profis zählen am Ende
des Monats das Geld. Für Guerillas zählen neue
Kundenbeziehungen. Da Menschen bekanntermaßen
Beziehungen eingehen möchten, setzen Guerillas
alles daran, zu jedem Kunden eine persönliche
Beziehung aufzubauen und zu pflegen.

16. Das traditionelle Marketing hat dem technolo-
gischen Fortschritt nie eine besondere Beachtung
geschenkt, da neue Technologien bis vor kurzem
zu teuer, zu unflexibel und zu kompliziert waren.
Heute ist die Situation völlig anders. Die verfügbaren
Möglichkeiten verhelfen Kleinunternehmen zu einem
relativ unfairen Wettbewerbsvorteil. Kleinunternehmen
können mittlerweile wie die ganz Großen agieren,
ohne jedoch ebenso viel investieren zu müssen.
Guerilla-Marketing erwartet von Ihnen, ein Techno-
logiefan zu werden, denn Technologiephobie
verhindert, dass Ihr Kleinunternehmen gedeiht.

17. Das traditionelle Marketing wendet sich mit Werbe-
botschaften an Zielgruppen. Je größer die Gruppe,
desto besser. Das Guerilla-Marketing wendet sich
mit Werbebotschaften üblicherweise an Einzelpersonen,
und wenn eine Zielgruppe angesprochen werden soll,
dann gilt die Regel: Je kleiner, desto besser. Im
traditionellen Marketing wird großflächig bombardiert,
während im Guerilla-Marketing ganz gezielt winzige
Ziele ins Visier genommen werden. Das großflächige
Bombardement wird in der Fachsprache als Broad-
casting bezeichnet, die Scharfschützenstrategie
als Narrowcasting, Microcasting und Nanocasting.
Guerillas wissen, dass 4 % der Kunden das wollen,
was ihnen gerade zum Verkauf angeboten wird, dass
4 % der Kunden zum Kaufen bereit sind, ihnen
aber noch ein wenig Information zur endgültigen
Entscheidung fehlt, und 92 % haben einfach kein
Interesse. Richten Sie Ihre Botschaft an die 8 %,
die Ihnen Aussicht auf Erfolg versprechen.

18. Das traditionelle Marketing landet größtenteils
zufällige Treffer. Obwohl ihm all die schweren
Geschütze wie Radio, Fernsehen, Printmedien und
Internet zur Verfügung stehen, werden die wichtigen
Kleinigkeiten — Aspekte wie schnell und freundlich
Anrufe entgegengenommen werden, wie das Büro
eingerichtet ist, wie sich die Mitarbeiter verhalten —
üblicherweise ignoriert.

19. Im traditionellen Marketing glaubt man fest
daran, dass allein schon die Werbung zu einem
Geschäftsabschluss führt. Das mag vielleicht früher
einmal der Fall gewesen sein, heute ist es eher die
Ausnahme. Das Guerilla-Marketing fordert uns auf,
die Sache realistisch zu sehen und zu akzeptieren,
dass heutzutage schon viel gewonnen ist, wenn die
Empfänger sich damit einverstanden erklären, noch
mehr Werbematerial zugeschickt zu bekommen.*
[Die meisten Menschen werden sich weitere Werbe-
materialien jedoch ausdrücklich verbitten, wofür Sie
ihnen dankbar sein sollten. Denn damit teilen sie
Ihnen doch ganz klar mit, dass weitere Bemühungen
Ihrerseits die reine Geldverschwendung wären.]**
Die Betreiberin eines Ferienlagers im Nordosten der
USA etwa inseriert in verschiedenen Zeitschriften.
In ihren Anzeigen wirbt sie allerdings nicht dafür, die
Kinder für das Ferienlager anzumelden, sondern
dafür, eine kostenlose DVD über das Ferienlager
anzufordern. Ihre Werbung sendet also die Botschaft,
sich in aller Ruhe zu Hause beraten zu lassen.
Nach einem solchen Beratungsgespräch melden
80 % der Eltern eines oder mehrere ihrer Kinder für
das Ferienlager an. Und dann sind die Verwandten,
Freunde oder Klassenkameraden nicht zu vergessen,
die es ihnen möglicherweise gleichtun und sich
anschließen.

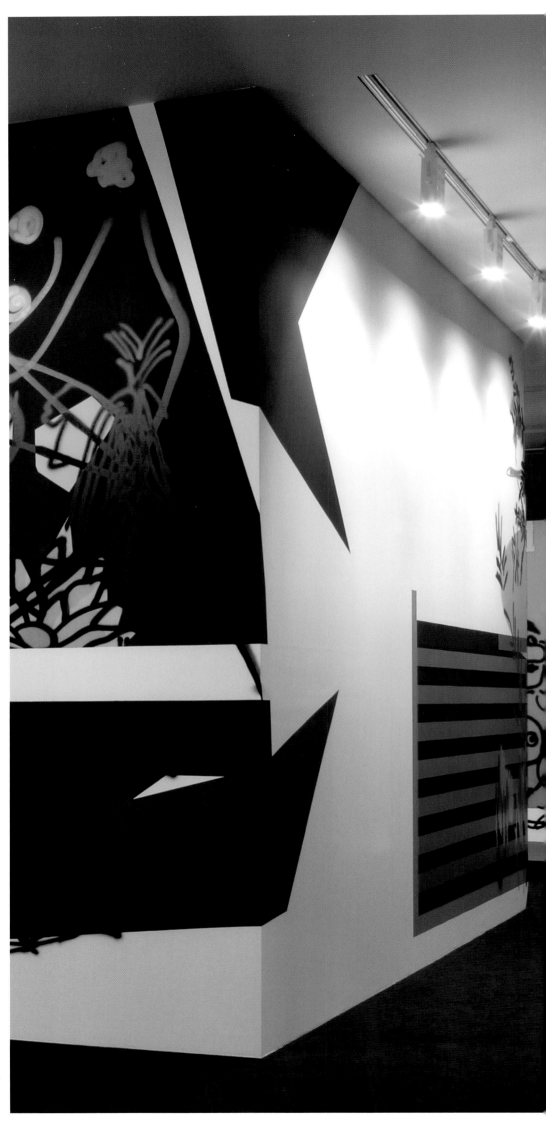

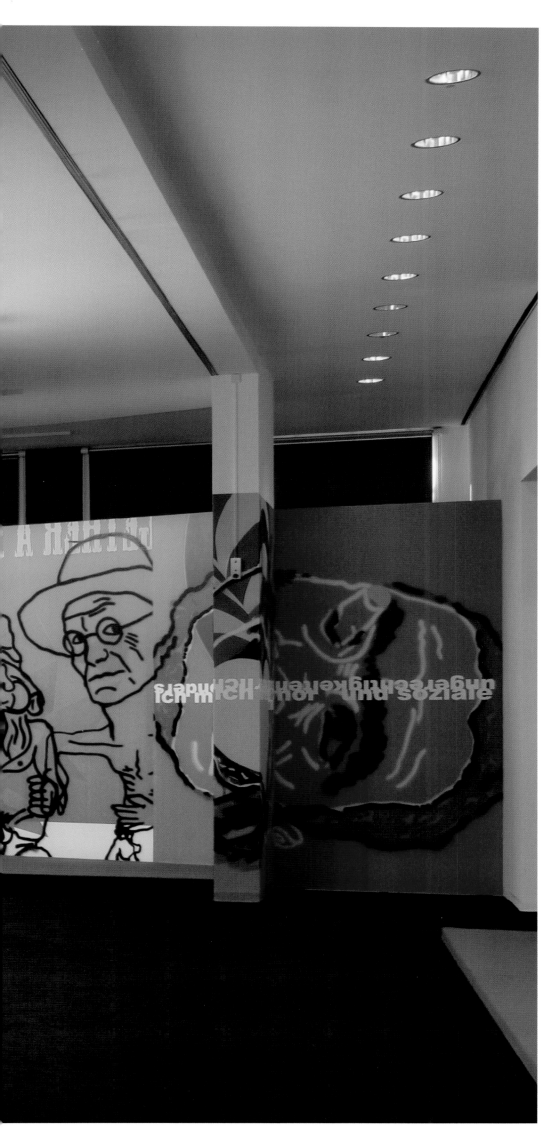

20. Traditionelles Marketing ist ein Monolog. Einer redet oder schreibt etwas, alle anderen hören zu oder lesen. Denkbar ungünstige Voraussetzungen für eine Beziehung. Guerilla-Marketing ist ein Dialog. Einer redet oder schreibt etwas, der andere reagiert darauf. Ein interaktiver Prozess beginnt. Der Kunde wird in das Marketing einbezogen.

21. Traditionelles Marketing verkauft alles, solange es sich verkaufen lässt. Wenn es letztendlich ein schädliches Produkt ist, so ist das die Schuld des Produzenten. Guerillas verkaufen, was gebraucht wird und sie punkten damit bei ihren Abnehmern.

22. Das Arsenal des traditionellen Marketings besteht hauptsächlich aus den schweren Geschützen: Radio, Fernsehen, Printmedien, Direktwerbung und Internet. Guerilla-Marketing ist mit seinen 200 Marketingwaffen, von denen viele sogar kostenlos zur Verfügung stehen, deutlich besser gerüstet. Um eine Liste aller 200 Marketingwaffen zu erhalten, schicken Sie bitte eine E-Mail an meine Tochter Amy Levinson. Ihre Adresse lautet: olympiagal@aol.com.

Und zum Schluss noch ein Extrapunkt: Das von Ihnen eingesetzte Grafikdesign sollte zu Ihrem Unternehmen und zu Ihrer Strategie passen. Niemals sollte es den Verkauf aushebeln. Zwar kann es herausragend und überraschend sein, es sollte sich aber innerhalb der von Ihnen festgelegten Strategien und Ihrem Fokus bewegen. Die dabei eingesetzte Kreativität hat im Sinne Ihrer Interessen zielgerichtet zu sein. Natürlich wollen Sie Aufmerksamkeit erregen. Trotzdem ist es ratsam, so prägnant das Design auch sein mag — und Guerillas wissen schließlich um die nachhaltige Wirkung dessen, was sich von der Masse abhebt —, es so anzuwenden, dass Sie Ihrer Unternehmensstrategie und Ihren Zielen treu bleiben. Denn nicht dem Marketing gilt die Aufmerksamkeit, sondern den Dingen, die Menschen interessieren — und nur selten ist es das Marketing selbst. Marketing ist notwendig, um die Wirtschaft in Gang zu halten. Dies kann das traditionelle Marketing jedoch nicht mehr so gut wie früher leisten — Guerilla-Marketing dagegen schon. Jeder Guerilla wird es Ihnen bestätigen.

Und wie ist der Nutzen vom Guerilla-Marketing für die Kunst?
Der Künstler Tobias Rehberger macht Werbeplakate im eigenen Auftrag für Produkte, die er gut findet und die er benutzt. Er entwirft ein Plakatdesign und plakatiert dann die Werke auf möglichst vielen Plätzen im öffentlichen Raum. Dieser Umgang mit Werbung ist neu, sehr unkonventionell und seine kreativen Strategien scheinen mir viel Aufmerksamkeit auf sich zu ziehen. Insofern weisen die Kunstplakate „Ads" (Nr. 48-67) von Tobias Rehberger, deren Thema Werbung ist, eine deutliche Nähe zum Guerilla auf. Wenn ich jedoch als ein echter Guerilla die Frage stelle, wie sich die Werkgruppe der „Ads" von Tobias Rehberger zum Profit als dem eigentlichen Ziel des Marketings verhält, dann muss ich feststellen, dass wir jetzt zur Perspektive der Kunst wechseln müssen. Damit verabschiede ich mich als Experte für Guerilla-Marketing und bin neugierig auf die Sicht der Kunst und ihre Ziele.

Übersetzung: Johannes Yong Böhm

*Anmerkung des Übersetzers: Dieses wird in den USA „Opt-in" genannt und ist ein Verfahren, bei dem der Verbraucher sich beispielsweise durch den Eintrag in eine Abonnentenliste explizit mit dem Empfang von Werbematerial einverstanden erklärt.
**Ergänzung des Übersetzers

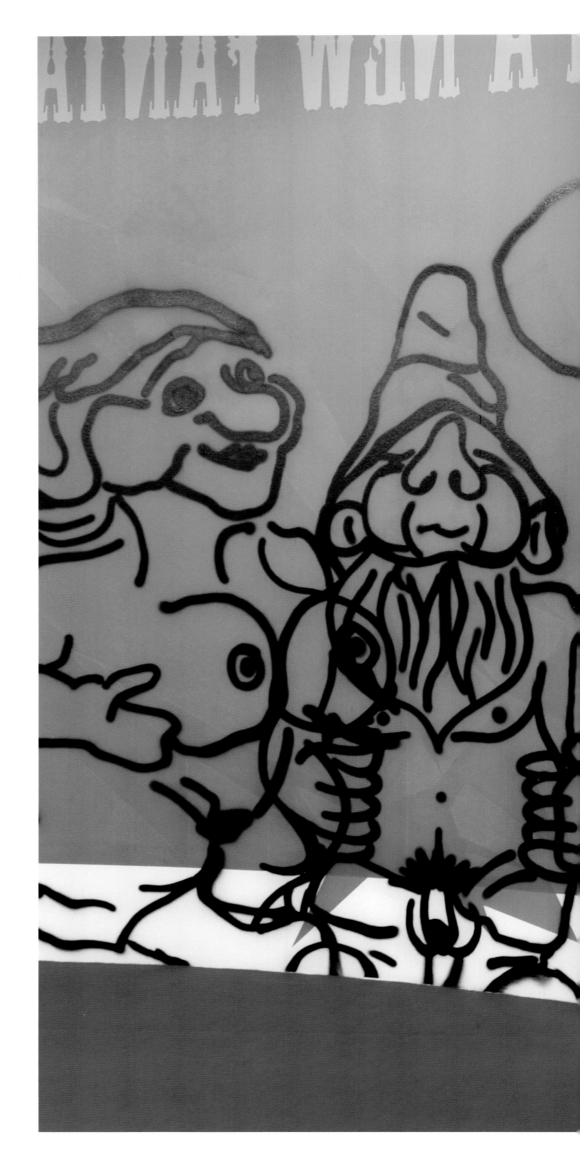

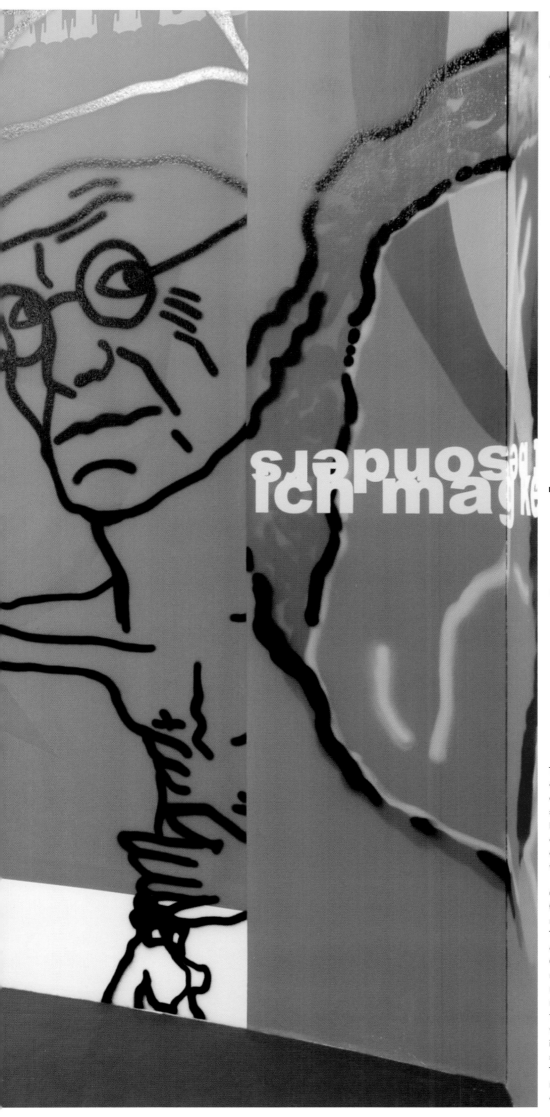

Jay Conrad Levinson

The Father of Guerrilla Marketing

The Truth about Guerrilla Marketing

The German artist Tobias Rehberger asked me to write an article on Guerrilla Marketing on behalf of his group of posters "Ads". I've found this a quite remarkable step. Particularly because of the correspondence between art and marketing as an exhibition in Frankfurt am Main — Germany's financial capital — where advertisement and marketing companies, some of which I have worked for myself, cluster.

Guerrilla Marketing now made its way into the arts through Tobias Rehberger's exhibits. Thus, let me reveal to you the truth about Guerrilla Marketing. This shall be the basis for our discussion on whether or not and how it can contribute to art.
Guerrilla Marketing is the simplest, yet the most misunderstood school of marketing. It is not ambush marketing, not sneaky marketing, not unethical marketing and not offensive marketing. Yet it is the fastest growing segment in the marketing world with over 21 million book sales in 62 languages. It is successful for two basic reasons: it is incredibly simple, and if you do it right, it always works.
To learn the real truth about Guerrilla Marketing, you must know what marketing really is. Marketing is all contact that anyone in your company has with anyone

who is not a part of your company. How your phone is answered is part of marketing. So is the attire worn by the people who represent you, the neatness of your premises, and your ability to pay attention to your customers even after they've purchased. Marketing is a process and not an event. It has a beginning and a middle, but if you do it properly, it has no end. It begins with a short and simple written plan and sprouts wings when you commit to that plan. This does not happen instantly. But with your commitment, it always happens. Guerrilla Marketing means not get-rich-quick, but get-rich-eventually.

Guerrilla Marketing is your chance to help your prospects and customers succeed at achieving their goal — whether that goal is earning more money, building their business, losing weight, attracting a mate or playing better tennis.
As a Guerrilla Marketer, you get to provide information, service, and products that will help your clientele reach their goals. If it does, you've proved the efficacy of your business. Marketing measures its efficacy by its ability to generate profits. Many businesses measure their performance by sales or hits to their website or traffic in their store. Those are false indicators. Many businesses set sales records only to lose money on each transaction. The only true measurement is profits.
Some would say that marketing is an art because it embraces all the arts. Writing is an art. Design is an art. Dancing is an art. Audio and video production are arts. Acting is an art. But those art forms don't have profits as their goal. The primary art in marketing is the art of getting people to change their minds — to switch from what they had been buying and begin to buy what you are selling. That takes art. That takes Guerrilla Marketing.

Just how is Guerrilla Marketing different from traditional marketing? It varies from that practice in 22 ways — each one very much the opposite of traditional marketing. It is called "guerrilla" marketing because, in warfare, guerrillas want the conventional goal of victory, but lacking the funds of their competition, they must resort to unconventional methods to achieve that goal.
In business, Guerrilla Marketers want the same as their competition: profits. To achieve that goal, they must turn to unconventional means such as the 22 differences between guerrilla and traditional marketing:

1. Traditional marketing always said that to market, you must invest money. Guerrilla Marketing says that you don't have to invest money if you're willing to invest time, energy, imagination and information. The more of those you invest, the less money you'll have to invest.

2. Traditional marketing intimidates most people because it is enveloped by a mystique. People do not want to make mistakes, so they use old-fashioned marketing or refrain from marketing at all. Guerrilla Marketing completely removes the mystique, putting the guerrilla in full control of the process.

3. Traditional marketing is geared to big business. When I wrote the first Guerrilla Marketing book in 1984, the only marketing books available were written for businesses with a $300,000 monthly marketing budget. I wrote "Guerrilla Marketing" as a service to the small businesses that were springing up all over the world, hardly any with $300,000 to put into marketing each month, and few with even a clue as to the real truth about marketing. Every word of every Guerrilla Marketing book is geared to small business. The soul, the spirit, the essence and the lifeblood of Guerrilla Marketing is small business.

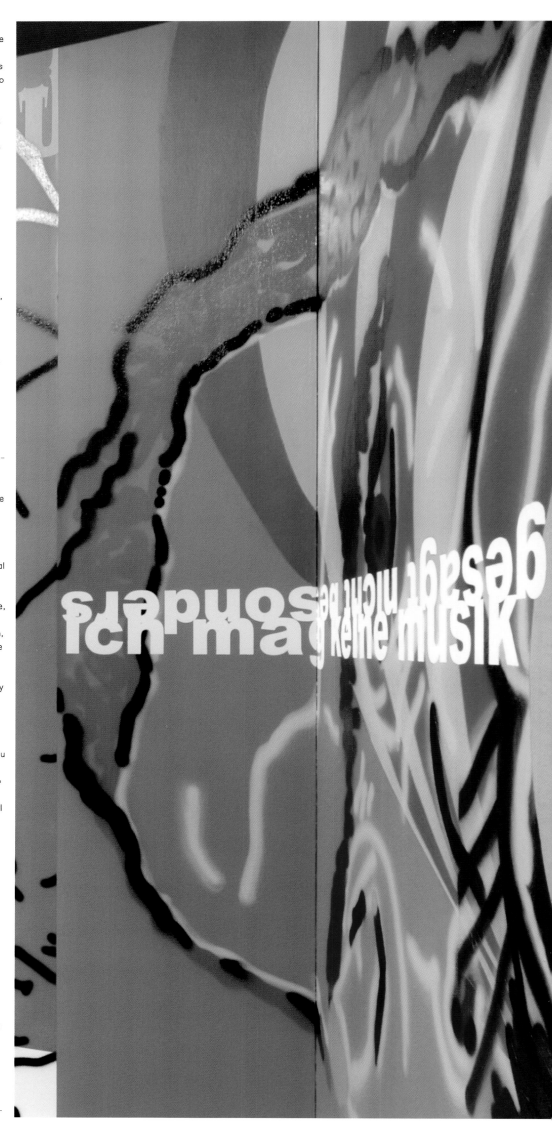

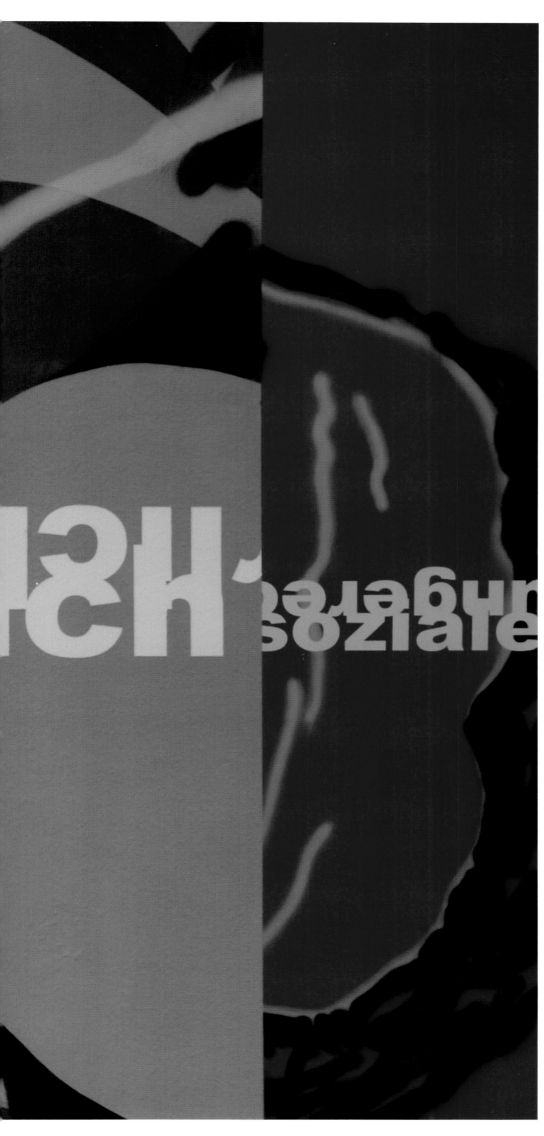

4. Traditional marketing measures its effectiveness by sales, by coupons clipped, by the sizes of a company's mailing lists, and by a host of other false indicators. Guerrillas know that only their bottom line discloses the truth — and the truth is their profitability or their lack of it.

5. Traditional marketing is based upon experience and judgment, which is a fancy way of saying "guesswork." But guerrillas cannot afford to make wrong guesses, so Guerrilla Marketing, as much as possible, is based upon psychology, actual laws of human behavior. We know that 90% of all purchase decisions are made in the unconscious mind. We now know a slam-dunk manner to reach the unconscious mind. That manner is repetition. Guerrillas also know that almost all purchase decisions are made for emotional reasons. The buyer may justify the purchase with rational and logical thinking, but it was core emotions — love, fear, security, power, prestige — that motivated the purchase.

6. Traditional marketing counsels marketers to grow their business and then diversify. But that leads otherwise sophisticated marketers, such as Coca-Cola, to believe they know beverages and to invest in a winery. After losing nearly $90 million in that venture, Coca-Cola realized that what they really know is soft drinks. Guerrillas do not think of diversifying. They think of maintaining their focus and adding more excellence to their offerings.

7. Traditional marketing suggests that the way to grow a business is linearly, adding new customers one at a time through advertising. Guerrillas know the best way to grow their business is geometrically — adding profits in four different ways: enlarging the size of each transaction which costs nothing, having more sales transactions per year with each customer which costs little, tapping the enormous cost-free referral power of each of their customers because each is the center of a network, and growing linearly, the old-fashioned way. When you are growing in four different directions at once, with hardly any strain on your marketing budget, you are heading toward profitability.

8. Traditional marketing maintains that once you've made the sale, the marketing is over. Guerrilla Marketing knows that that's when the real fun begins. An appalling 68% of business lost in America, Europe and Asia is lost not due to shabby quality or poor service, but to apathy after the sale — customers being ignored after they've made the purchase. The opposite of apathy is follow-up.

9. Traditional marketing advises that you scan the horizon for those businesses you want to obliterate. Guerrilla Marketing advises that scan the horizon in a quest for those businesses with which you might cooperate because they have the same kind of prospects as you and the same lofty standards. Connecting with those businesses enables you to stretch your marketing budget by sharing the costs with others. Guerrillas refer to this as "fusion marketing," not dismissing competition but emphasizing cooperation.

10. Traditional marketing recommends selling positive benefits, believing that people are attracted most of all to features and benefits. Guerrilla Marketing recommends selling solutions to problems, knowing it is far easier to sell the end of pain than to sell a helpful benefit.

11. Traditional marketing believes in logos because points made to the eye are 78% more effective than points made to the ear. Guerrilla Marketing believes that logos are passé now because they don't go far enough in advancing the sale. Instead of a logo, Guerrillas create a meme — the lowest common

denominator of an idea. A meme requires no time or language to be understood because it communicates pure ideas. A hitchhiker holds out his thumb and you give him a ride because you understand what he wants. Each day, almost all motorists respond to the ideas conveyed by international traffic symbols. No language. No time. No misunderstanding. Wise guerrillas embrace memes and put them on their websites so they can communicate an idea even if the visitor clicks away.

12. Traditional marketing, especially online, is "me" marketing. Visit almost any website. You'll be greeted by "about our company," "about our management," and "about our headquarters." But people don't really care about you. They care about themselves. So guerrilla websites use "you" marketing. Almost everything they say is about the visitor.

13. Traditional marketers worship the shrine of taking. They're always thinking of what they can take from each prospect. Guerrilla marketers think of giving, always thinking what they can give to their prospects to make their lives more enjoyable. An apartment building in Los Angeles enjoyed a 100% occupancy rate where the other buildings had occupancy rates hovering around 70%. There was the same square footage and same leasing prices in all the buildings. How did one manage to maintain a 100% occupancy rate? They put up a sign out front that said, "Sign a lease. Get free auto-grooming." That means they paid someone to wash the tenants' cars once week. The salary paid him was easily covered by the difference between 70% and 100% occupancy. Guerrillas are creative in what they give away.

14. Traditional marketing maintains that advertising works, that PR works, that having a website works. To those notions, guerrillas say "Nonsense!" Advertising doesn't work as well as it used to. You can't build a profitable business solely by PR. And almost everyone has learned that a website is akin to digging a hole in the water. So what does work? Guerrillas know that the only thing that works in 2010 and will work beyond are marketing combinations. If you advertise and have a PR campaign and have a website, each will help the other work. The days of single-weapon marketing have faded away. This is the age of marketing combinations.

15. Traditional marketers, at the end of the month, count up money they've taken in. Guerrilla marketers count up new relationships. "How many new relationships did we establish this month?" They know that a key to Guerrilla Marketing is long-term and caring relationships. Customers want relationships.

16. Traditional marketing makes no allowance for technology. The technology of yesteryear was too expensive, limited, and complicated. But Guerrilla Marketing requires that you be techno-cozy because guerrillas know that technology today is inexpensive, versatile, and simple to use. Techno-phobia is fatal these days. Technology can empower a small business. If you're techno-phobic, make an appoint-ment with your techno-shrink.

17. Traditional marketing is directed at groups, the bigger the group the better. Guerrilla Marketing is directed to individuals, and if it must be a group, the smaller the better. Guerrillas practice nanocasting — far more precision-targeted and less expensive than broadcasting, narrowcasting or even micro-casting. It lets you pinpoint the hottest prospects for your message. Guerrillas know that at any given moment, 4% of people want to buy what they're selling right now, 4% are almost ready but want a bit more information. And 92% just plain aren't interested at this time. Direct your message to the 8% most torrid of prospects.

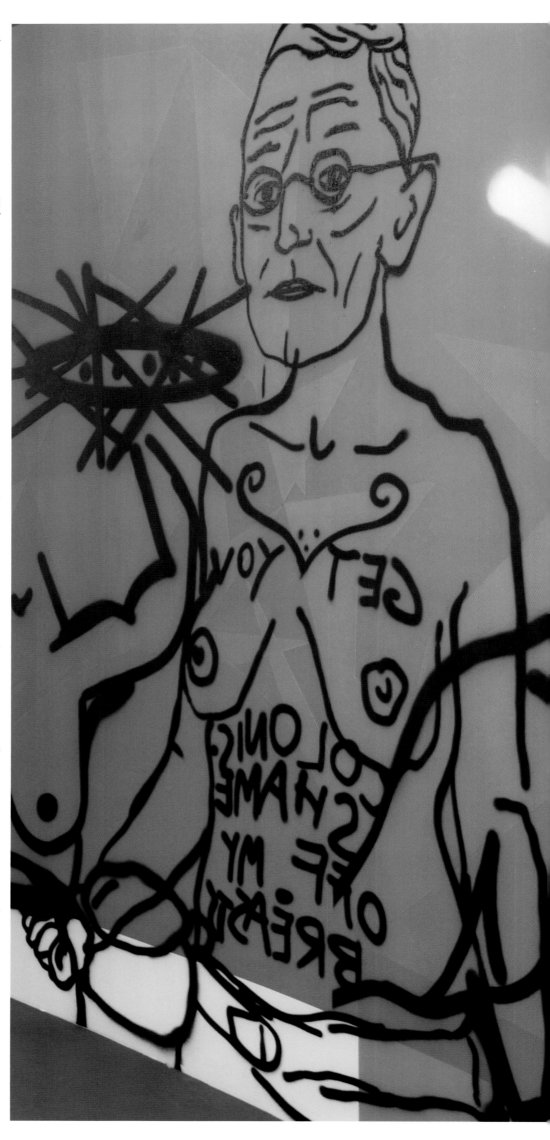

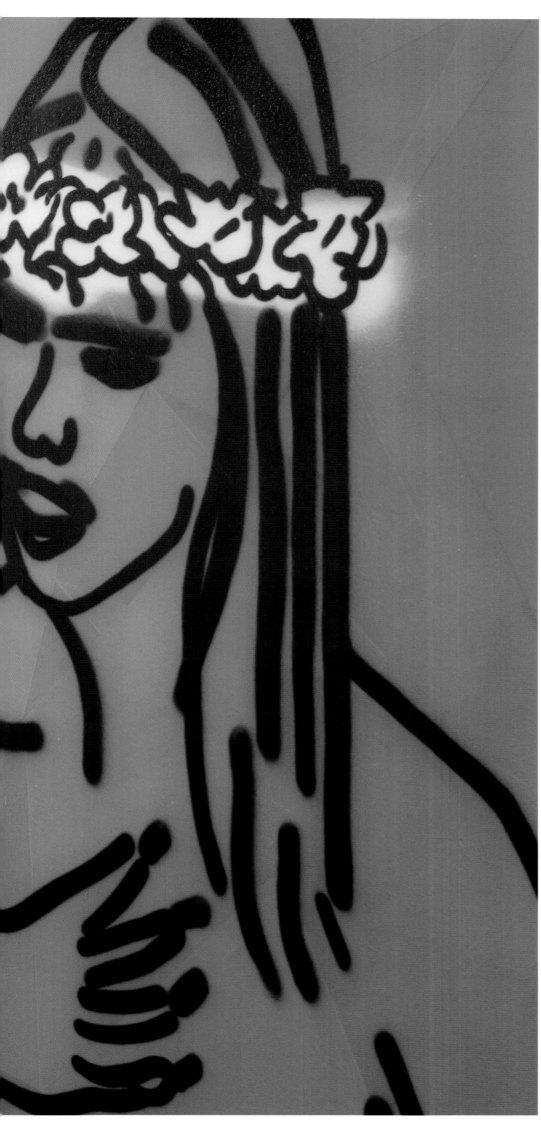

18. Traditional marketing is for the most part unintentional because big business concentrates on the big picture — radio, TV, magazines, newspapers, and the internet. Guerrilla Marketing focuses on the details — how your phone is answered, the personality of your service people, the cleanliness of your restrooms. The number one reason that people patronize McDonald's is their clean restrooms.

19. Traditional marketing would have you believe that you can make a sale with marketing. Guerrilla Marketing says that used to be true, but now, the goal is to gain consent — motivate people to ask or opt-in for more marketing materials from you, then for you to broaden that consent. A summer camp in New York state is one of the largest in the eastern United States. The owner runs tiny ads in the back of magazines, offering her free DVD. She has a booth at the annual camping show where she gives away her free DVD. The only purpose of the DVD is to get people to sign up for a free in-home consultation. 82% of the people sign their kid up for the next summer session, and possibly the one after that. You can be sure their brothers and sisters also sign up. And their classmates.

20. Traditional marketing has always been a monologue with one person doing all the talking or writing and one person doing all the listening or reading. That's no way to establish a relationship. So Guerrilla Marketing is a dialogue, a conversation between buyer and seller, fertile ground for a relationship.

21. Traditional marketers sell people what they want. If it turns on poorly for the customer, the marketer is to blame. Guerrilla Marketers sell people what they need — asking questions to be sure they'll be making the right purchase. If it works out, the guerrilla gets the credit.

22. Traditional marketing provides you with a short list of high-priced marketing weapons: radio, television, magazines, newspapers and the internet. Guerrilla Marketing provides 200 weapons, the majority of them free. To get a list of them, send an e-mail to my daughter, Amy Levinson. She's Olympiagal@aol.com.

And last but not least, an extra aspect: The graphics in Guerrilla Marketing must stay on strategy and never interfere with advancing the sale. They can be gorgeous or startling, but must stay within the bounds of the strategy. Of course, they must command attention. Still, it is advisable to employ compelling art and to remain on strategy. After all, guerrillas know well the power of standing out in a crowd. People do not pay attention to marketing, only to things that interest them — and sometimes that's marketing. Marketing is necessary to help the wheels of economy to turn around. Traditional marketing can no longer do that as well as it used to. But Guerrilla Marketing can. Ask any guerrilla.

And what's the benefit of Guerilla Marketing for the arts?
The artist Tobias Rehberger creates "Ads" for products and brands he likes and uses on his own behalf. He drafts a design and posts his exhibits on as many public spaces as possible. This method of advertising is new, very unconventional and its creative strategies seem to attract a lot of attention. Thus, Tobias Rehberger's artistic posters "Ads" (Nos. 48-67) — whose subject is advertisement — demonstrate a striking proximity to Guerilla Marketing.
However, when I raise the question as a true guerrilla how the group of posters "Ads" by Tobias Rehberger pertains to profit as the actual goal of marketing, I must conclude that one needs to shift to the perspective of art. I therefore leave my realm and am curious to experience the point of view of art and its goal.

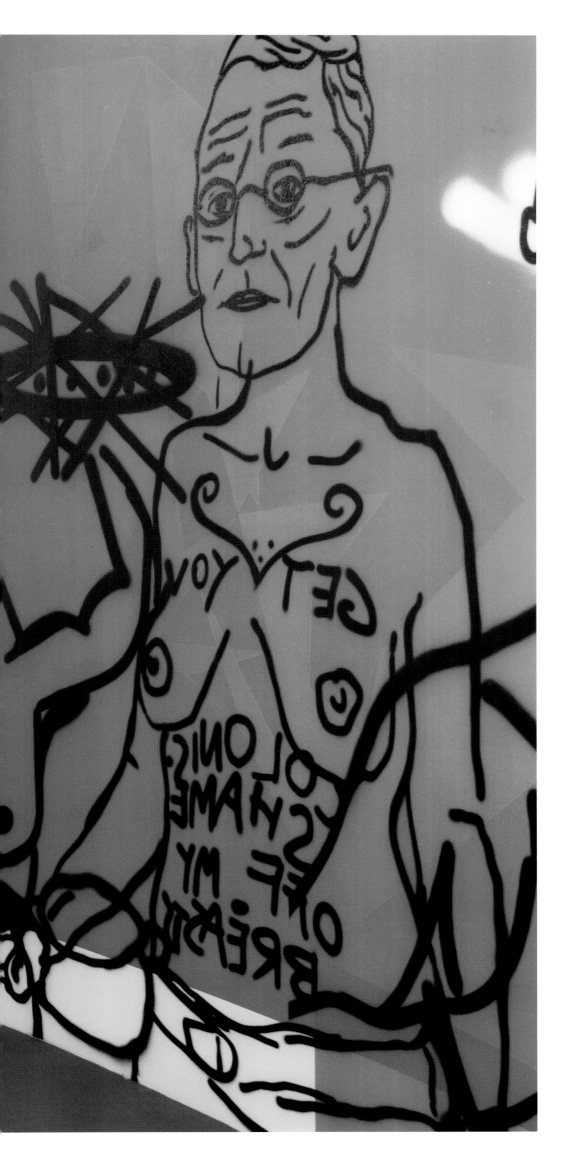

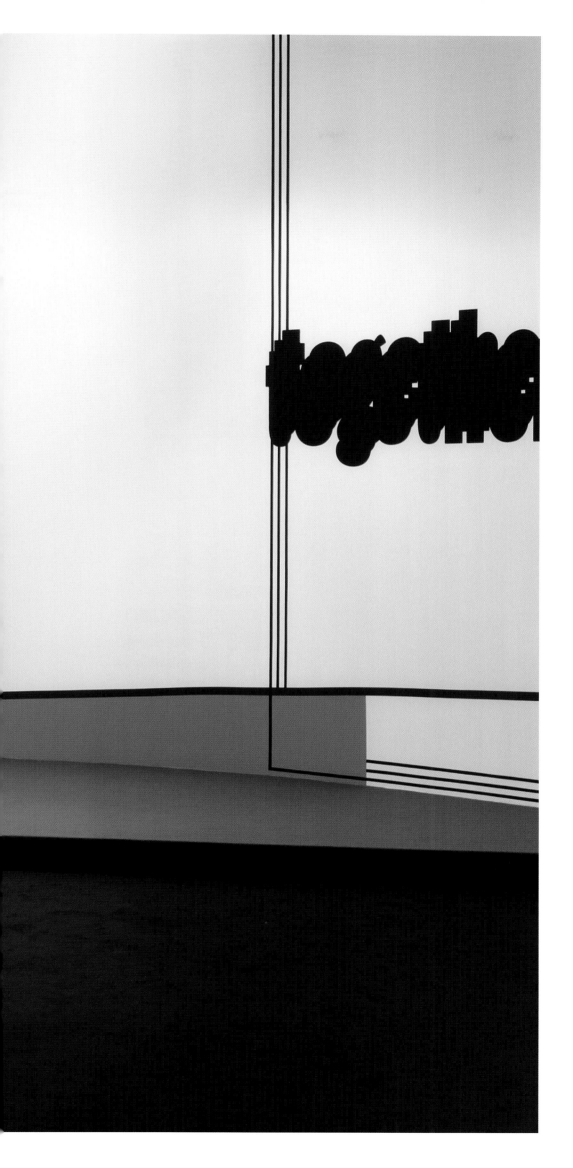

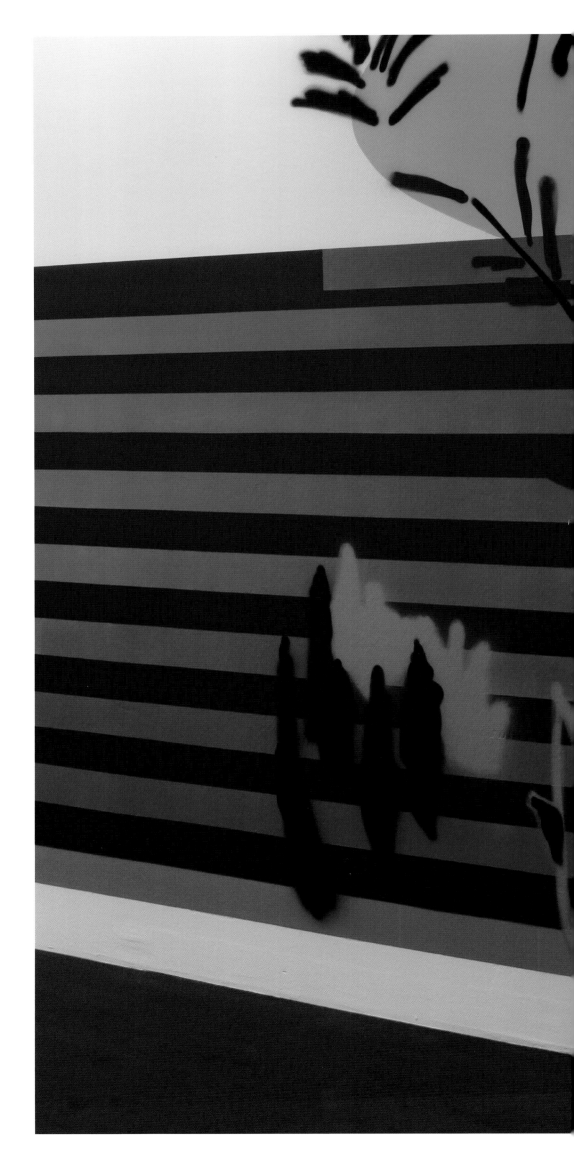

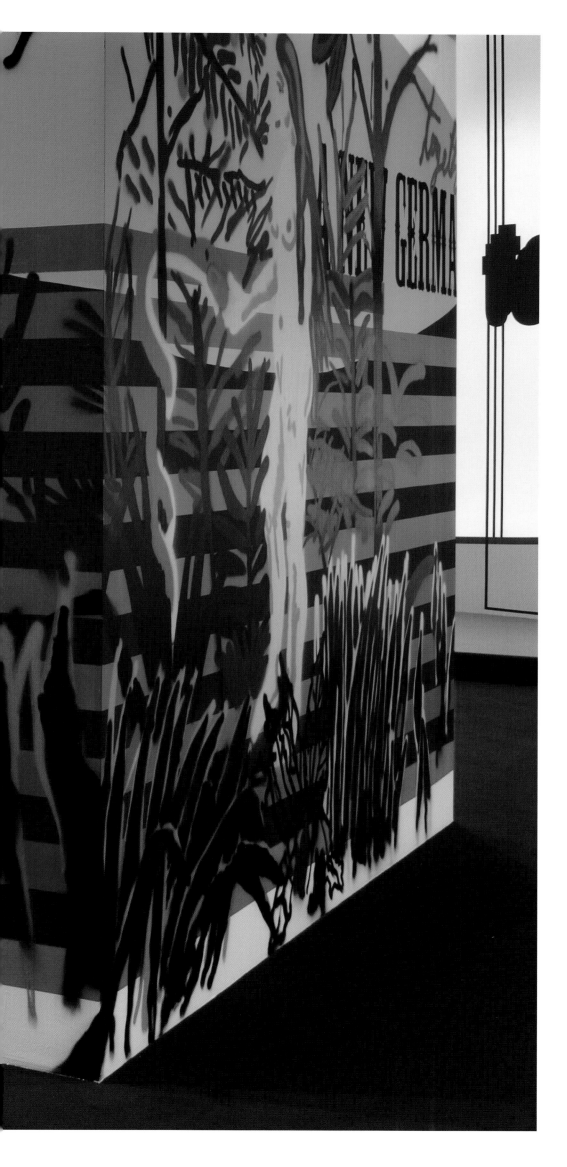

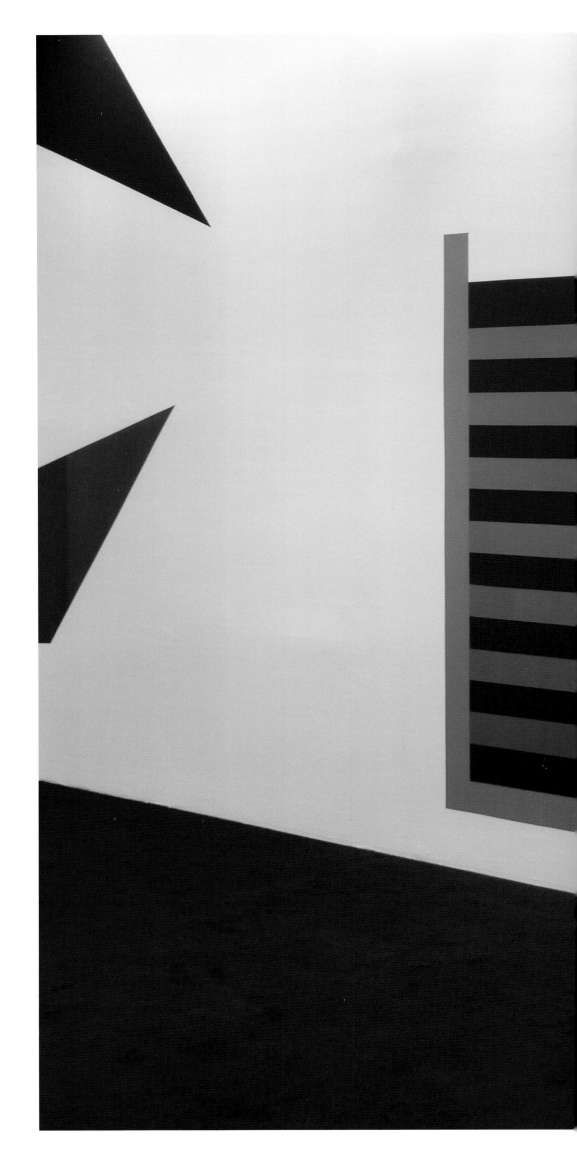

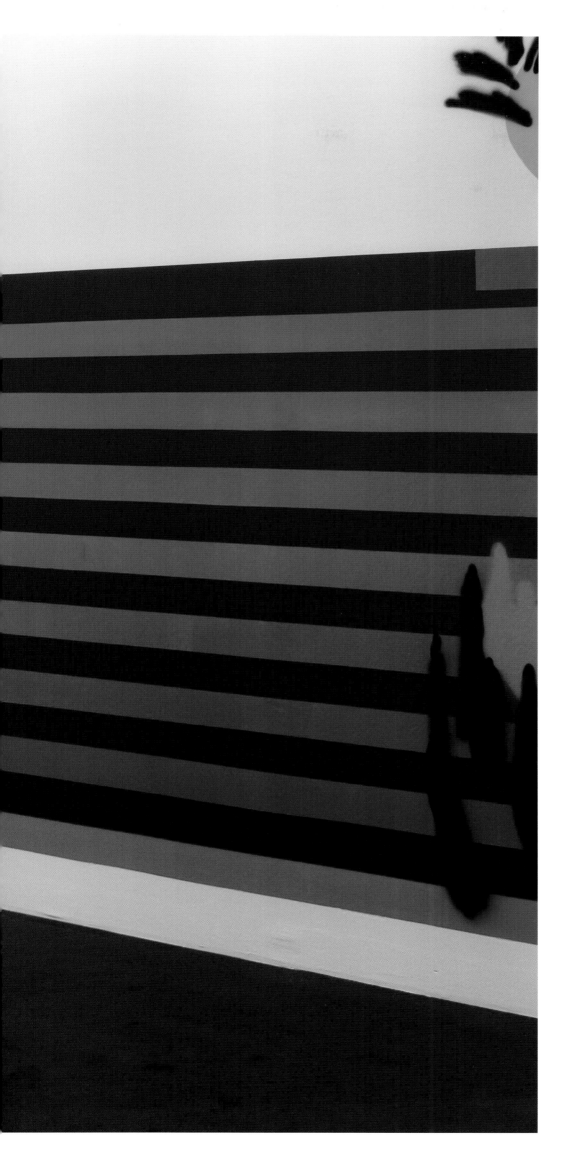

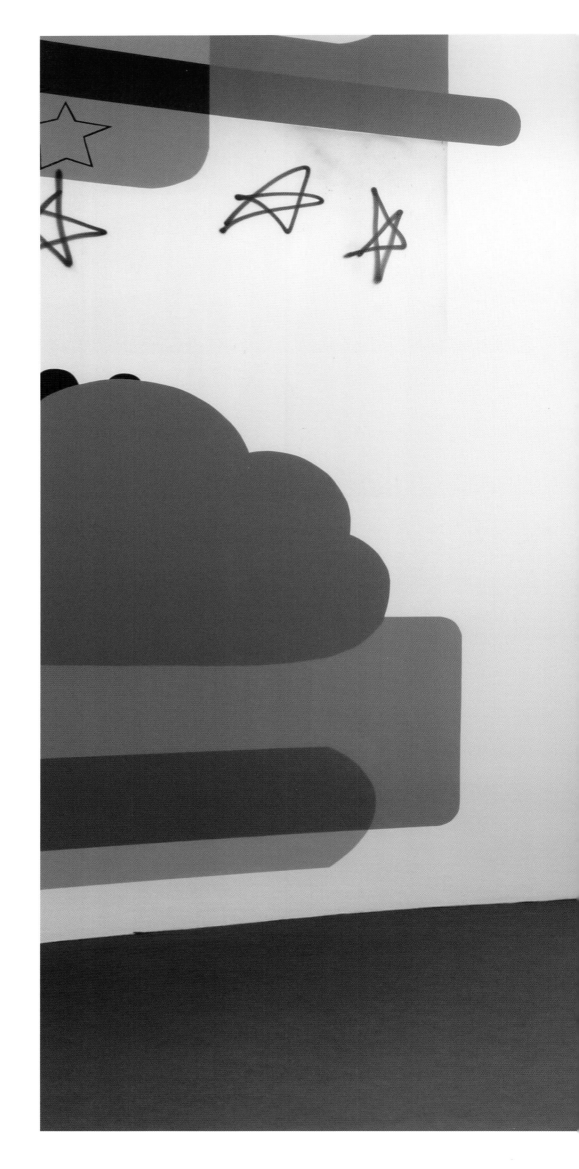

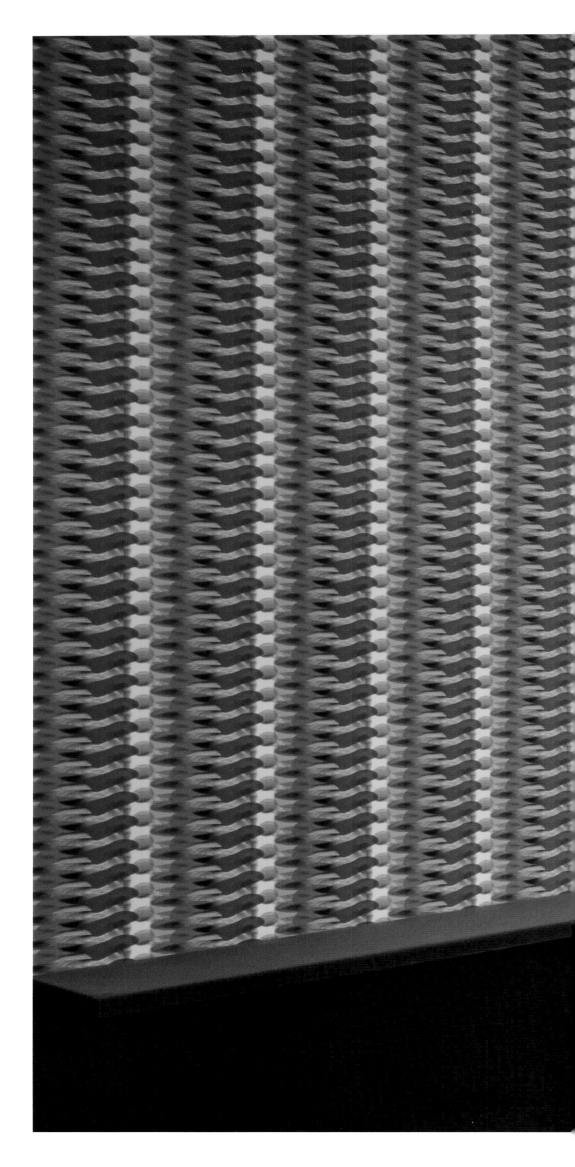

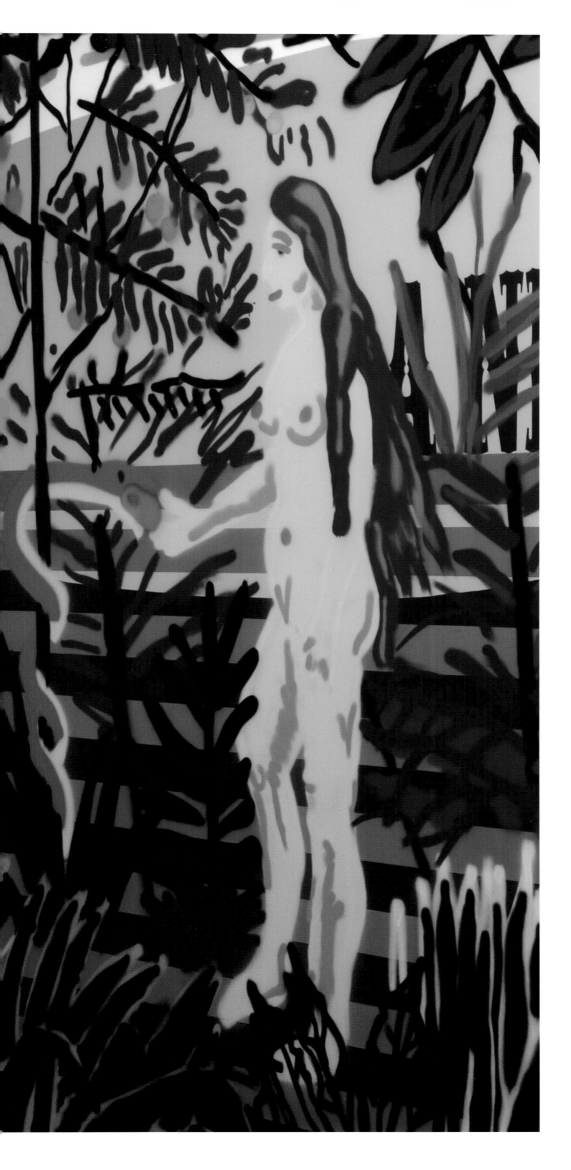

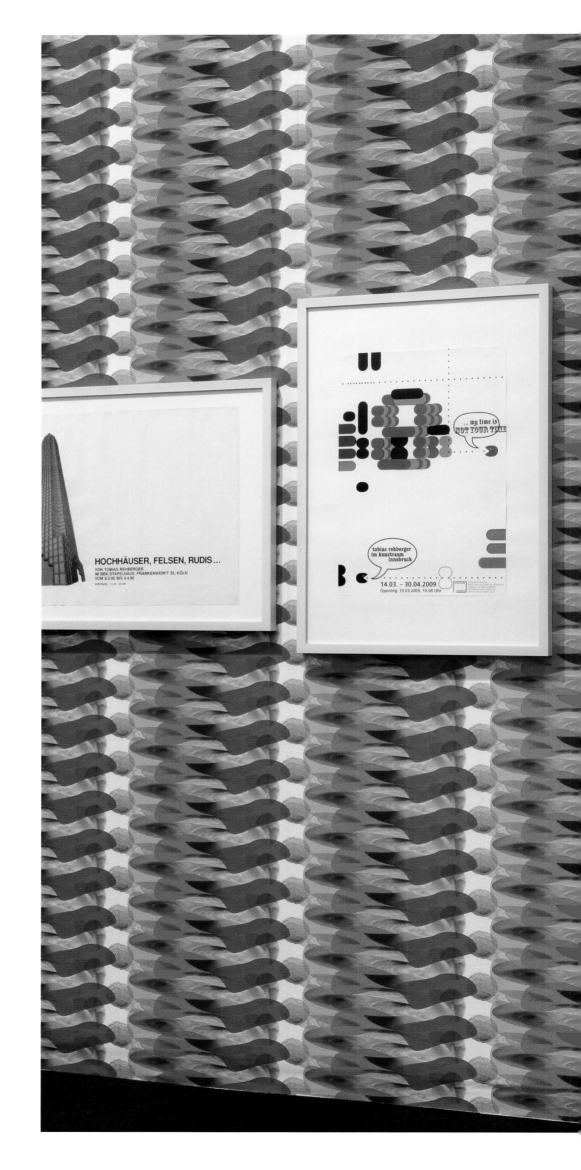

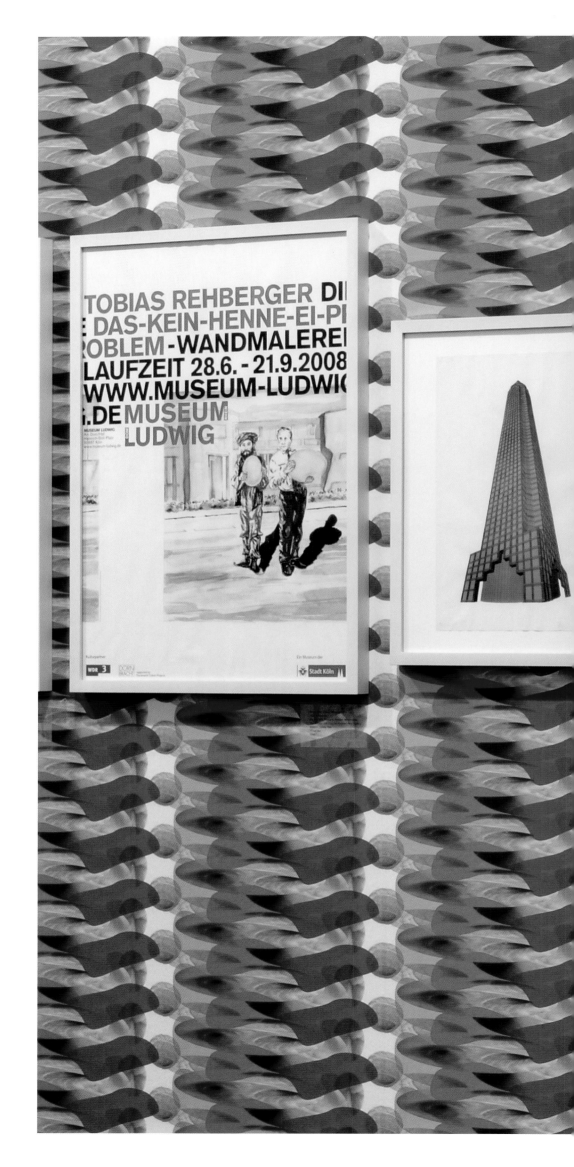

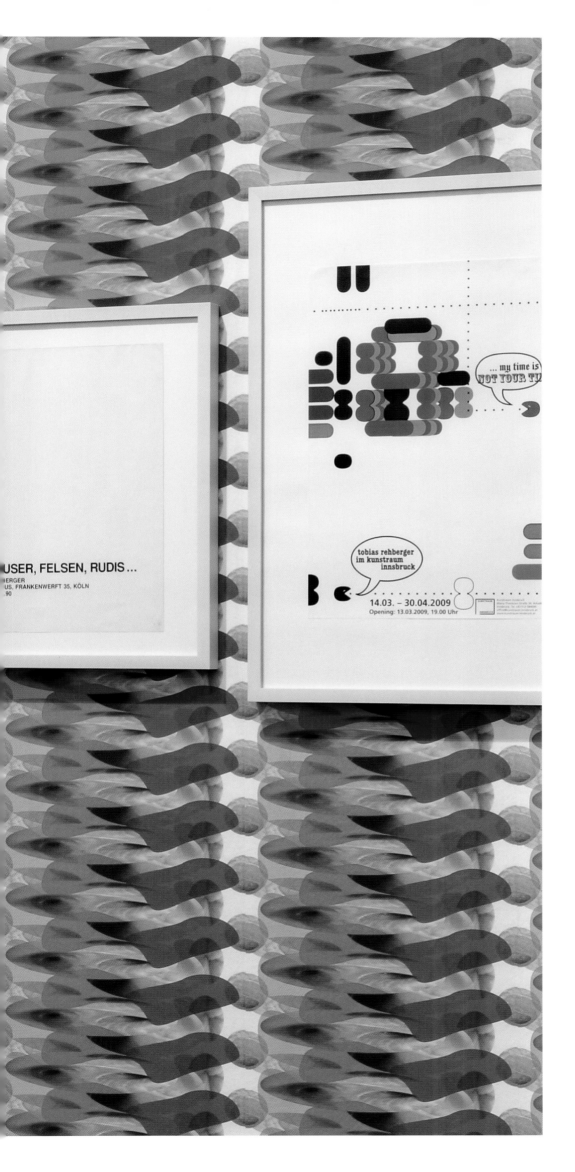

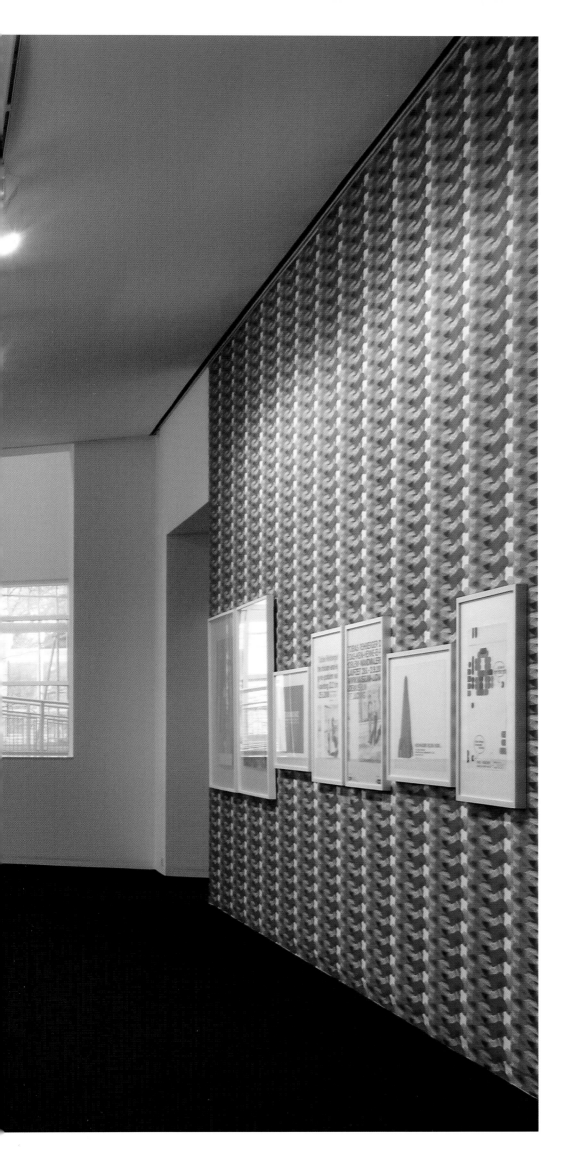

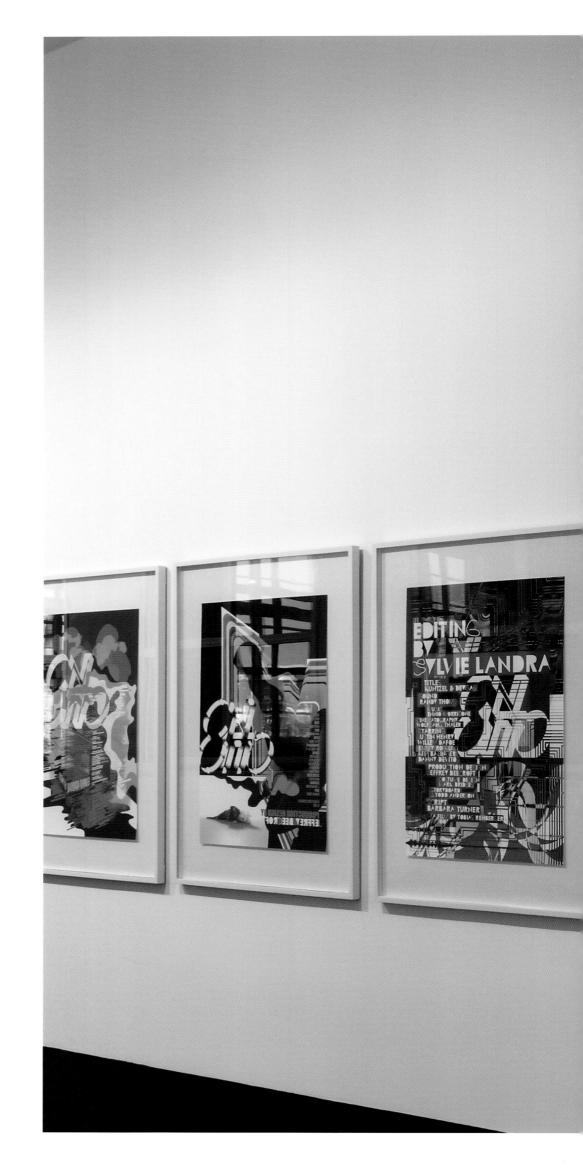

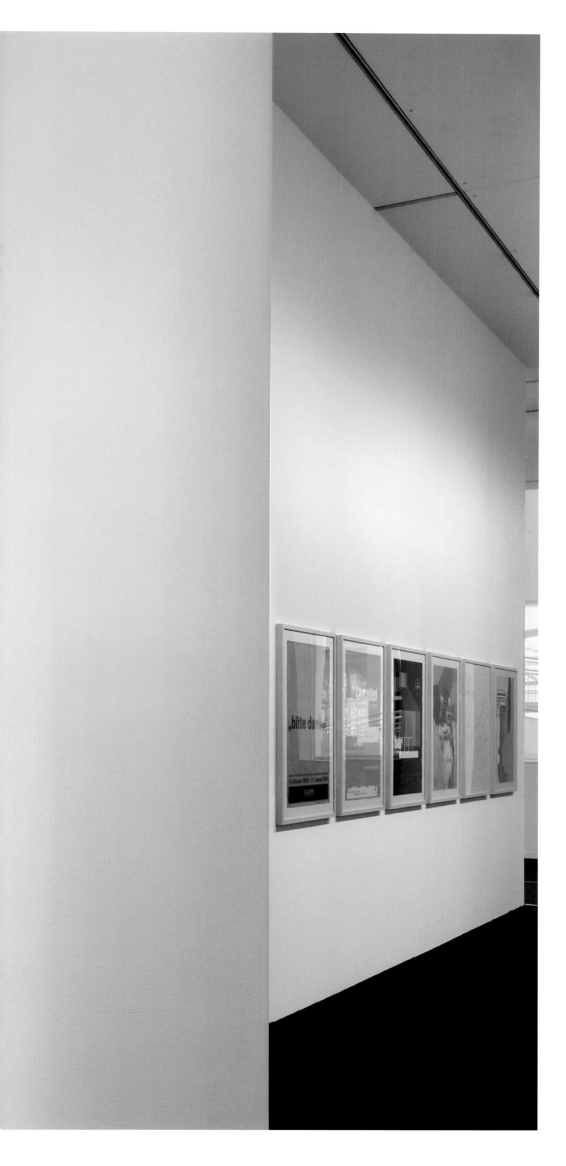

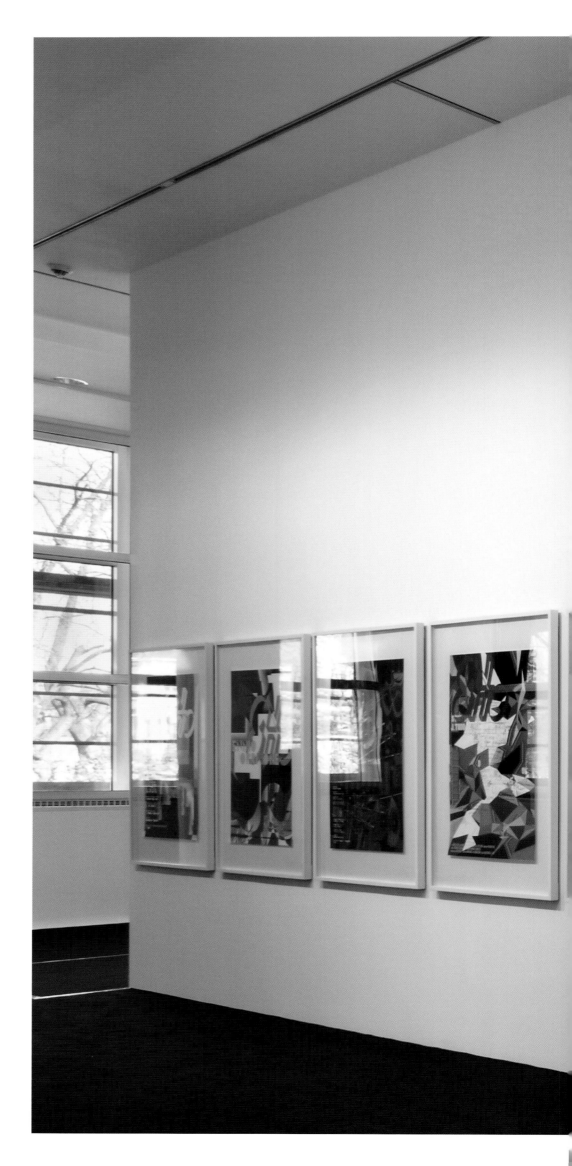

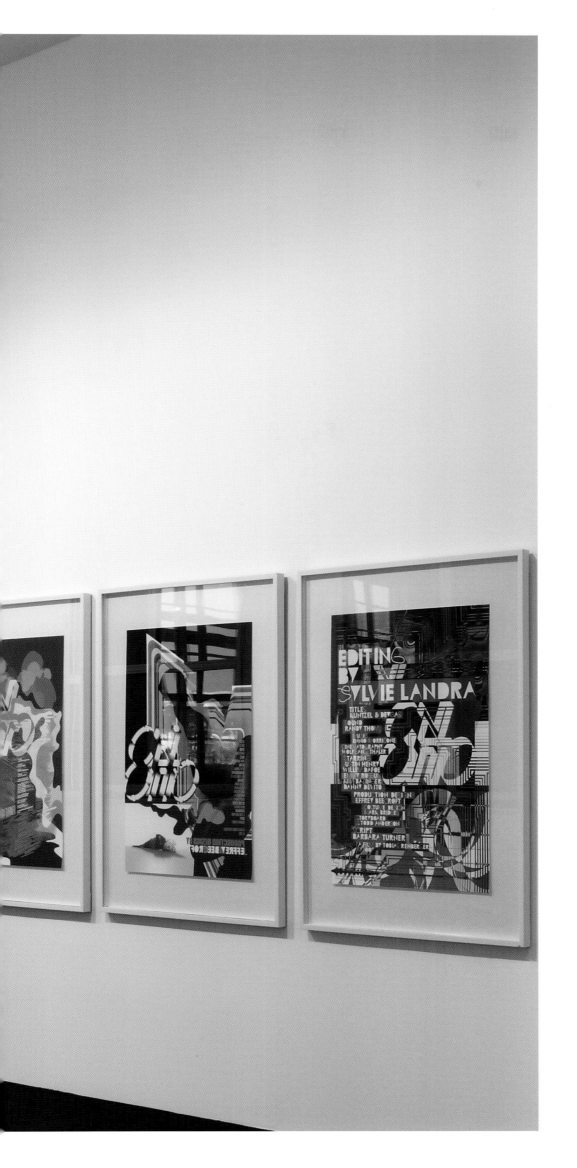

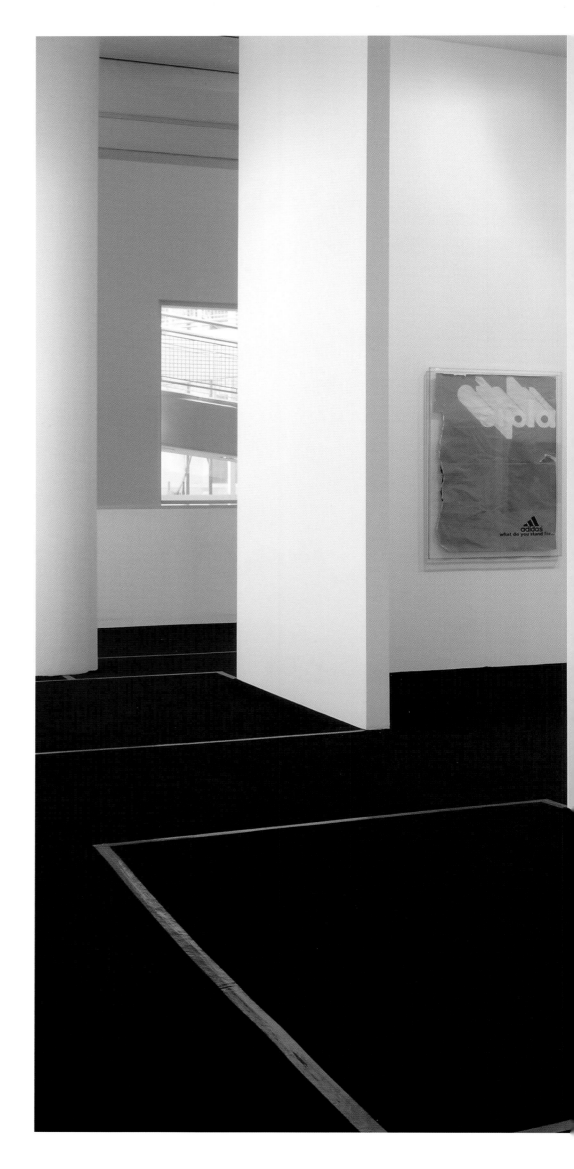

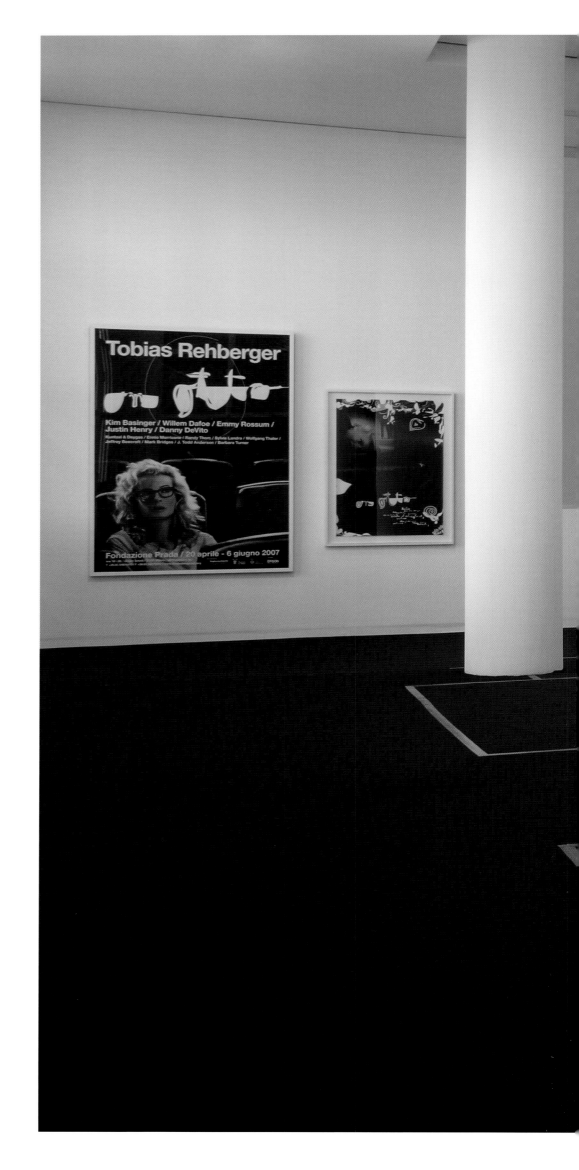

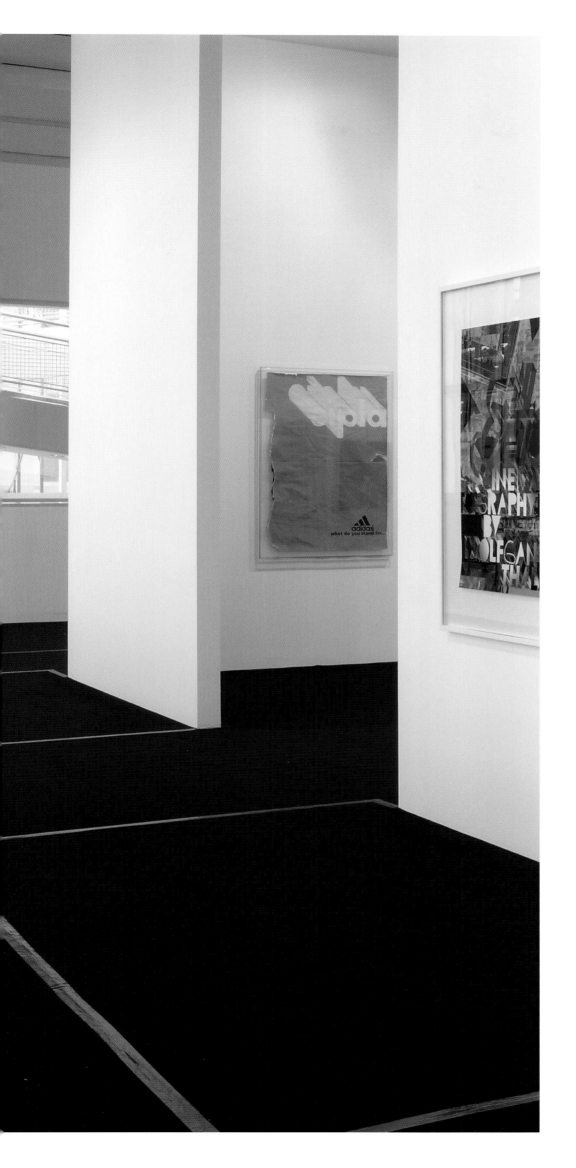

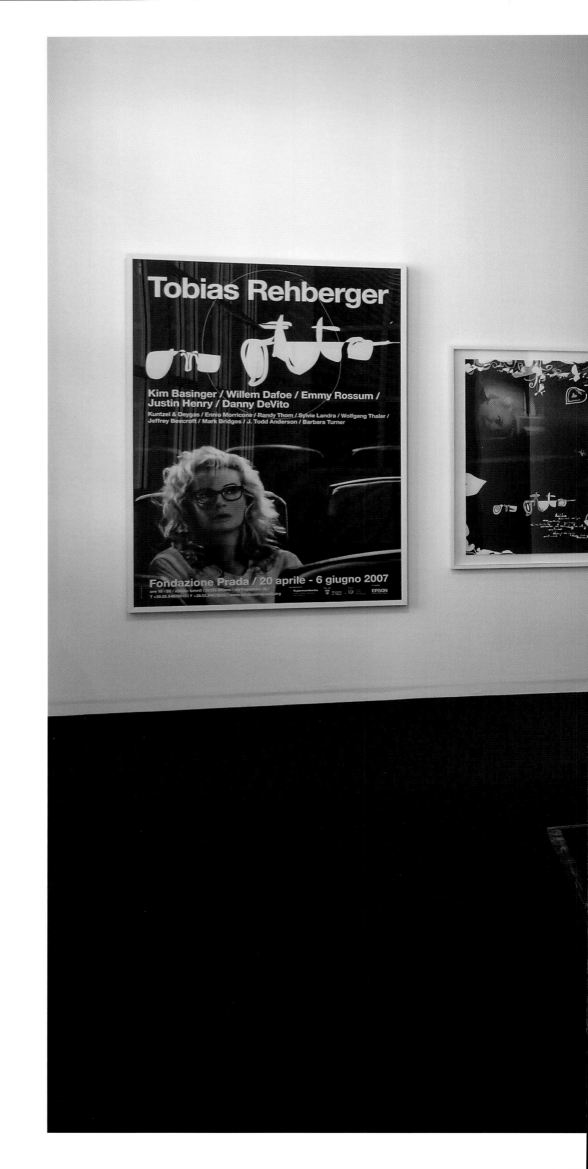

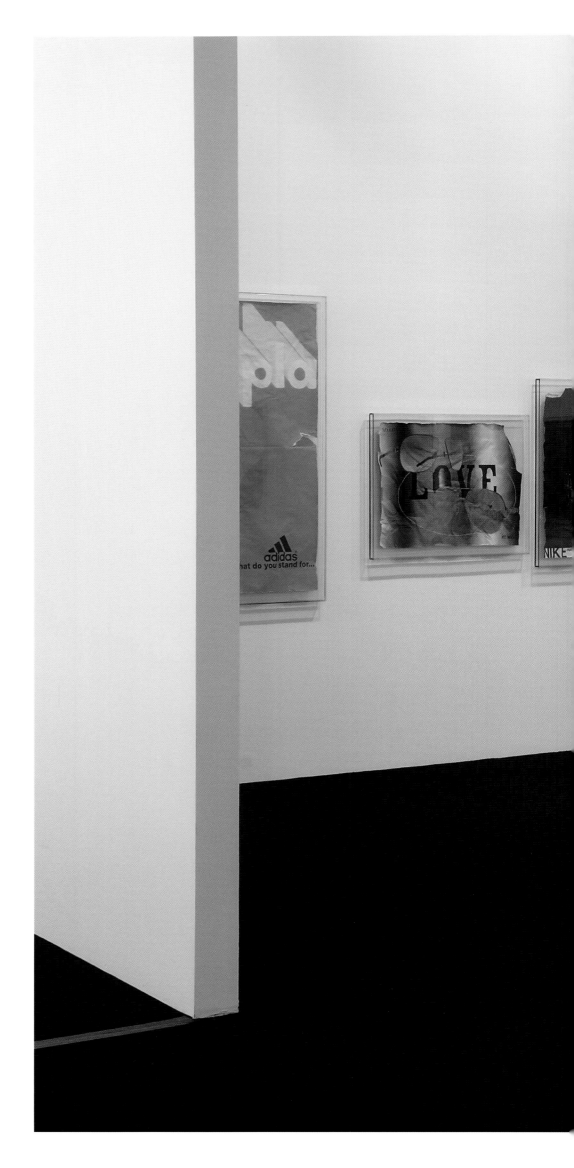

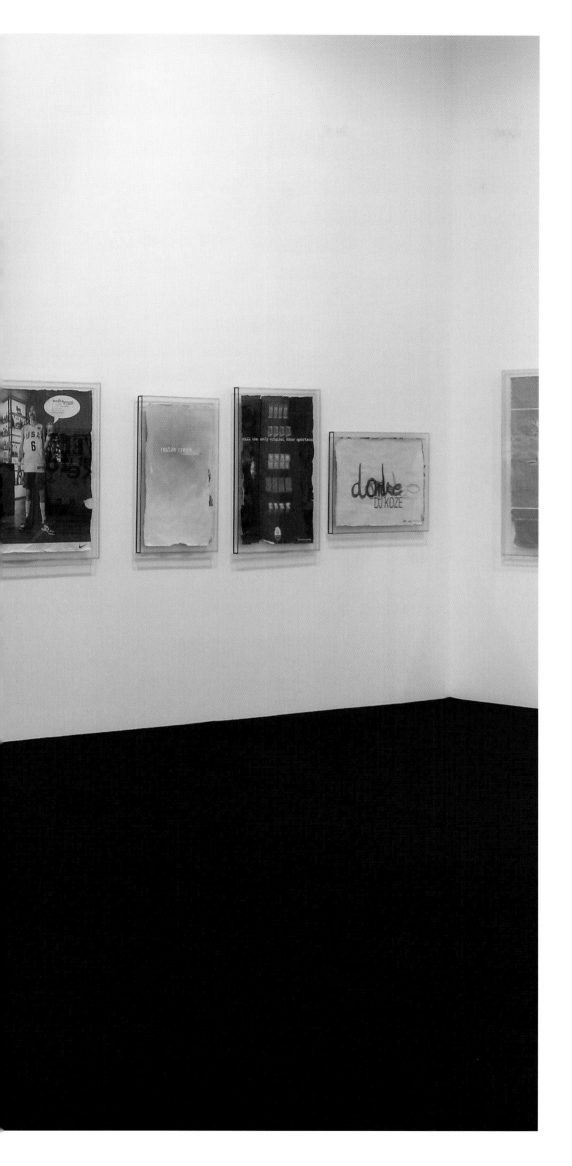

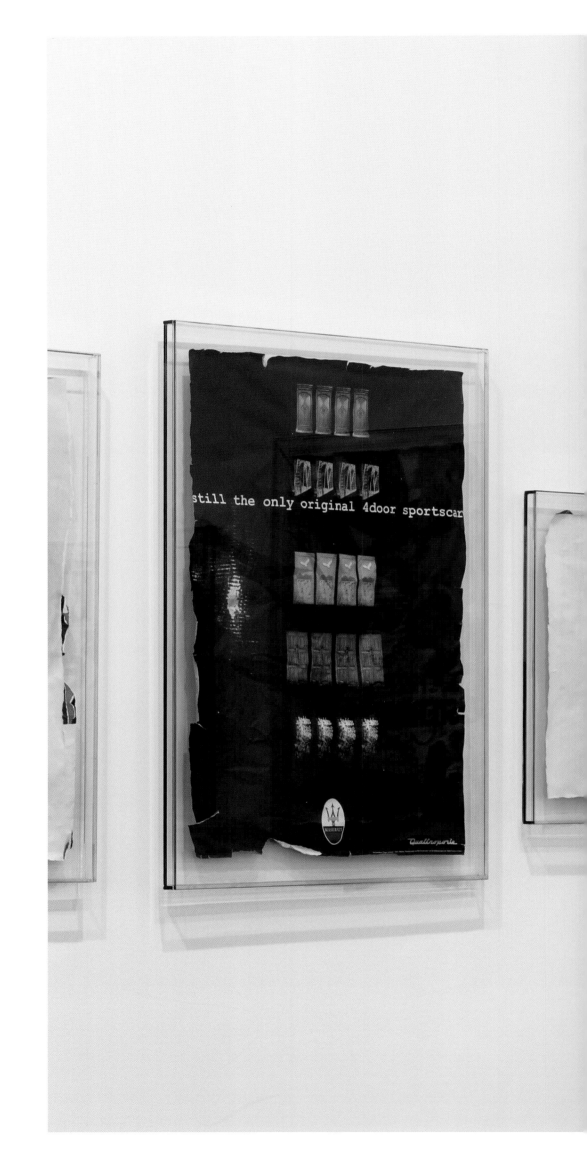

Abbildungsverzeichnis

(Die Werke sind jeweils von links nach rechts und von oben nach unten gelistet, die Nummerierungen beziehen sich auf die Liste der ausgestellten Werke.)

Seiten 4/5, 6/7: Erscheinungsbild der Ausstellung am Eingang; Entwurf VIER5

Seiten 8/9, 10/11: Tapete Nr. 9, und Wandmalerei „Kinder leiden am meisten*/*nicht immer ganz richtig" Nr. 1 (Detail)

Seiten 12/13: Wandmalerei „Oranges from Eden" Nr. 7

Seiten 14/15: Wandmalereien „Oranges from Eden" Nr. 7 (Detail), „Translator" Nr. 8 und „Horrible Flute Player" Nr. 6 (Detail)

Seiten 16/17: Wandmalereien „Translator" Nr. 8 (Detail), „Horrible Flute Player" Nr. 6 (Detail) und Wandmalerei „Kinder leiden am meisten*/*nicht immer ganz richtig" Nr. 1 (Detail)

Seiten 18/19: Wandmalereien „New Germany 1" Nr. 2 (Detail) und „Horrible Flute Player" Nr. 6 (Detail)

Seiten 20/21 und 22/23: Wandmalerei „New Germany 1" Nr. 2 (Detail)

Seiten 24/25 und 26/27: Wandmalereien „Kinder leiden am meisten*/*nicht immer ganz richtig" Nr. 1 (Detail) und Wandmalerei „New Germany 1" Nr. 2 (Detail)

Seiten 28/29: Wandmalerei „Kinder leiden am meisten*/*nicht immer ganz richtig" Nr. 1 (Detail)

Seiten 30/31: Wandmalereien „New Germany 1" Nr. 2 (Detail), „Two Chairs" Nr. 3 (Detail) und „Horrible Flute Player" Nr. 6 (Detail)

Seiten 32/33: Wandmalereien „Horrible Flute Player" Nr. 6 (Detail), „Oranges from Eden" Nr. 7 (Detail) und „Seven Naked Hermann Hesse Fans" Nr. 4 (Detail)

Seiten 34/35: Wandmalereien „Horrible Flute Player" Nr. 6 (Detail), „Oranges from Eden" Nr. 7 (Detail), „Seven Naked Hermann Hesse Fans" Nr. 4 (Detail) und „Ich mag keine Musik ich hab keinen Humor und soziale Ungerechtigkeiten stören mich ehrlich gesagt nicht besonders" Nr. 5

Seiten 36/37: Wandmalerei „Seven Naked Hermann Hesse Fans" Nr. 4 (Detail)

Seiten 38/39: Wandmalerei „Ich mag keine Musik ich hab keinen Humor und soziale Ungerechtigkeiten stören mich ehrlich gesagt nicht besonders" Nr. 5 (Detail)

Seiten 40/41: Wandmalerei „Seven Naked Hermann Hesse Fans" Nr. 4 (Detail)

Seiten 42/43 und 44/45: Wandmalereien „Two Chairs" Nr. 3 (Detail) und „Seven Naked Hermann Hesse Fans" Nr. 4 (Detail)

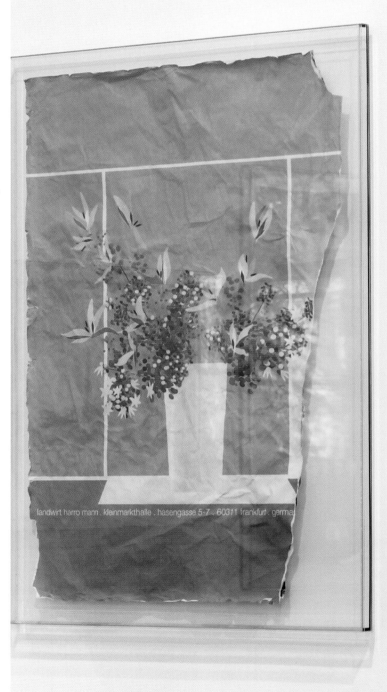

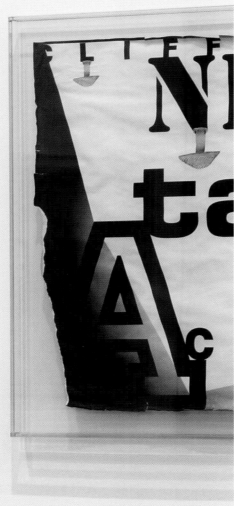

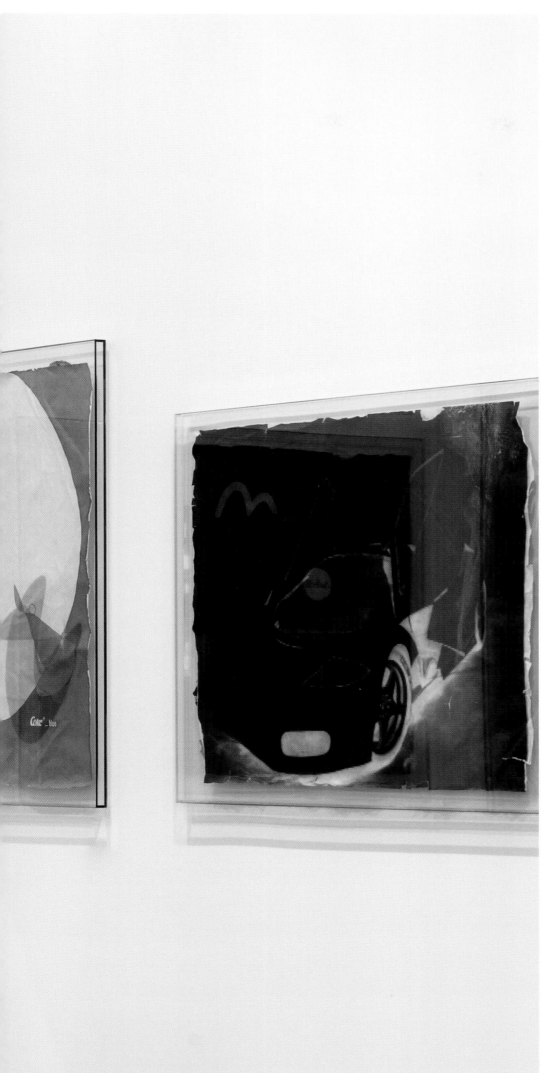

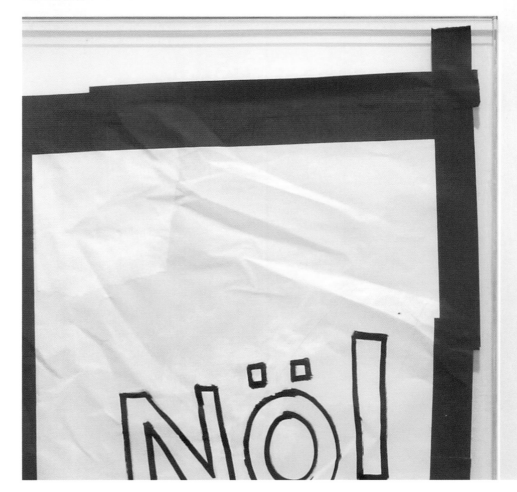

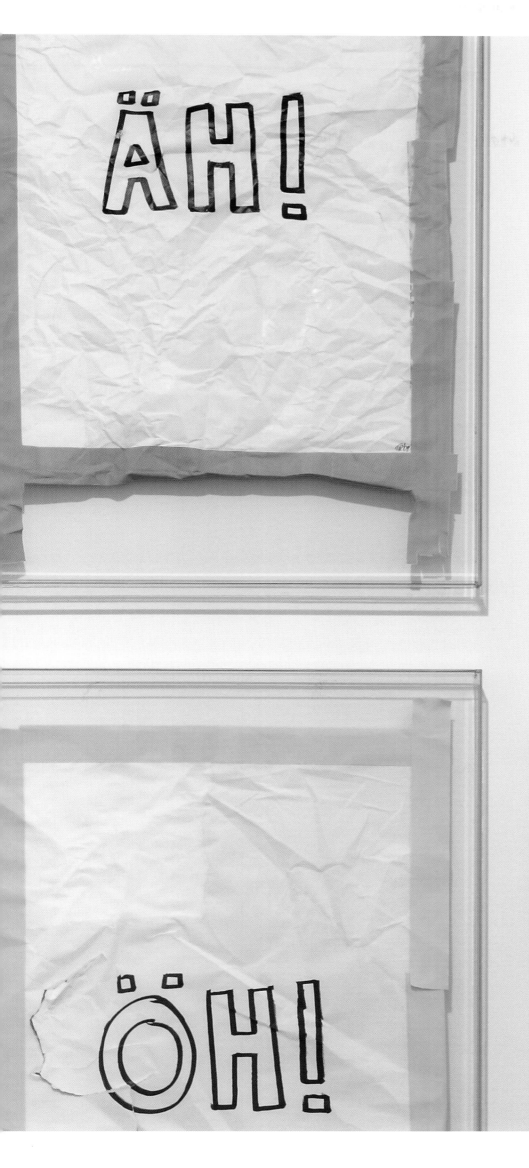

Index of Illustrations

(Throughout the index, the works are listed from left to right and from top to bottom; the numbers refer to those in the list of works on exhibition.)

Pages 42/43 and 44/45: Wall paintings "Two Chairs", No. 3 (detail), and "Seven Naked Hermann Hesse Fans", No. 4 (detail)

Pages 46/47 and 48/49: Wall paintings "Oranges from Eden", No. 7 (detail), and "Two Chairs", No. 3 (detail)

Pages 50/51: Wall paintings "Horrible Flute Player", No. 6 (detail), and "Oranges from Eden", No. 7 (detail)

Pages 52/53: Wall paintings "New Germany 1", No. 2 (detail), and "Two Chairs", No. 3 (detail)

Pages 54/55: Wallpaper, No. 9, and wall painting "Oranges from Eden", No. 7 (detail)

Pages 56/57: Posters "Highrises, Rocks, Rudis", No. 10 (detail) and "My time is not your time", No. 21 Wallpaper, No. 9, and wall paintings "Oranges from Eden", No. 7 (detail), and "Two Chairs", No. 3 (detail)

Pages 58/59: Wallpaper, No. 9, and posters "The Chicken-and-Egg-No-Problem-Wall-Painting", No. 20, "Highrises, Rocks, Rudis", No. 10, and "My time is not your time", No. 21

Pages 60/61: Posters, Nos. 10 to 22, and wallpaper, No. 9

Page 62: Posters "On Otto, Script", No. 38, "On Otto, Production Design", No. 35, and "On Otto, Editing", No. 32

Page 63: Posters "Please Thank You", No. 18, "Cancelled Projects", No. 11, "Bar Münster", No. 13, "Ringing Until I Hear It …", No. 15, "Don't work too much", No. 16, and "Suggestions from the visitors of the shows #74 and #75, Portikus", No. 12

Pages 64/65: Posters "On Otto, Sound", No. 30, "On Otto, Music", No. 31, "On Otto, Titels", No. 29, "On Otto, Storyboard", No. 37, "On Otto, Script", No. 38, "On Otto, Production Design", No. 35, and "On Otto, Editing", No. 32

Page 66: Poster "First Ads, adidas" as single copy in full glass frame, No. 53

Page 67: Posters "On Otto, Cinematography", No. 33, and "On Otto, Sound", No. 30

Page 68: Posters "On Otto", exhibition poster for the Fondazione Prada Milan, No. 28, and "On Otto", poster as first production step in art project, No. 27

Page 69: Posters "First Ads, adidas" as single copy in full glass frame, No. 53, and "On Otto, Cinematography", No. 33 (detail)

Pages 70/71: Posters "On Otto", exhibition poster for the Fondazione Prada Mailand, No. 28, and "On Otto", poster as first production step in art project, No. 27

Pages 72/73: Posters as single copies in full glass frames: "First Ads, adidas", No. 53 (detail), "Ads 3, Mykita/icberlin", No. 65, "Ads 3, Nike", No. 64, "Ads 2, Bach Rescue Cream", No. 61, "Ads 3, Maserati", No. 62, "Ads 2, DJ Koze", No. 59, and "First Ads, Bauer Mann", No. 48 (detail)

Pages 74/75: Posters as single copies in full glass frames: "Ads 3, Maserati", No. 62, "Ads 2, DJ Koze", No. 59, and "First Ads, Bauer Mann", No. 48 (detail)

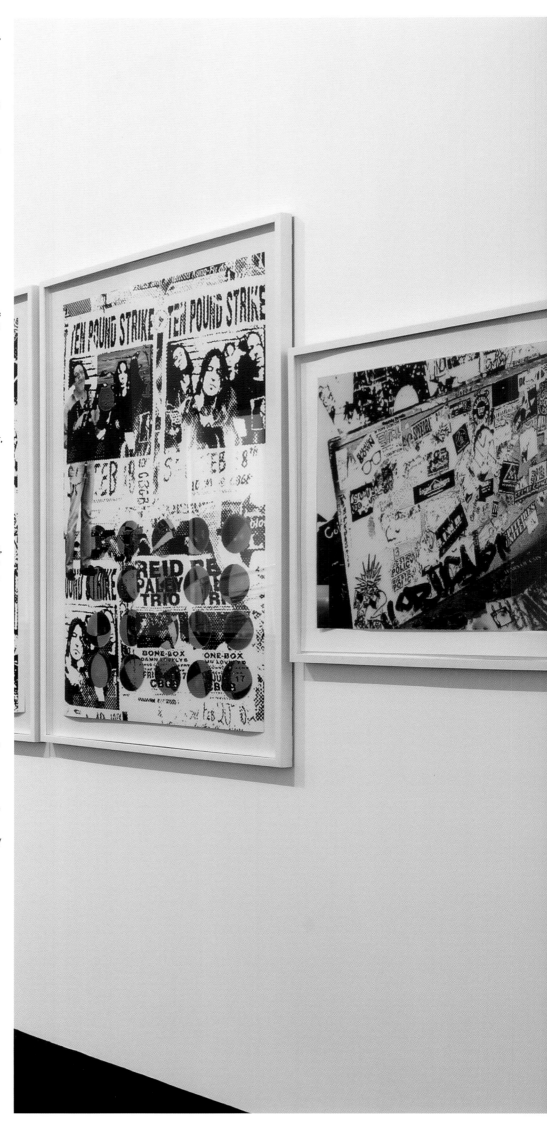

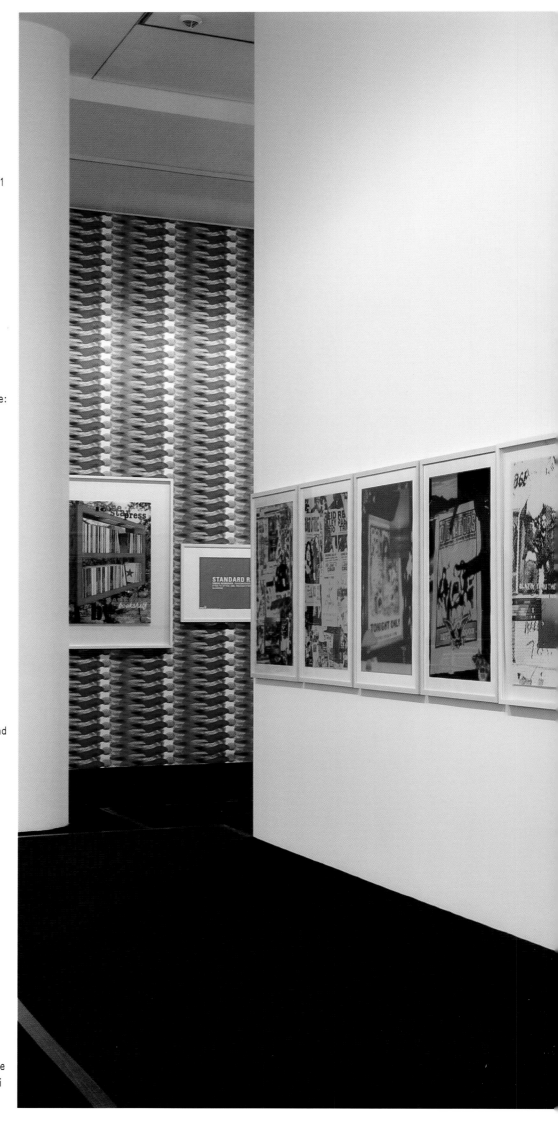

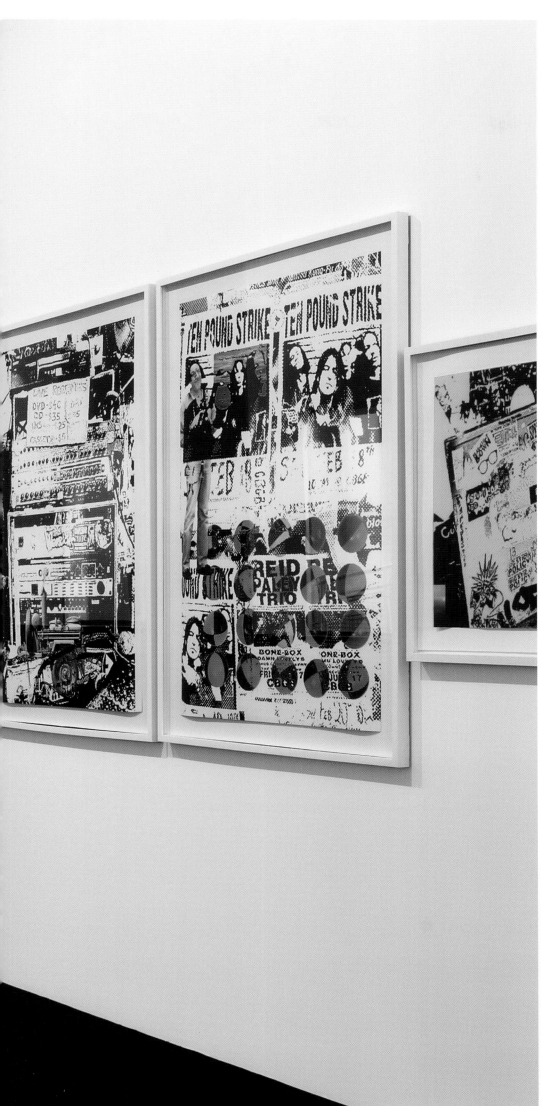

HOCHHÄUSER, FELSEN, RUDIS ...

VON TOBIAS REHBERGER
IM BBK/STAPELHAUS, FRANKENWERFT 35, KÖLN
VOM 8.3.90 BIS 4.4.90

ERÖFFNUNG 7. 3. 90 20 UHR

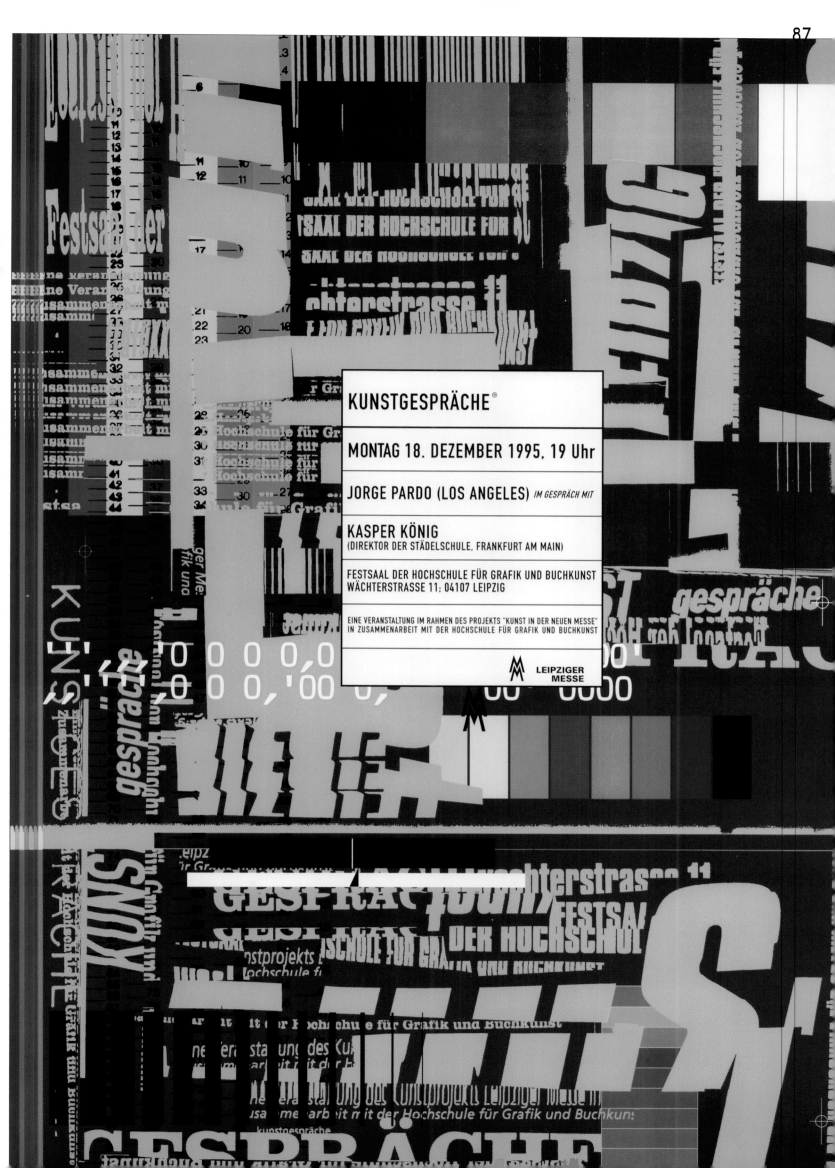

KUNSTGESPRÄCHE®

MONTAG 18. DEZEMBER 1995, 19 Uhr

JORGE PARDO (LOS ANGELES) *IM GESPRÄCH MIT*

KASPER KÖNIG
(DIREKTOR DER STÄDELSCHULE, FRANKFURT AM MAIN)

FESTSAAL DER HOCHSCHULE FÜR GRAFIK UND BUCHKUNST
WÄCHTERSTRASSE 11; 04107 LEIPZIG

EINE VERANSTALTUNG IM RAHMEN DES PROJEKTS "KUNST IN DER NEUEN MESSE"
IN ZUSAMMENARBEIT MIT DER HOCHSCHULE FÜR GRAFIK UND BUCHKUNST

LEIPZIGER
MESSE

Cancelled
Projects

Tobias Rehberger

25.06 bis 20.08 1995

and and ar

MUSEUM FRIDERICIANUM KASSEL
Friedrichsplatz Di bis So 10 bis 17 Uhr

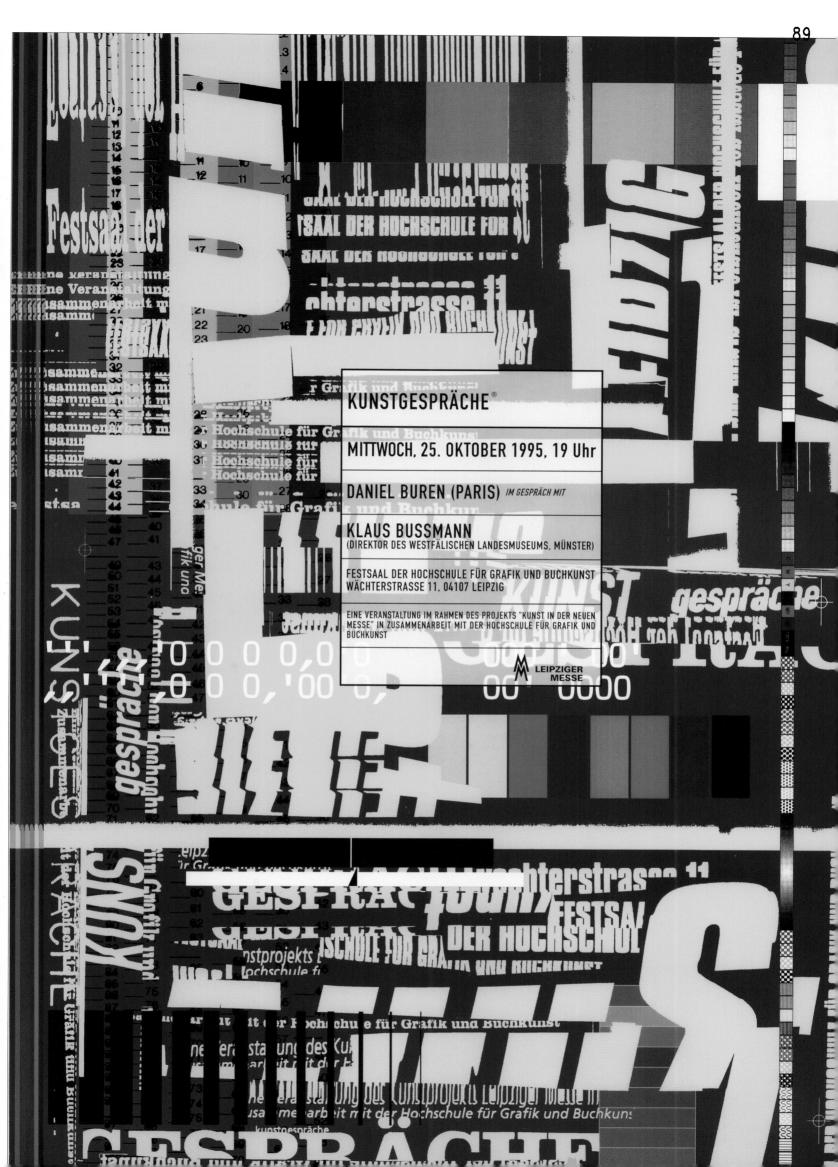

KUNSTGESPRÄCHE®

MITTWOCH, 25. OKTOBER 1995, 19 Uhr

DANIEL BUREN (PARIS) *IM GESPRÄCH MIT*

KLAUS BUSSMANN
(DIREKTOR DES WESTFÄLISCHEN LANDESMUSEUMS, MÜNSTER)

FESTSAAL DER HOCHSCHULE FÜR GRAFIK UND BUCHKUNST
WÄCHTERSTRASSE 11, 04107 LEIPZIG

EINE VERANSTALTUNG IM RAHMEN DES PROJEKTS "KUNST IN DER NEUEN
MESSE" IN ZUSAMMENARBEIT MIT DER HOCHSCHULE FÜR GRAFIK UND
BUCHKUNST

**LEIPZIGER
MESSE**

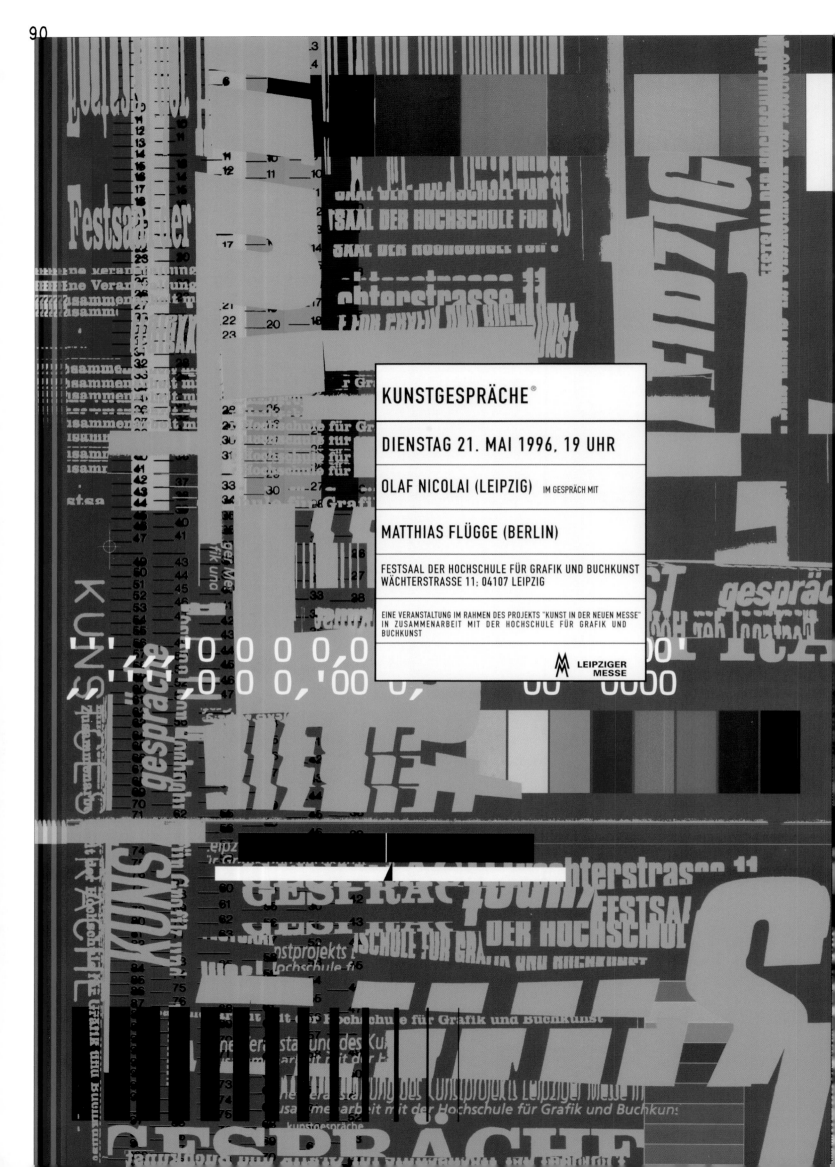

KUNSTGESPRÄCHE®

DIENSTAG 21. MAI 1996, 19 UHR

OLAF NICOLAI (LEIPZIG) IM GESPRÄCH MIT

MATTHIAS FLÜGGE (BERLIN)

FESTSAAL DER HOCHSCHULE FÜR GRAFIK UND BUCHKUNST
WÄCHTERSTRASSE 11; 04107 LEIPZIG

EINE VERANSTALTUNG IM RAHMEN DES PROJEKTS "KUNST IN DER NEUEN MESSE"
IN ZUSAMMENARBEIT MIT DER HOCHSCHULE FÜR GRAFIK UND
BUCHKUNST

LEIPZIGER
MESSE

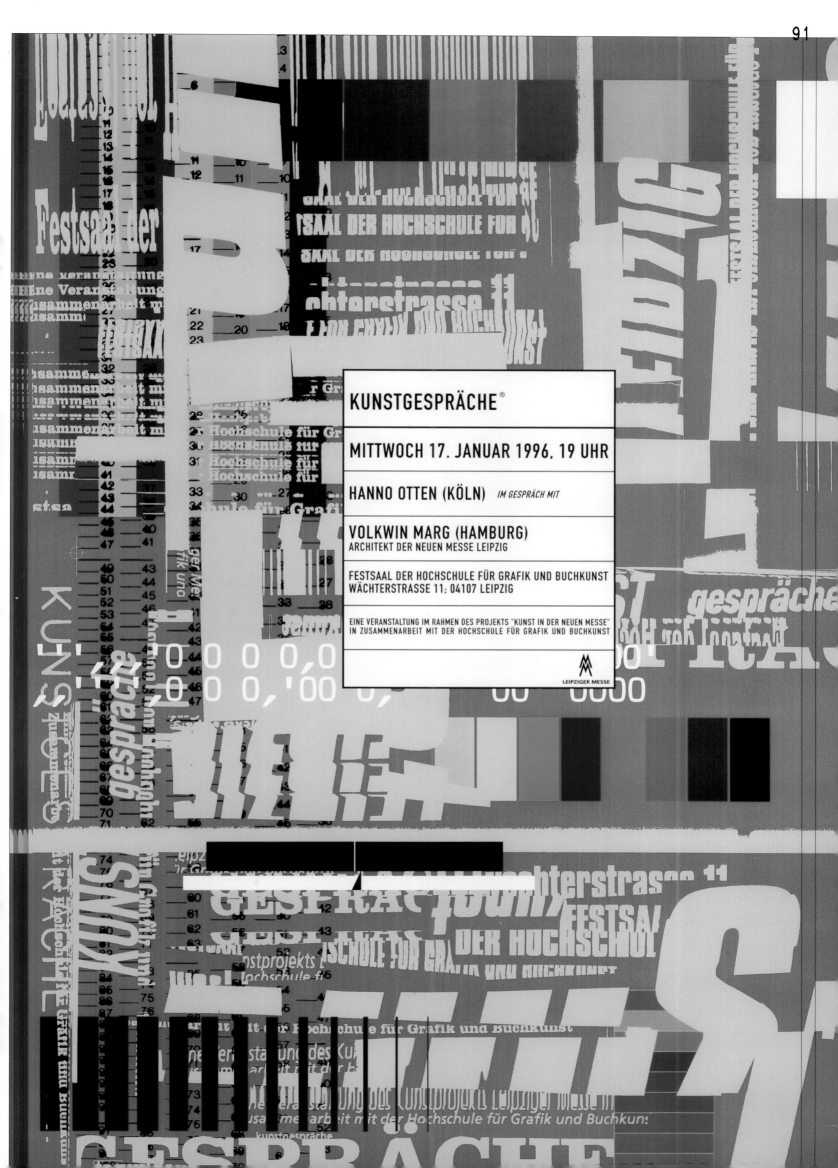

KUNSTGESPRÄCHE®

MITTWOCH 17. JANUAR 1996, 19 UHR

HANNO OTTEN (KÖLN) *IM GESPRÄCH MIT*

VOLKWIN MARG (HAMBURG)
ARCHITEKT DER NEUEN MESSE LEIPZIG

FESTSAAL DER HOCHSCHULE FÜR GRAFIK UND BUCHKUNST
WÄCHTERSTRASSE 11; 04107 LEIPZIG

EINE VERANSTALTUNG IM RAHMEN DES PROJEKTS "KUNST IN DER NEUEN MESSE"
IN ZUSAMMENARBEIT MIT DER HOCHSCHULE FÜR GRAFIK UND BUCHKUNST

LEIPZIGER MESSE

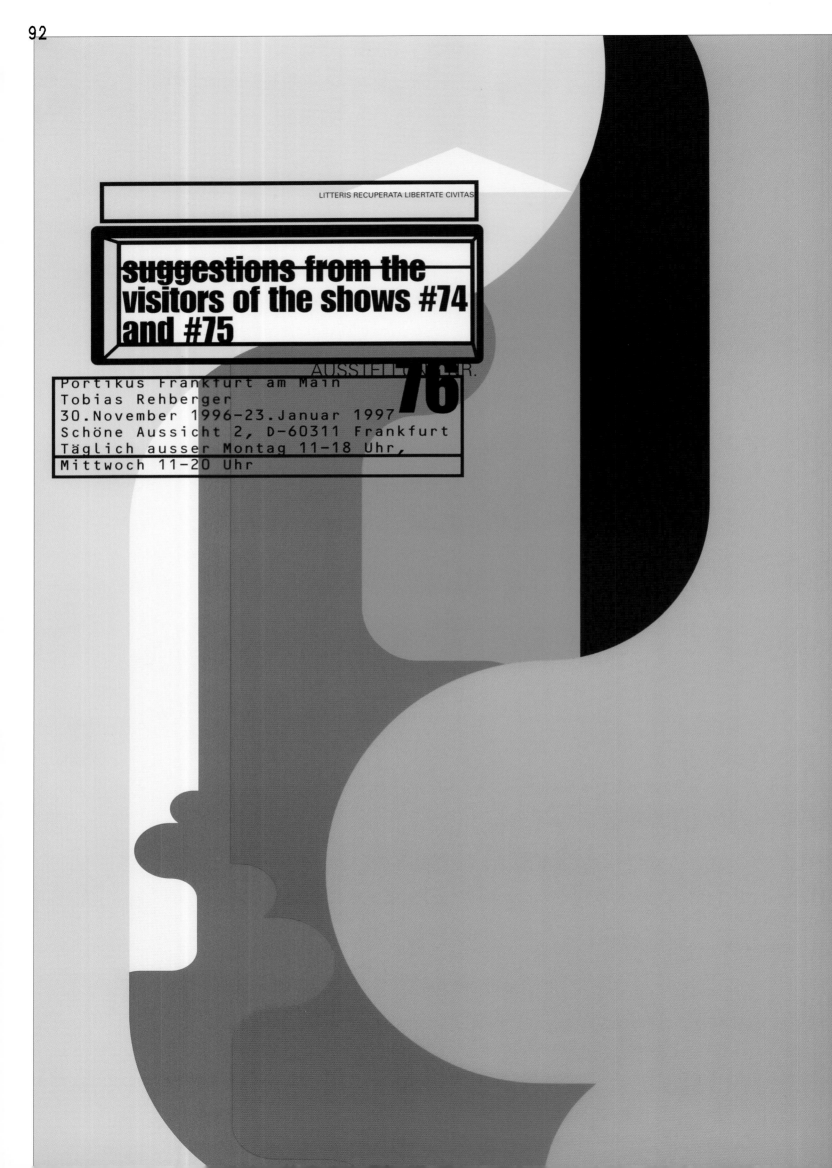

LITTERIS RECUPERATA LIBERTATE CIVITAS

suggestions from the visitors of the shows #74 and #75

AUSSTELLUNG.
76

Portikus Frankfurt am Main
Tobias Rehberger
30.November 1996–23.Januar 1997
Schöne Aussicht 2, D–60311 Frankfurt
Täglich ausser Montag 11–18 Uhr,
Mittwoch 11–20 Uhr

GELÄUT-BIS ICHS HÖR...

1.5.-11.8.2002

TOBIAS REHBERGER

Lorenzstr.9
76135 Karlsruhe
0721-81001325
www.mnk.zkm.de
Mi 10-20 Uhr
Do-So 10-18 Uhr
Mo/Di geschlossen

museum für neue kunst

zkm karlsruhe

STANDARD RAD. ^{LTD}

TOBIAS REHBERGER. TRANSMISSION GALLERY
9TH FEB TO 27TH FEB 1999. PREVIEW 6TH FEB 7.30 PM
GLASGOW

 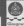

STANDARD RAD. is supported by the Goethe Institut, Glasgow

no

Coke® ... blue

Whitehall-Robins Healthcare, Madison, NJ 07940

U.S. Patent No. 5,087,454 Y

.LENS .BOTTROP .FUKUOKA .WATERLOO .OMSK .HULL .RAPID CITY .

think diffrent

CUSTOM MADE

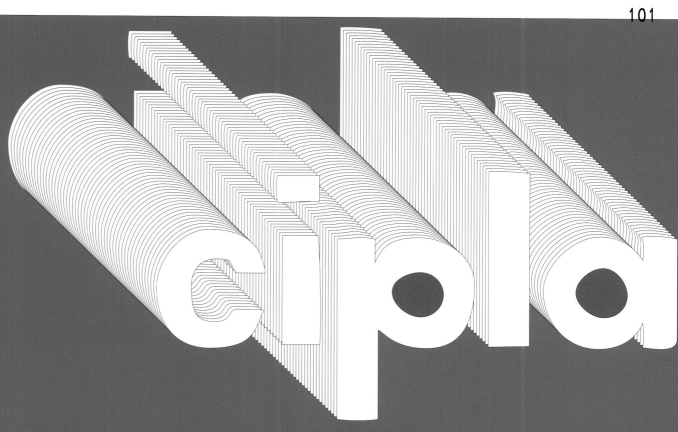

adidas®
what do you stand for...

landwirt harro mann . kleinmarkthalle . hasengasse 5-7 . 60311 frankfurt . germany

geschmacklich wunderbare,

liebevollst verzierte,

schönstens angerichtete brötchen,

würzig oder mild, rosa oder gelblich,

fisch, fleisch, gemüse und pasten,

die wie seide die kehle hinunter fallen,

die magenwände wie mit pfirsichhaut streicheln

und so samtig durch den darm gleiten...

FRANKOWITSCH
Stempfergasse 2-4 8010 Graz www.frankowitsch.at

bar

LB≡BW
Landesbank Baden-Württemberg

„bitte danke"

Arbeiten von Tobias Rehberger aus der Sammlung Landesbank Baden-Württemberg

18. Oktober 2003 – 11. Januar 2004

GALERIE
DER STADT STUTTGART

FIFA WORLD CUP
GERMANY
2006

ART POSTER TOBIAS REHBERGER GERMANY
90 MINUTES 2004

rescue cream
to sooth and restore skin

Bach

The Rock & Sole Plaice

tel 020 783 63 85

traditional english fish & chips

DJ KOZE (THANK YOU)

finest swiss cotton underwear

zimmerli
of Switzerland

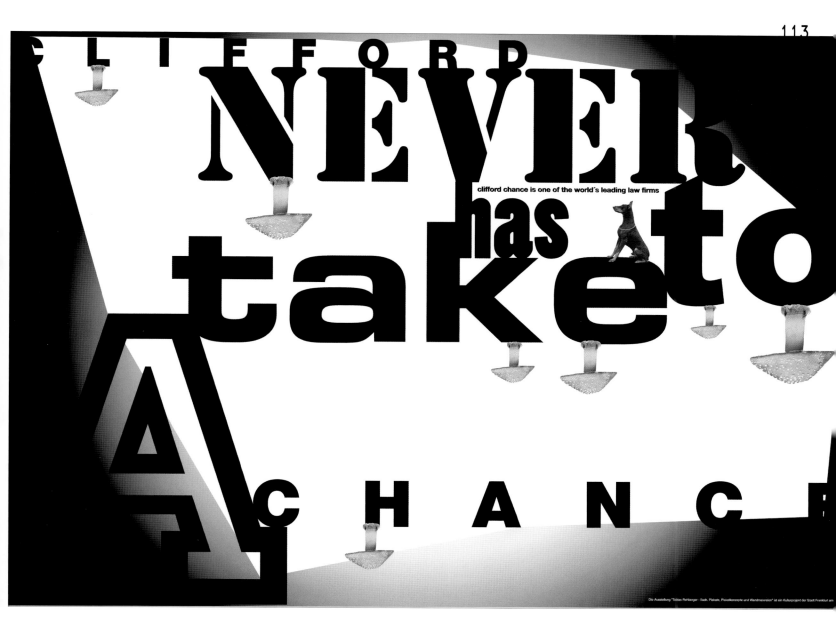

CLIFFORD

NEVER

clifford chance is one of the world's leading law firms

has taketo

A CHANCE

Die Ausstellung "Tobias Rehberger - Tisch, Plakate, Plakatkonzepte und Wandmalereien" ist ein Kulturprojekt der Stadt Frankfurt am

ToGETHER A
germa

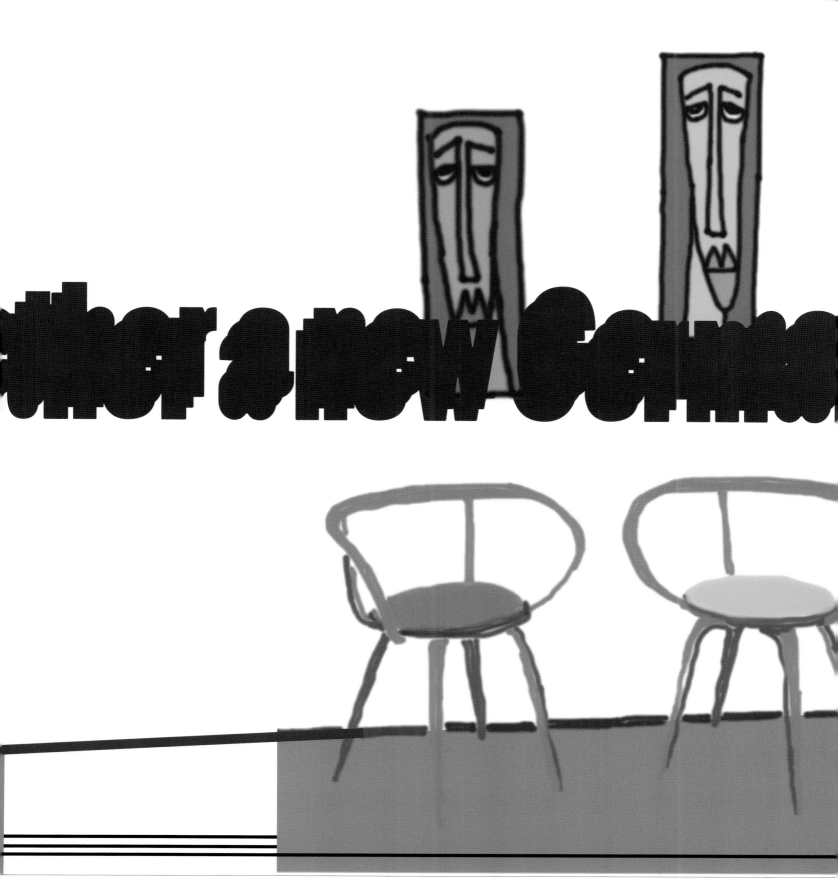

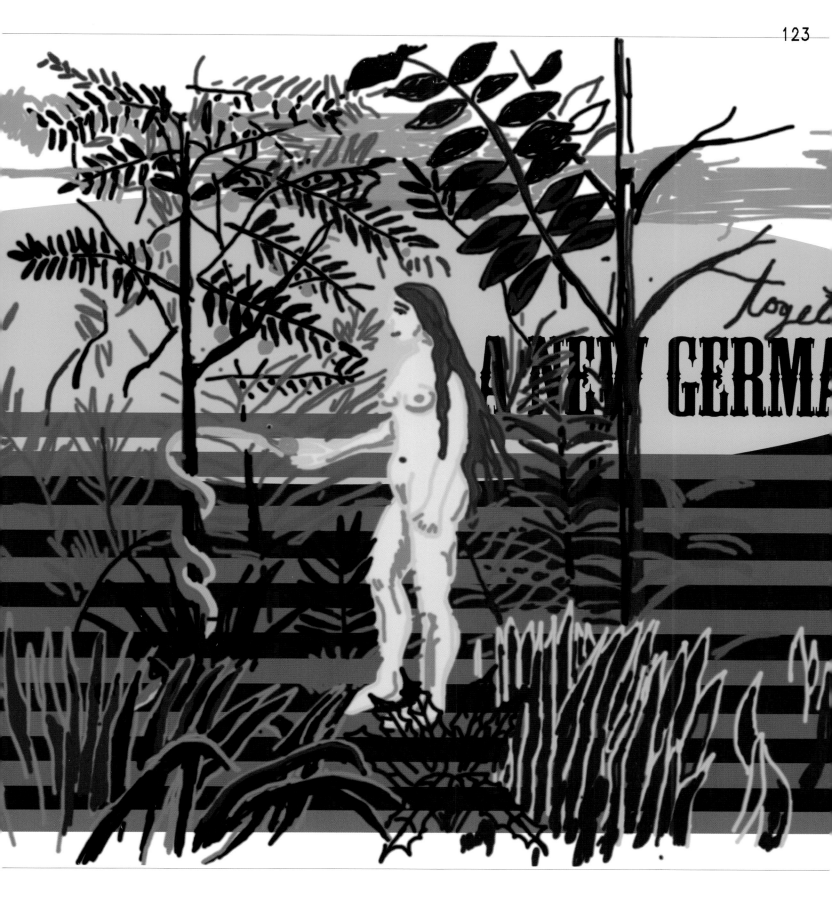

kinder
leiden
am
meisten

*NICHT IMMER GANZ RICHTIG

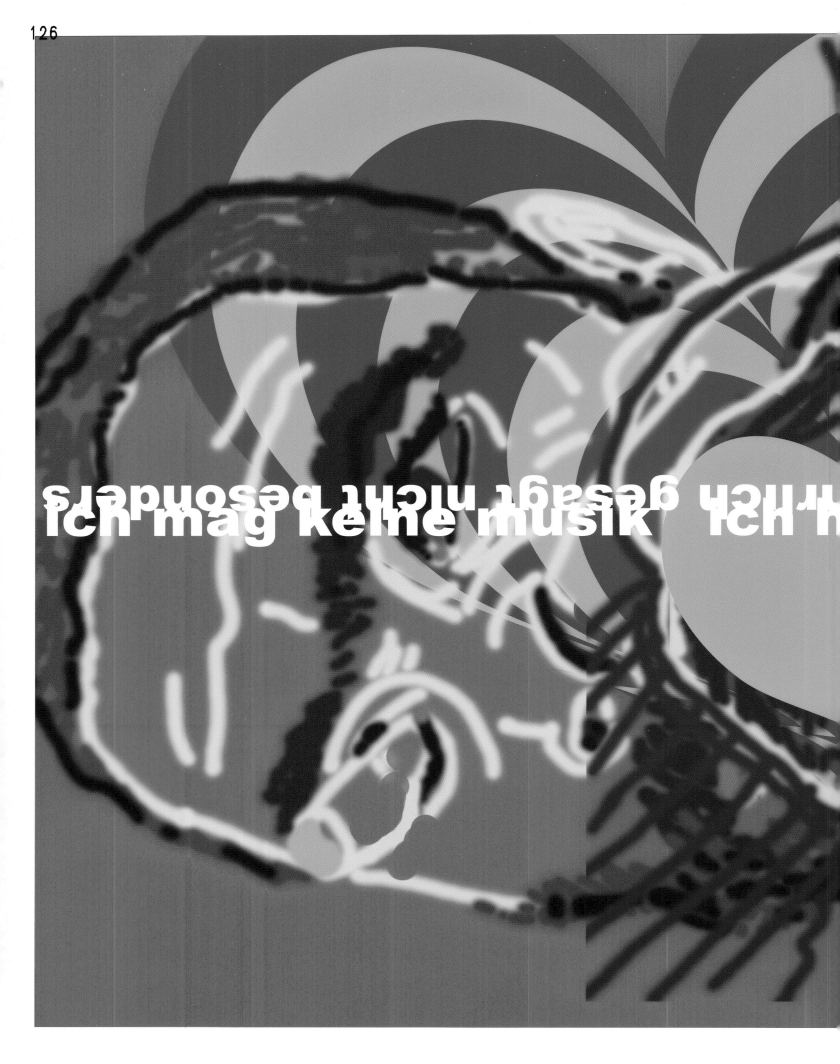

ich mag keine musik

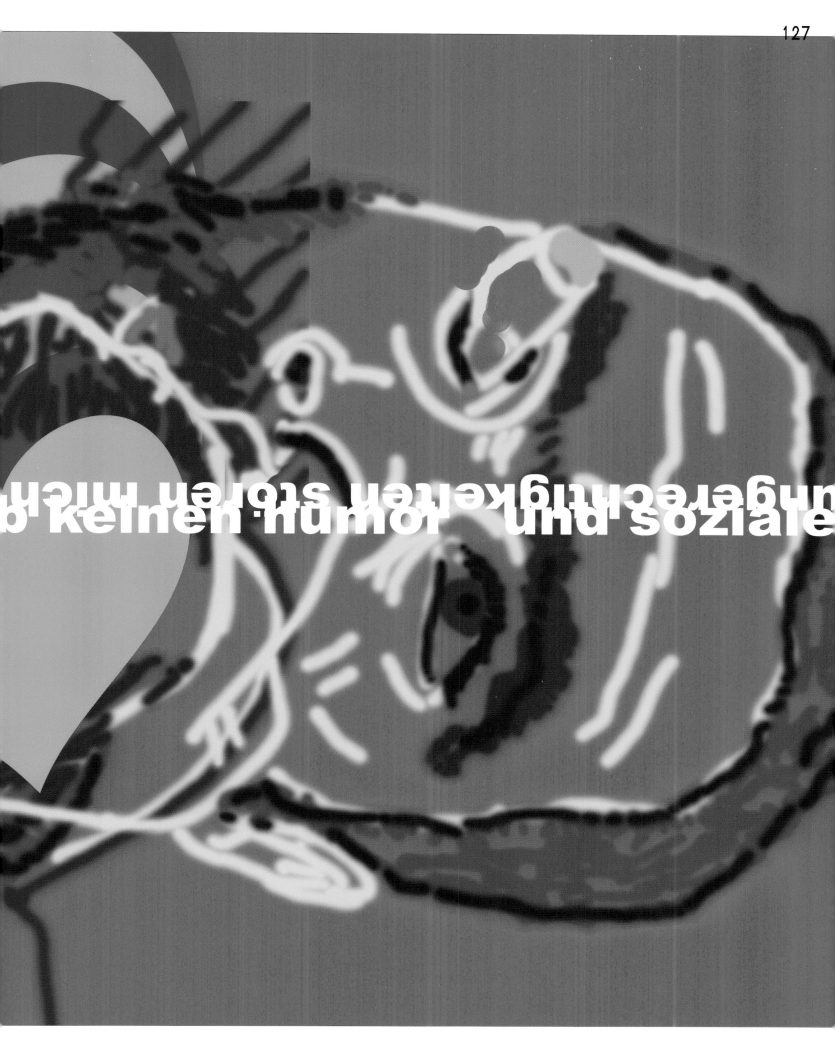

ungerechtigkeiten stören mich. Humor und soziale

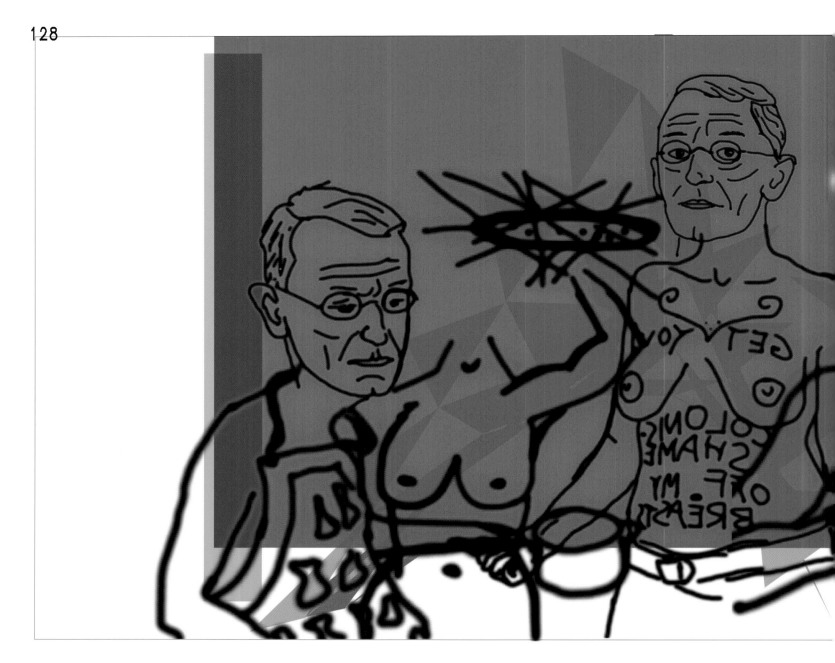

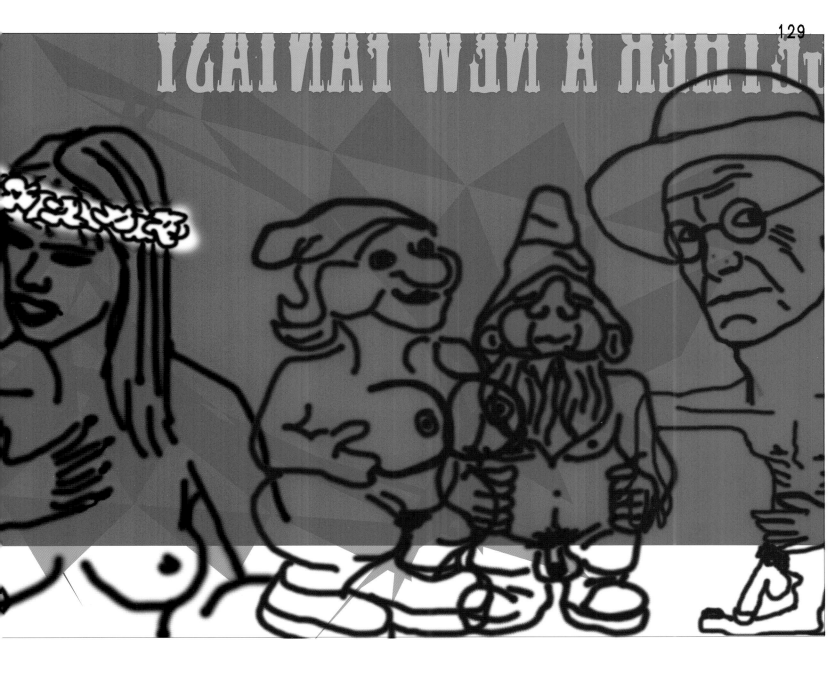

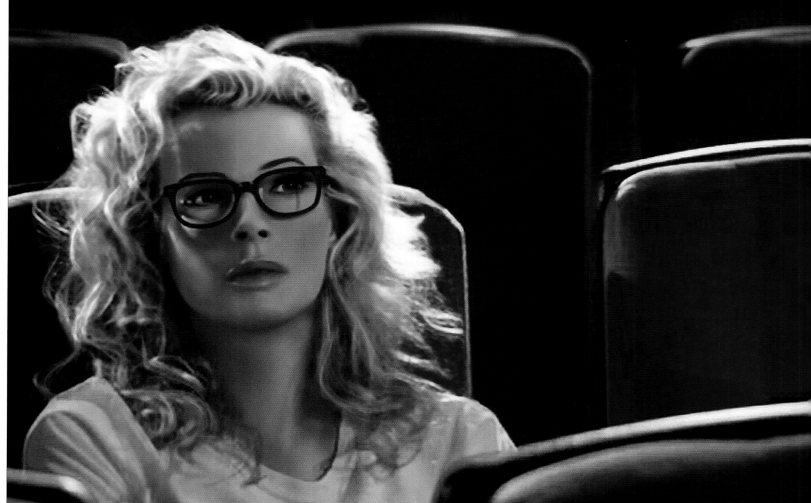

Tobias Rehberger

Kim Basinger / Willem Dafoe / Emmy Rossum / Justin Henry / Danny DeVito

Kuntzel & Deygas / Ennio Morricone / Randy Thom / Sylvie Landra / Wolfgang Thaler / Jeffrey Beecroft / Mark Bridges / J. Todd Anderson

Fondazione Prada / April - June 07

10 am - 8 pm / closed on Monday / 20135 Milan / via Fogazzaro 36 / ph. +39.02.54670515 / fax +39.02.54670258 / www.fondazioneprada.org

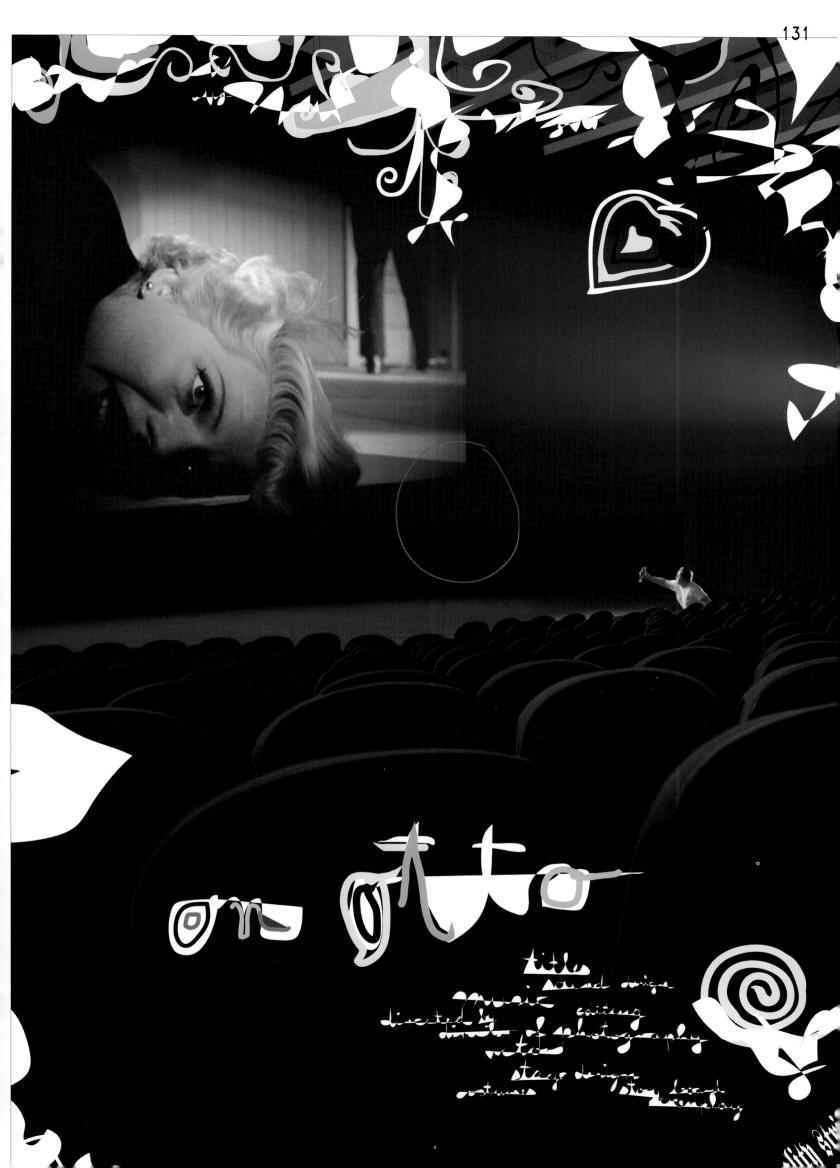

Tobias Rehberge

the chicken-and-e

gg-no-problem wa

ll-painting 22.2 t/r

25.5.2008

Stedelijk Museum CS

Oosterdokskade 5
1011 AD Amsterdam
tel. + 31 (0)20 5732811

Dagelijks open: 10 – 18 uur
Open daily: 10 am – 6 pm
www.stedelijk.nl

ABN·AMRO

Gemeente
Amsterdam

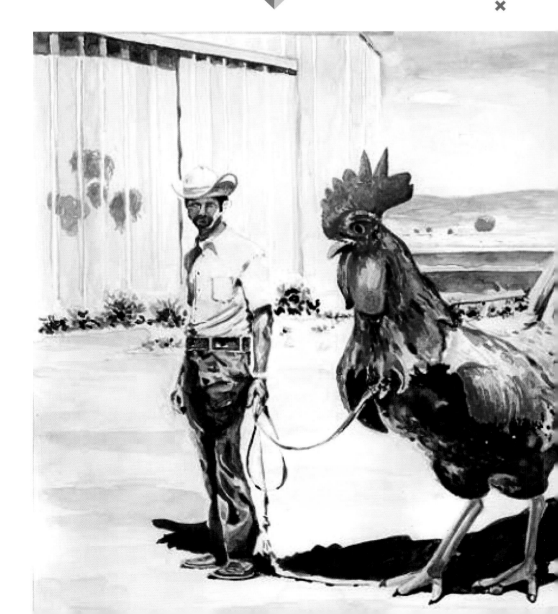

TOBIAS REHBERGER DIE DAS-KEIN-HENNE-EI-PROBLEM-WANDMALEREI
LAUFZEIT 28.6. - 21.9.2008
WWW.MUSEUM-LUDWIG.DE

MUSEUM LUDWIG
Am Dom/Hbf
Heinrich-Böll-Platz
50667 Köln
www.museum-ludwig.de

MUSEUM LUDWIG
DOM RHEIN

Kulturpartner Medienpartner

monopol
Magazin für Kunst und Leben

DORN
BRACHT
supported by
Dornbracht Culture Projects

Ein Museum der

Stadt Köln

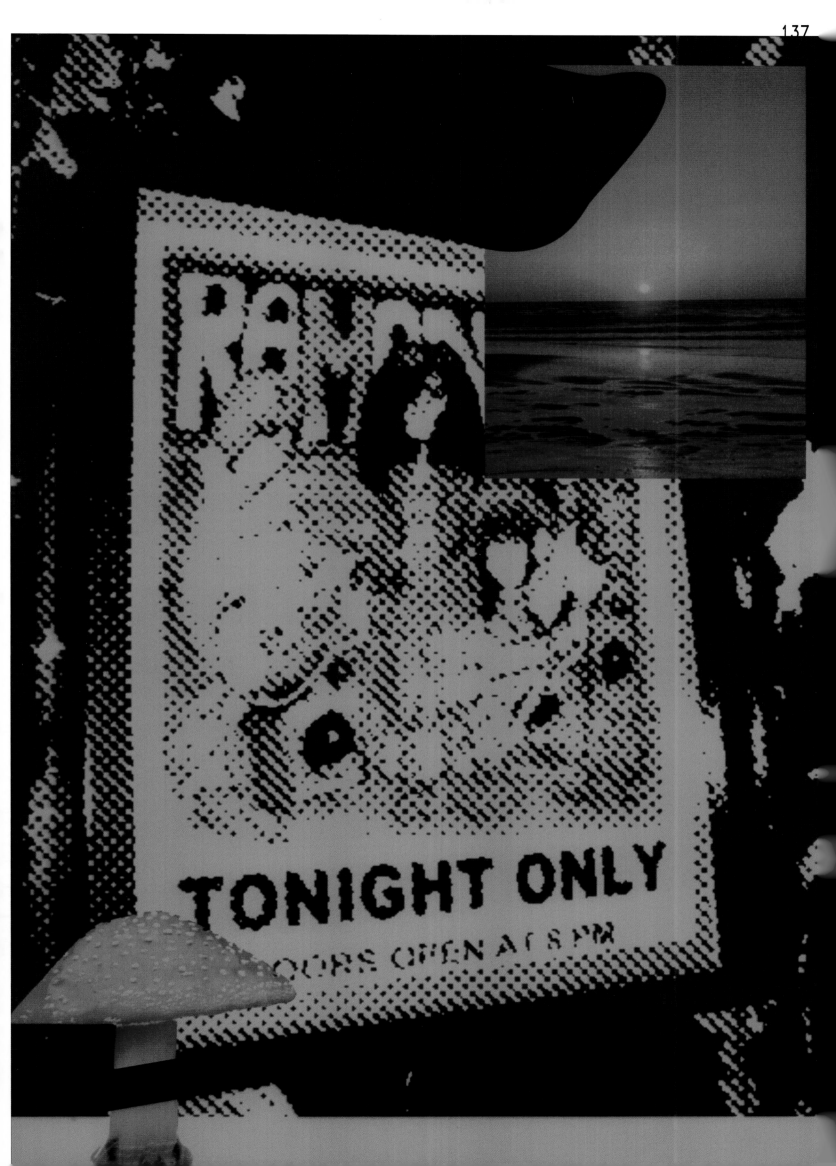

one star press

PARADISE
bookshelf
by tobiasrehberger

TITLES BY
KUNTZEL & DEYGAS

SOUND
RANDY THOM

MUSIC
ENNIO MORRICONE

EDITING
SYLVIE LANDRA

CINEMATOGRAPHY
WOLFGANG THALER

STARRING:
JUSTIN HENRY
WILLEM DAFOE
EMMY ROSSUM
KIM BASINGER
DANNY DEVITO

PRODUCTION DESIGN
JEFFREY BEECROFT

COSTUME DESIGN
MARK BRIDGES

STORYBOARD
J. TODD ANDERSON

SCRIPT
BARBARA TURNER

A FILM BY TOBIAS REHBERGER
© 2007

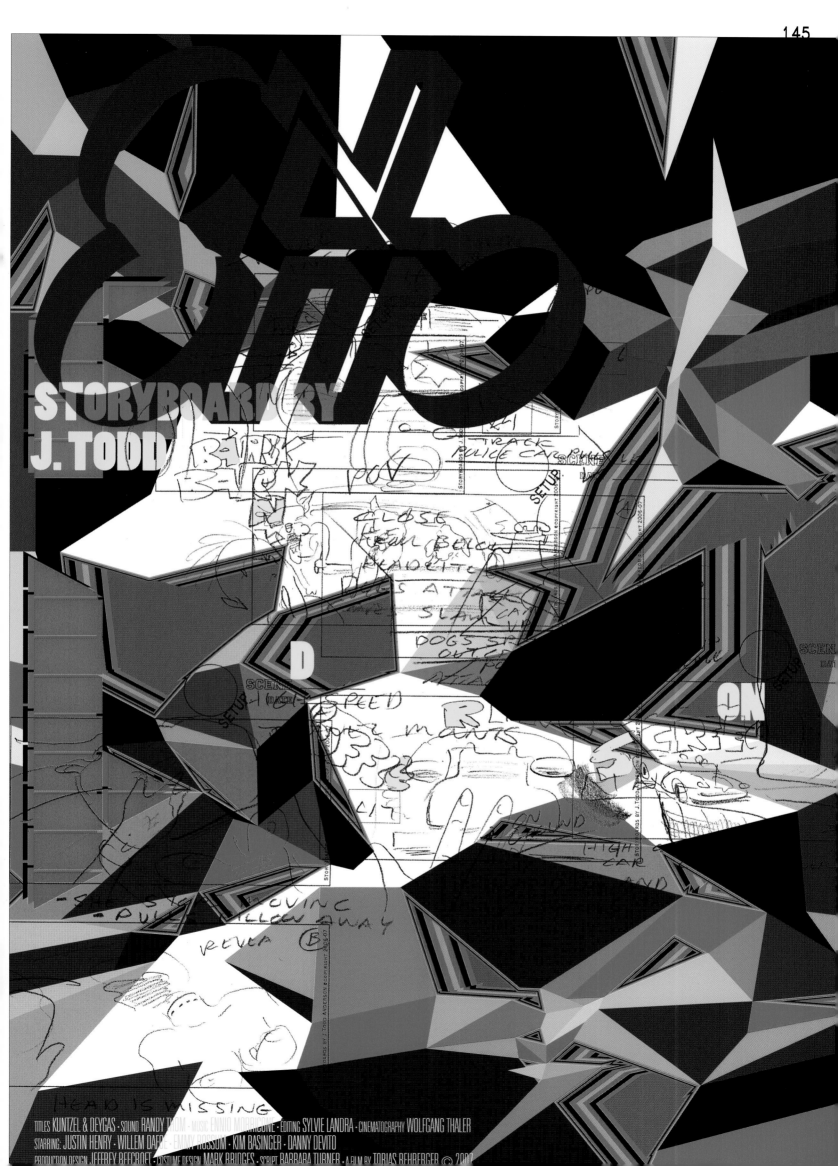

STORYBOARD BY
J. TODD

STORYBOARD BY

TITLES KUNTZEL & DEYGAS · SOUND RANDY THOM · MUSIC ENNIO MORRICONE · EDITING SYLVIE LANDRA · CINEMATOGRAPHY WOLFGANG THALER
STARRING JUSTIN HENRY · WILLEM DAFOE · EMMY ROSSUM · KIM BASINGER · DANNY DEVITO
PRODUCTION DESIGN JEFFREY BEECROFT · COSTUME DESIGN MARK BRIDGES · SCRIPT BARBARA TURNER · A FILM BY TOBIAS REHBERGER © 2007

SOUND BY
RANDY THOM

TITLES
KUNTZEL & DEYGAS

MUSIC
ENNIO MORRICONE

EDITING
SYLVIE LANDRA

CINEMATOGRAPHY
WOLFGANG THALER

STARRING:
JUSTIN HENRY
WILLEM DAFOE
EMMY ROSSUM
KIM BASINGER
DANNY DEVITO

PRODUCTION DESIGN
JEFFREY BEECROFT

COSTUME DESIGN
MARK BRIDGES

STORYBOARD
J. TODD ANDERSON

SCRIPT
BARBARA TURNER

A FILM BY TOBIAS REHBERGER

JUSTIN HENRY

WILLEM DAFOE

EMMY ROSSUM

KIM BASINGER

DANNY DEVITO

TITLES KUNTZEL & DEYGAS · SOUND RANDY THOM · MUSIC ENNIO MORRICONE · EDITING SYLVIE LANDRA
CINEMATOGRAPHY WOLFGANG THALER · PRODUCTION DESIGN JEFFREY BEECROFT
COSTUME DESIGN MARK BRIDGES · STORYBOARD J. TODD ANDERSON · SCRIPT BARBARA TURNER
A FILM BY TOBIAS REHBERGER © 2007

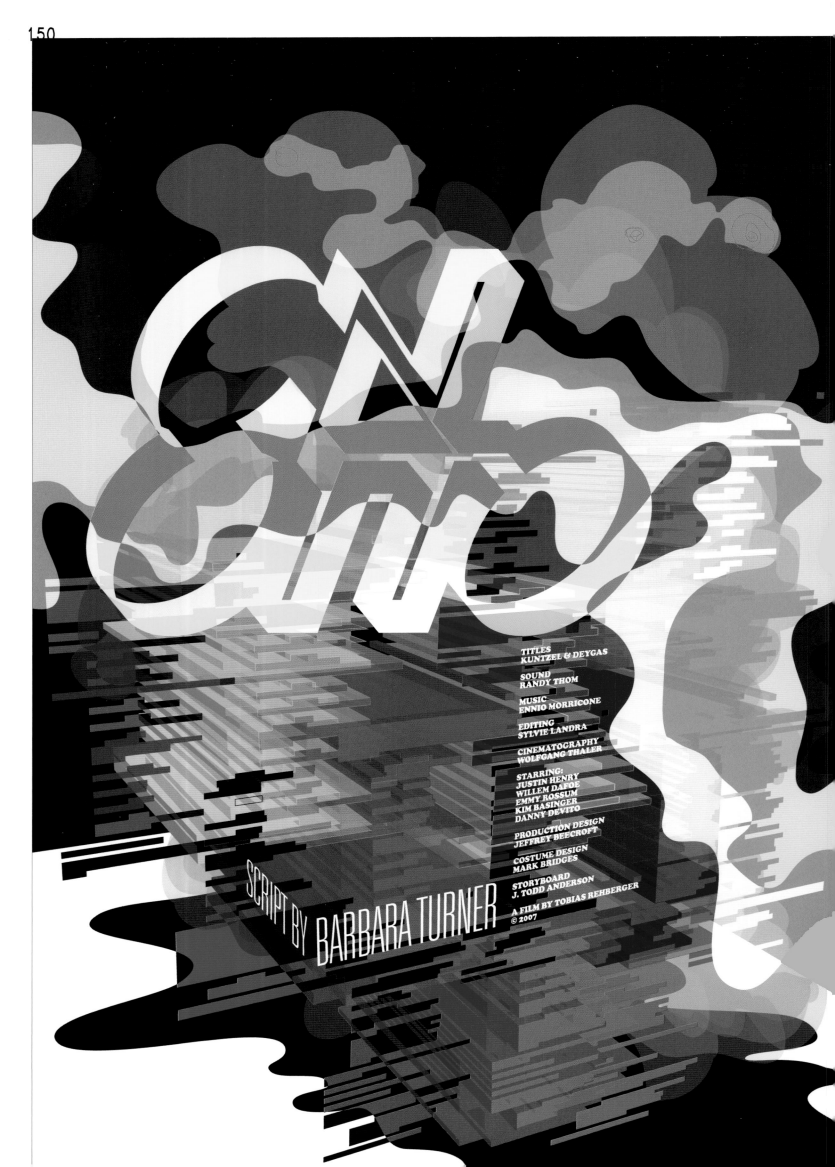

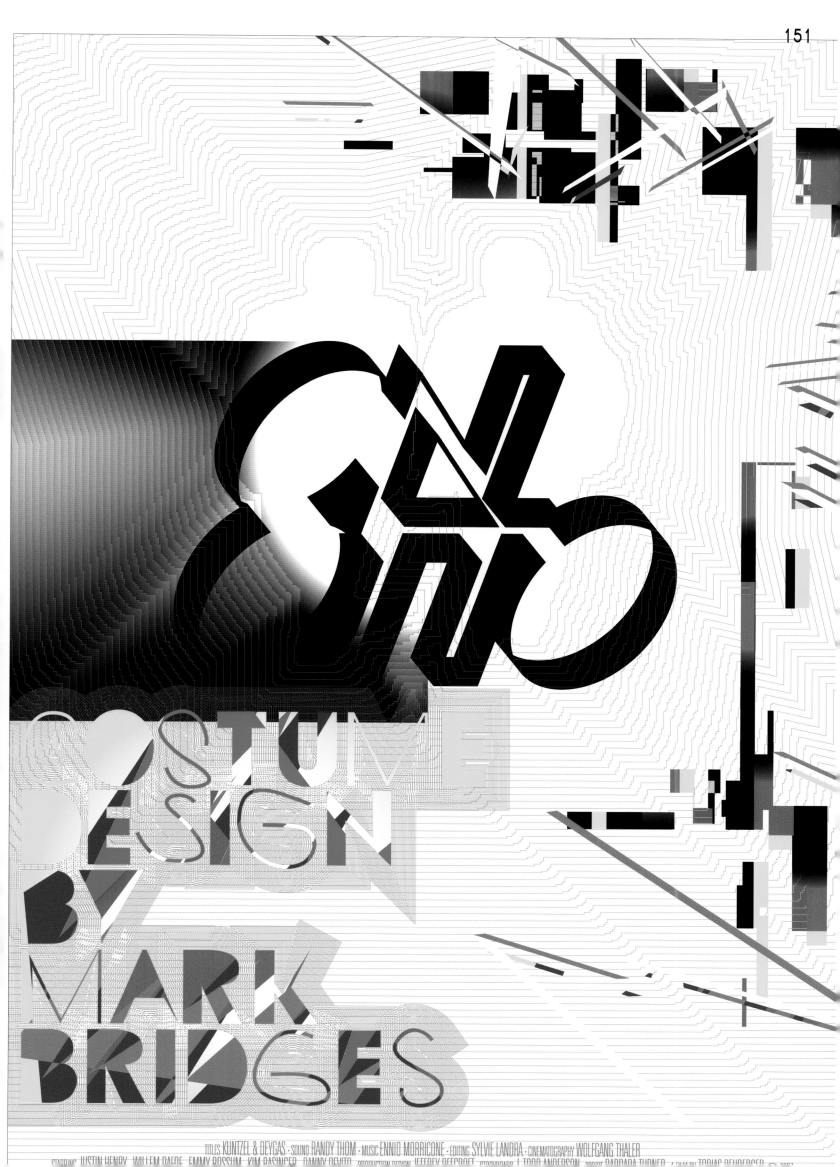

COSTUME DESIGN BY MARK BRIDGES

TITLES KUNTZEL & DEYGAS · SOUND RANDY THOM · MUSIC ENNIO MORRICONE · EDITING SYLVIE LANDRA · CINEMATOGRAPHY WOLFGANG THALER

STARRING JUSTIN HENRY · WILLEM DAFOE · EMMY ROSSUM · KIM BASINGER · DANNY DEVITO · PRODUCTION DESIGN JEFFREY BEECROFT · STORYBOARD J. TODD ANDERSON · SCRIPT BARBARA TURNER · A FILM BY TOBIAS REHBERGER

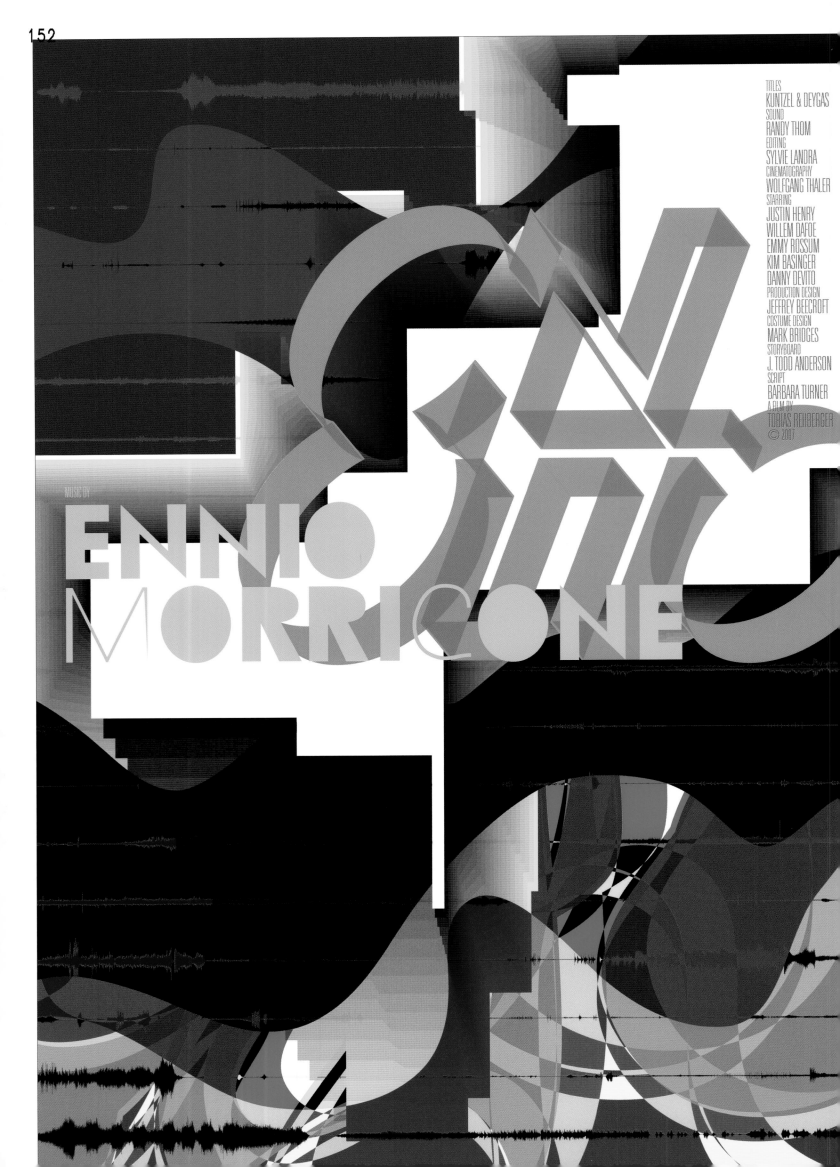

MUSIC BY
ENNIO MORRICONE

TITLES
KUNTZEL & DEYGAS
SOUND
RANDY THOM
EDITING
SYLVIE LANDRA
CINEMATOGRAPHY
WOLFGANG THALER
STARRING
JUSTIN HENRY
WILLEM DAFOE
EMMY ROSSUM
KIM BASINGER
DANNY DEVITO
PRODUCTION DESIGN
JEFFREY BEECROFT
COSTUME DESIGN
MARK BRIDGES
STORYBOARD
J. TODD ANDERSON
SCRIPT
BARBARA TURNER
A FILM BY
TOBIAS REHBERGER
© 2007

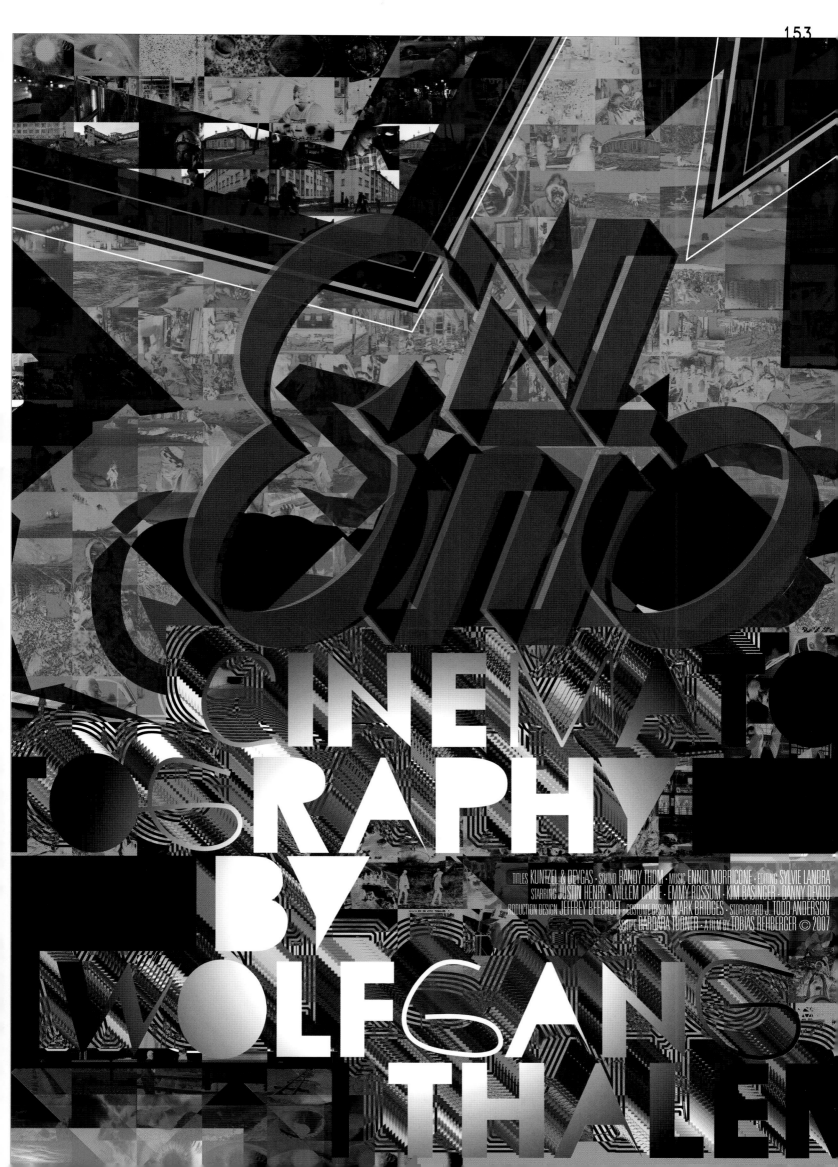

CINEMATOGRAPHY BY WOLFGANG THALER

TITLES KUNTZEL & DEYGAS · SOUND RANDY THOM · MUSIC ENNIO MORRICONE · EDITING SYLVIE LANDRA
STARRING JUSTIN HENRY · WILLEM DAFOE · EMMY ROSSUM · KIM BASINGER · DANNY DEVITO
PRODUCTION DESIGN JEFFREY BEECROFT · COSTUME DESIGN MARK BRIDGES · STORYBOARD J. TODD ANDERSON
SCRIPT BARBARA TURNER · A FILM BY TOBIAS REHBERGER © 2007

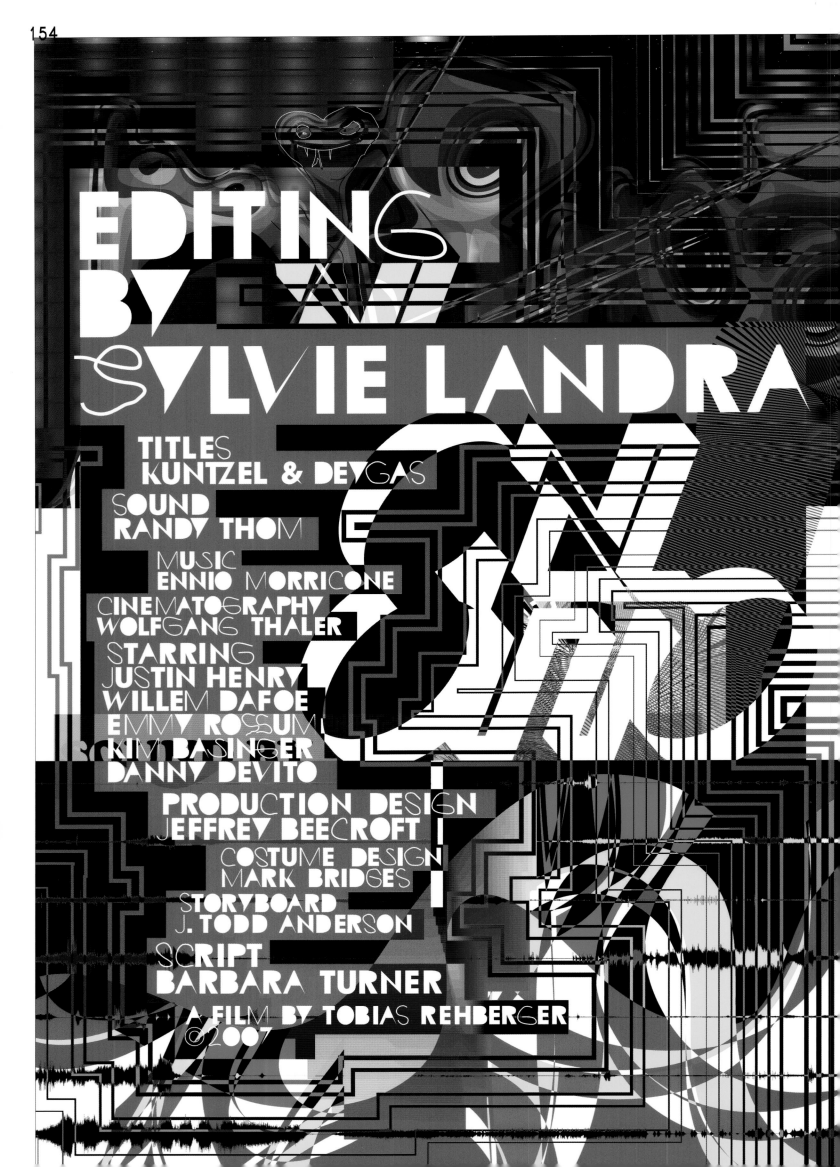

EDITING BY

SYLVIE LANDRA

TITLES
KUNTZEL & DEYGAS

SOUND
RANDY THOM

MUSIC
ENNIO MORRICONE

CINEMATOGRAPHY
WOLFGANG THALER

STARRING
JUSTIN HENRY
WILLEM DAFOE
EMMY ROSSUM
KIM BASINGER
DANNY DEVITO

PRODUCTION DESIGN
JEFFREY BEECROFT

COSTUME DESIGN
MARK BRIDGES

STORYBOARD
J. TODD ANDERSON

SCRIPT
BARBARA TURNER

A FILM BY TOBIAS REHBERGER
© 2007

... my time is NOT YOUR TIME

tobias rehberger
im kunstraum
innsbruck

14.03. – 30.04.2009
Opening: 13.03.2009, 19.00 Uhr

KUNSTRAUM INNSBRUCK

Kunstraum Innsbruck
Maria-Theresien-Straße 34, Arkadenhof
Innsbruck, Tel +43-512-584000
office@kunstraum-innsbruck.at
www.kunstraum-innsbruck.at

the quick brown fox

jumps

on weekends

at robert´s

johnson

still the only original 4door sportscar

Quattroporte

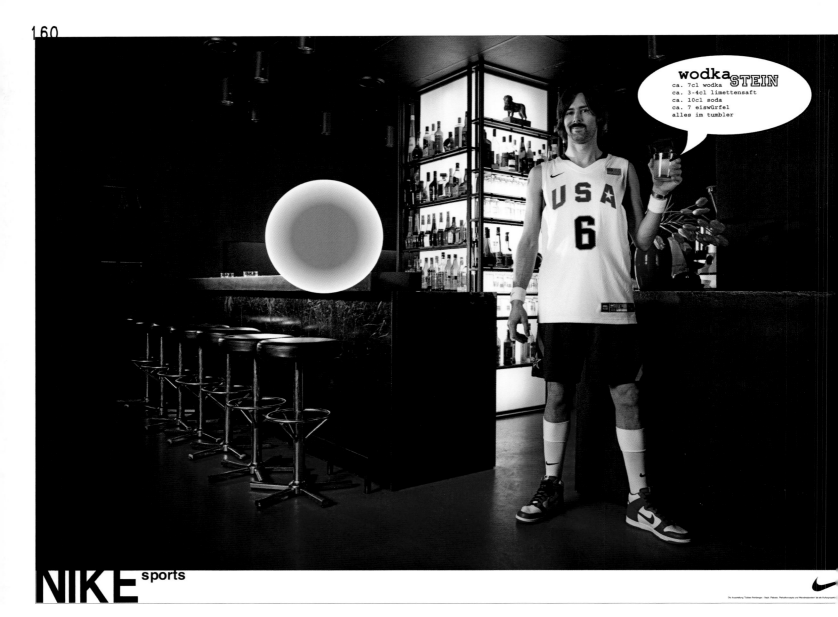

NIKE sports

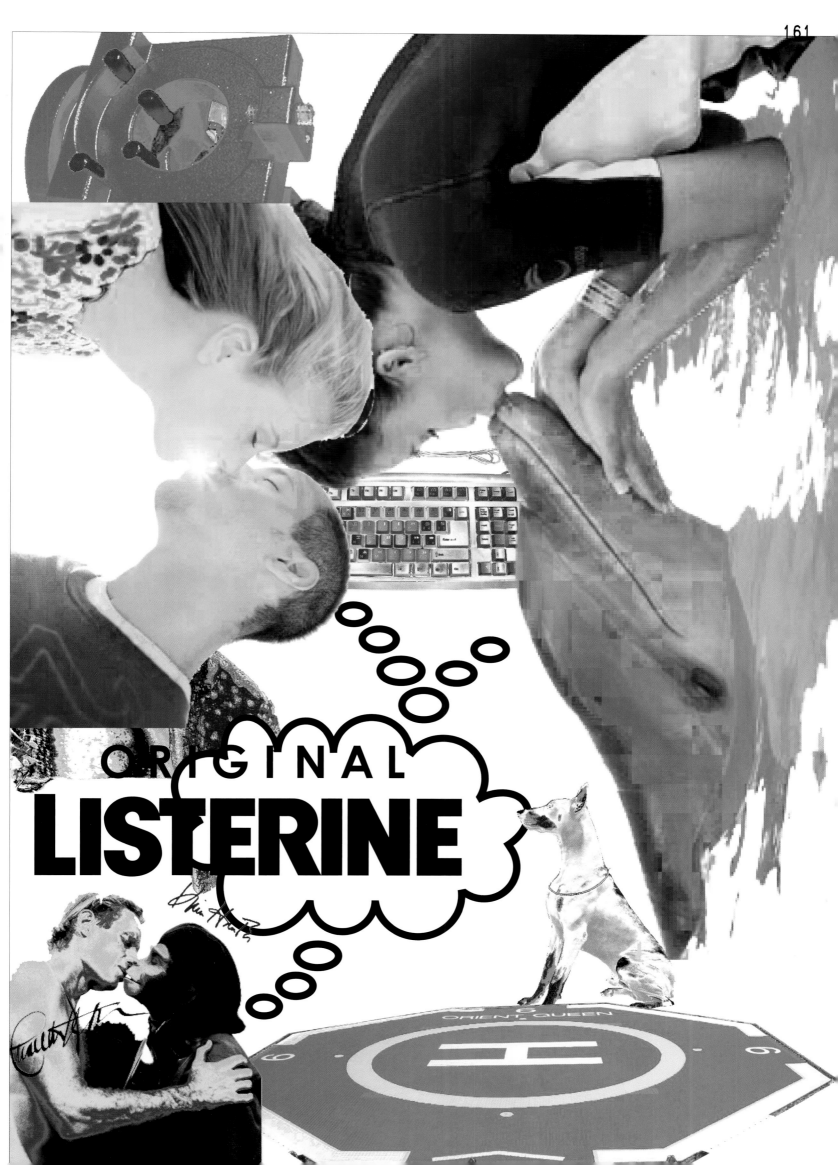

MYKITA

ic! berlin

Ausgestellte Werke
Wandmalereien

Nr. 1
Kinder leiden am meisten*
*nicht immer ganz richtig
Acryl, Pinsel
Größe variabel
Courtesy GGNGrafik Frankfurt
Abbildungen: Entwurf: S. 124/125; in der
Ausstellung: S. 9 (Detail), S. 11 (Detail), S. 17,
S. 24, S. 26/27, S. 28/29

Nr. 2
New Germany 1
Acryl, Pinsel und Spray
2006
Größe variabel
Courtesy Neugerriemschneider, Berlin
Abbildungen: Entwurf: S. 116/117; in der
Ausstellung: S. 18, S. 20/21, S. 30/31, S. 52

Nr. 3
Two Chairs
Acryl, Pinsel und Spray
2006
Größe variabel
Courtesy Neugerriemschneider, Berlin
Abbildungen: Entwurf: S. 118/119; in der Ausstellung:
S. 30/31, S. 42, S. 44/45, S. 47, S. 49 (Detail), S. 57

Nr. 4
Seven Naked Hermann Hesse Fans
Acryl, Pinsel und Spray
2006
Größe variabel
Courtesy Neugerriemschneider, Berlin
Abbildungen: Entwurf: S. 128/129; in der Ausstellung:
S. 33, S. 34/35, S. 36/37, S. 40/41, S. 42/43,
S. 45 (Detail)

Nr. 5
Ich mag keine Musik ich hab keinen Humor und
soziale Ungerechtigkeiten stören mich ehrlich
gesagt nicht besonders
Acryl, Pinsel und Spray
2006
Größe variabel
Courtesy GGNGrafik Frankfurt
Abbildungen: Entwurf: S. 126/127; in der Ausstellung:
S. 35, S. 38/39

Nr. 6
Horrible Flute Player
Acryl, Pinsel und Spray
2006
Größe variabel
Courtesy Neugerriemschneider, Berlin
Abbildungen: Entwurf: S. 120/121; in der Ausstellung:
S. 15 (Detail), S. 16, S. 18/19, S. 31 (Detail),
S. 32/33, S. 34, S. 50 (Detail)

Nr. 7
Oranges from Eden
Acryl, Pinsel und Spray
2006
Größe variabel
Courtesy Neugerriemschneider, Berlin
Abbildungen: Entwurf: S. 122/123; in der Ausstellung:
S. 12/13, S. 14 (Detail), S. 33, S. 34, S. 46,
S. 48/49, S. 50/51, S. 55, S. 56/57 (Detail)

Nr. 8
Translator
Acryl, Spray
2002
Größe variabel
Abbildungen in der Ausstellung: S. 14/15, S. 16
(Detail)

Tapete

Nr. 9
Tapete der Installation
UP On 1-5
Digitaldruck
2004
Courtesy Neugerriemschneider, Berlin
Abbildungen: in der Ausstellung: S. 8, S. 10, S. 54,
S. 56-59, S. 61, S. 84

Plakate

Nr. 10
Hochhäuser, Felsen, Rudis
Berufsverband Bildender Künstler, Stapelhaus, Köln
Siebdruck
1990
49,8 x 69,8 cm
Abbildungen: S. 86; in der Ausstellung: S. 56
(Detail), S. 58/59, S. 61

Nr. 11
Cancelled Projects
Museum Fridericianum Kassel
Offset
1995
DIN A1
Abbildungen: S. 88; in der Ausstellung: S. 60, S. 63

Nr. 12
Suggestions from the visitors of the shows #74
and #75
Portikus, Frankfurt am Main
Offset
1996
DIN A1
Abbildungen: S. 92; in der Ausstellung: S. 60, S. 63

Nr. 13
Bar Münster
Digitaldruck
1997
DIN A1
Abbildungen: S. 104; in der Ausstellung: S. 60,
S. 63

Nr. 14
Standard Rad.
Transmission
Gallery Glasgow
Offset
1999
DIN A2
Abbildungen: S. 94; in der Ausstellung: S. 61, S. 84

Nr. 15
Geläut — bis ichs hör...
MNK Karlsruhe 2003
Offset
2003
DIN A1
Abbildungen: S. 93; in der Ausstellung: S. 60, S. 63

Nr. 16
Don't work too much
Offset
2003
DIN A1
Abbildungen: S. 105; in der Ausstellung:
S. 60, S. 63

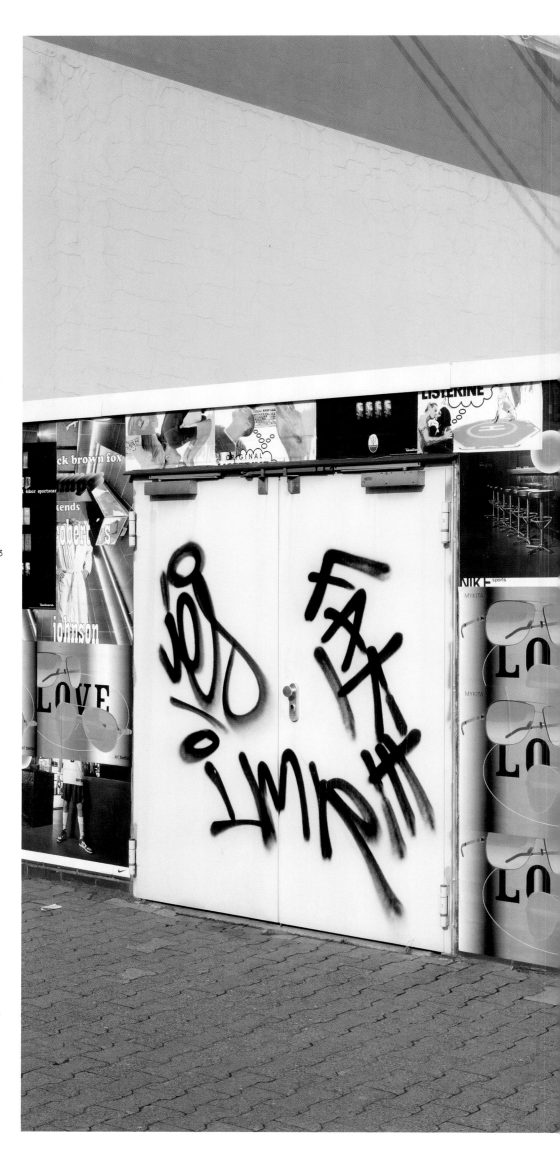

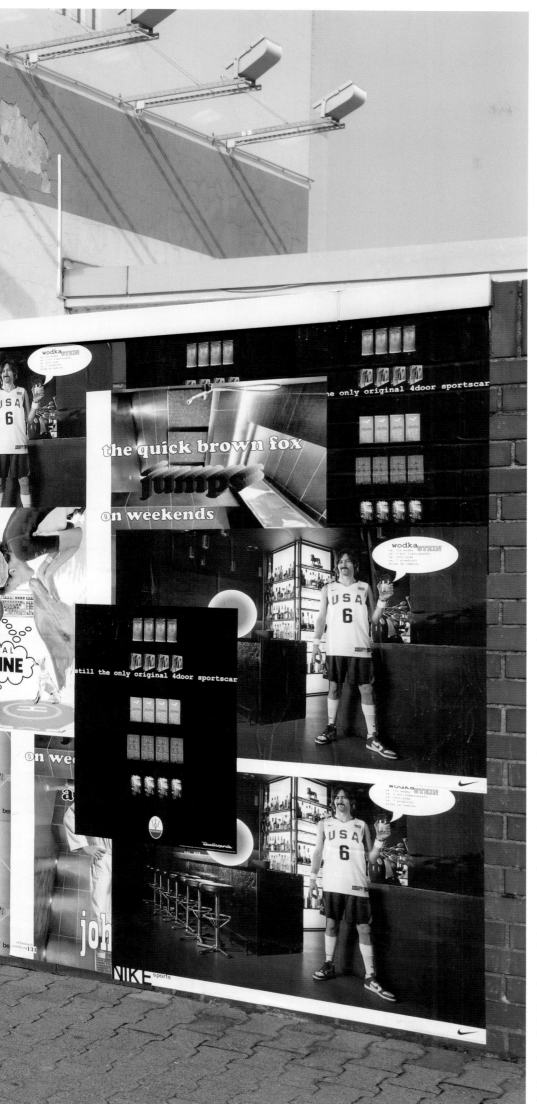

Nr. 17
90 minutes
Offsetdruck
2004
97 x 66,4 cm
Abbildungen: S. 107; in der Ausstellung: S. 61

Nr. 18
bitte danke
Galerie der Stadt Stuttgart
Offset
2004
DIN A1
Abbildungen: S. 106; in der Ausstellung: S. 63

Nr. 19
Kooperation Tobias Rehberger und Chris Rehberger
The chicken-and-egg-no-problem wall-painting
Stedelijk Museum Amsterdam
Offset tbc
2008
DIN A2
Abbildungen: S. 132; in der Ausstellung: S. 61

Nr. 20
Kooperation Tobias Rehberger und Chris Rehberger
Die das Kein-Henne-Ei-Problem Wandmalerei
Museum Ludwig Köln
Offset tbc
2008
DIN A1
Abbildungen: S. 133; in der Ausstellung: S. 58,
S. 61

Nr. 21
My time is not your time
Kunstraum Innsbruck
Offset
2009
DIN A1
Abbildungen: S. 155; in der Ausstellung: S. 56,
S. 59, S. 61

Nr. 22
Paradise Bookshelf
Offset
2009
DIN A1
Abbildungen: S. 142; in der Ausstellung: S. 84

Nr. 23
Kooperation Tobias Rehberger und Chris Rehberger
Kunst-Gespräche Leipziger Messe
25. Oktober
Offset tbc
1995
DIN A1
Abbildung: S. 89

Nr. 24
Kooperation Tobias Rehberger und Chris Rehberger
Kunst-Gespräche Leipziger Messe
18. Dezember
Offset tbc
1995
DIN A1
Abbildung: S. 87

Nr. 25
Kooperation Tobias Rehberger und Chris Rehberger
Kunst-Gespräche Leipziger Messe
21. Mai
Offset tbc
1995/1996
DIN A1
Abbildung: S. 90

Nr. 26
Kooperation Tobias Rehberger und Chris Rehberger
Kunst-Gespräche Leipziger Messe
17. Januar
Offset tbc
1995/1996
DIN A1
Abbildung: S. 91

On Otto

Nr. 27
On Otto
(Plakat als erster Produktionsschritt des
Kunstprojekts)
2007
Offset
DIN A0
Courtesy Fondazione Prada Mailand
Abbildungen: S. 131; in der Ausstellung: S. 68, S. 70

Nr. 28
Kooperation Tobias Rehberger und Chris Rehberger
On Otto
Ausstellungsplakat Fondazione Prada Mailand
2007
Offset
199,4 x 138,7 cm
Abbildungen: S. 130; in der Ausstellung: S. 68, S. 70

Nr. 29
Kooperation Tobias Rehberger und Florian Markl
On Otto
Titles (Titel)
Digitaldruck auf Photo Rag
2009
100 x 70 cm
Courtesy Edition Schellmann
Abbildungen: S. 144; in der Ausstellung: S. 64

Nr. 30
Kooperation Tobias Rehberger und Florian Markl
On Otto
Sound
Digitaldruck auf Photo Rag
Druck Recom Art, Ostfildern
2009
100 x 70 cm
Courtesy Edition Schellmann
Abbildungen: S. 146; in der Ausstellung: S. 64,
S. 67 (Detail)

Nr. 31
Kooperation Tobias Rehberger und Florian Markl
On Otto
Music (Musik)
Digitaldruck auf Photo Rag
Druck Recom Art, Ostfildern
2009
100 x 70 cm
Courtesy Edition Schellmann
Abbildungen: S. 152; in der Ausstellung: S. 64

Nr. 32
Kooperation Tobias Rehberger und Florian Markl
On Otto
Editing (Schnitt)
Digitaldruck auf Photo Rag
Druck Recom Art, Ostfildern
2009
100 x 70 cm
Courtesy Edition Schellmann
Abbildungen: S. 154; in der Ausstellung: S. 62, S. 65

Nr. 33
Kooperation Tobias Rehberger und Florian Markl
On Otto
Cinematography (Kamera)
Digitaldruck auf Photo Rag
Druck Recom Art, Ostfildern
2009
100 x 70 cm
Courtesy Edition Schellmann
Abbildungen: S. 153; in der Ausstellung: S. 67

Nr. 34
Kooperation Tobias Rehberger und Florian Markl
On Otto
Actors (Schauspieler)
Digitaldruck auf Photo Rag
Druck Recom Art, Ostfildern
2009
100 x 70 cm
Courtesy Edition Schellmann
Abbildung: S. 148

Nr. 35
Kooperation Tobias Rehberger und Florian Markl
On Otto
Production Design (Szenenbild)
Digitaldruck auf Photo Rag
Druck Recom Art, Ostfildern
2009
100 x 70 cm
Courtesy Edition Schellmann
Abbildungen: S. 147; in der Ausstellung: S. 62, S. 65

Nr. 36
Kooperation Tobias Rehberger und Florian Markl
On Otto
Costume Design (Kostümbild)
Digitaldruck auf Photo Rag
Druck Recom Art, Ostfildern
2009
100 x 70 cm
Courtesy Edition Schellmann
Abbildung: S. 151

Nr. 37
Kooperation Tobias Rehberger und Florian Markl
On Otto
Story Board
Digitaldruck auf Photo Rag
Druck Recom Art, Ostfildern
2009
100 x 70 cm
Courtesy Edition Schellmann
Abbildungen: S. 145; in der Ausstellung: S. 64

Nr. 38
Kooperation Tobias Rehberger und Florian Markl
On Otto
Script
Digitaldruck auf Photo Rag
Druck Recom Art, Ostfildern
2009
100 x 70 cm
Courtesy Edition Schellmann
Abbildungen: S. 150; in der Ausstellung: S. 62, S. 65

Nr. 39 - Nr. 47
Neun Plakatmotive für die Venedig-Kunstbiennale
2009/Bar Cafeteria Palazzo delle Esposizioni
Giardini, gedruckt in Offset auf farbigem und
weißem Affichenpapier, DIN A1 oder DIN A0
Abbildungen: S. 134-141; in der Ausstellung:
S. 82-85

Ads

Nr. 48
First Ads
Bauer Mann
Offset
2001
107,2 x 77,4 x 2,9 cm
Abbildungen: S. 102; in der Ausstellung: S. 75
(Detail), S. 76

Nr. 49
First Ads
Frankowitsch
Offset
2001
91,2 x 67,2 x 2,9 cm
Abbildung: S. 103

Nr. 50
First Ads
Margiela
Offset
2001
101,5 x 137,3 x 2,9 cm
Abbildung: S. 98

Nr. 51
First Ads
Evisu
Offset
2001
87,3 x 120,3 x 2,9 cm
Abbildungen: S. 100; in der Ausstellung: S. 79
(Detail)

Nr. 52
First Ads
apple
Offset
2001
108,3 x 77,4 x 2,9 cm
Abbildung: S. 99

Nr. 53
First Ads
adidas
Offset
2001
137,2 x 100,4 x 2,9 cm
Abbildungen: S. 101; in der Ausstellung: S. 66,
S. 69, S. 72 (Detail)

Nr. 54
First Ads
advil
Offset
2001
101,3 x 137,3 x 2,9 cm
Abbildungen: S. 96; in der Ausstellung: S. 78
(Detail)

Nr. 55
First Ads
Blush
Offset
2001
91,3 x 126,3 x 2,9 cm
Abbildung: S. 97

Nr. 56
First Ads
Coke
Offset
2001
108,2 x 77,3 x 2,9 cm
Abbildungen: S. 95; in der Ausstellung: S. 78/79

Nr. 57
Ads 2
The Rock and Soul Plaice
Digitaldruck
2004
83,3 x 58,3 x 2,9 cm
Abbildung: S. 109

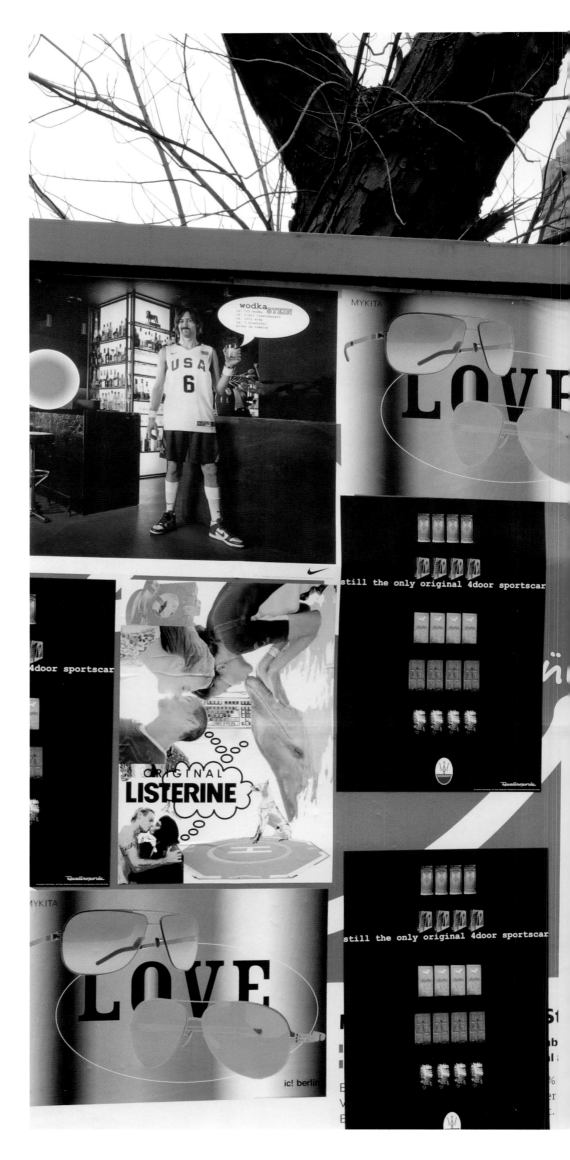

Nr. 58
Ads 2
Fiat Panda
Digitaldruck
2004
83,3 x 58,2 x 2,9 cm
Abbildung: S. 111

Nr. 59
Ads 2
DJ Koze
Digitaldruck
2004
58,2 x 83,3 x 2,9 cm
Abbildungen: S. 110; in der Ausstellung:
S. 73, S. 74/75

Nr. 60
Ads 2
Zimmerli
Digitaldruck
2004
83,3 x 58,2 x 2,9 cm
Abbildung: S. 112

Nr. 61
Ads 2
Bach Rescue Cream
Digitaldruck
2001
83,3 x 58,3 x 2,9 cm
Abbildungen: S. 108; in der Ausstellung: S. 73

Nr. 62
Ads 3
Maserati
Offset
2010
91,3 x 67,1 x 2,9 cm
Abbildungen: S. 159; in der Ausstellung: S. 73,
S. 74; im Frankfurter Stadtraum: S. 164-183

Nr. 63
Ads 3
Listerine
Offset
2010
91,2 x 67,3 x 2,9 cm
Abbildungen: S. 161; in der Ausstellung: S. 76/77;
im Frankfurter Stadtraum: S. 164-183

Nr. 64
Ads 3
Nike
Offset
2010
91,2 x 126,3 x 2,9 cm
Foto: Dieter Schwer
Abbildungen: S. 160; in der Ausstellung: S. 73;
im Frankfurter Stadtraum: S. 164-183

Nr. 65
Ads 3
Mykita/icberlin
Offset
2010
67,1 x 91,1 x 2,9 cm
Abbildungen: S. 162/163; in der Ausstellung:
S. 72; im Frankfurter Stadtraum: S. 164-183

Nr. 66
Ads 3
Robert Johnson
Offset
2010
126,2 x 91,3 x 2,9 cm
Foto: Dieter Schwer
Abbildungen: S. 158; im Frankfurter Stadtraum:
S. 164–183

Nr. 67
Ads 3
Clifford Chance
Offset
2010
67,2 x 91,3 x 2,9 cm
Abbildungen: S. 113; in der Ausstellung: S. 77
(Detail)

Unikatplakate

Nr. 68
PF!
Marker, Kugelschreiber, Tipp-Ex, Klebeband auf
Affichenpapier
2009/2010
101,3 x 65,3 x 2,9 cm

Nr. 69
NIE!
Marker, Kugelschreiber, Tipp-Ex, Klebeband auf
Affichenpapier
2009/2010
101,2 x 65,3 x 2,9 cm
Abbildung: S. 115

Nr. 70
NÖ! (rot)
Marker, Kugelschreiber, Tipp-Ex, Klebeband auf
Affichenpapier
2009/2010
94,3 x 67,5 x 2,9 cm

Nr. 71
ÖH!
Marker, Kugelschreiber, Tipp-Ex, Klebeband auf
Affichenpapier
2009/2010
101,5 x 65,2 x 2,9 cm
Abbildungen: S. 81

Nr. 72
NÖ! (braun)
Marker, Kugelschreiber, Tipp-Ex, Klebeband auf
Affichenpapier
2009/2010
101,5 x 65,3 x 2,9 cm
Abbildungen: S. 80

Nr. 73
HM!
Marker, Kugelschreiber, Tipp-Ex, Klebeband auf
Affichenpapier
2009/2010
101,5 x 65,3 x 2,9 cm
Abbildung: S. 80

Nr. 74
ÄH!
Marker, Kugelschreiber, Tipp-Ex, Klebeband auf
Affichenpapier
2009/2010
101,5 x 65,3 x 2,9 cm
Abbildung: S. 81

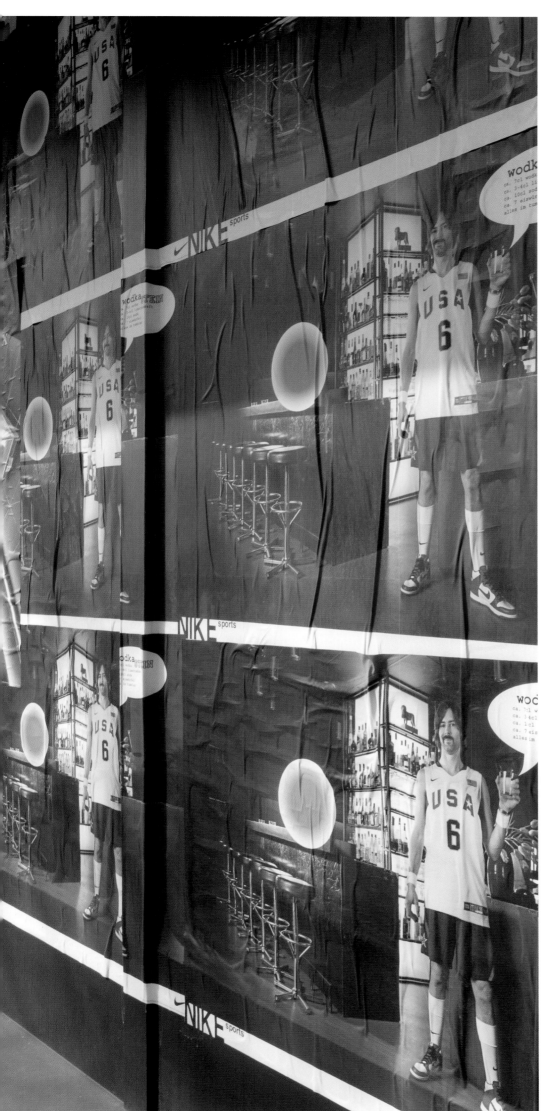

Buchkunst

Nr. 75
Tobias Rehberger — Hochhäuser, Felsen, Rudis,
Tore, Schäferhunde
Verlag: Edition Robert Wilk, Frankfurt am Main 1990
Hrsg: Robert Wilk
56 Seiten
Gestaltung: Tobias Rehberger
Beiträge: Marko Lehanka, Kasper König

Nr. 76
Tobias Rehberger — Ausstellung im Forum der
Frankfurter Sparkasse
Gesamtherstellung: P. R. Wilk, Friedrichsdorf
4 Seiten
Jahr: 1991

Nr. 77
Tobias Rehberger — Arbeitsamt Schwäbisch-Gmünd
Hrsg: O. Schweizer, Frankfurt am Main 1991
20 Seiten
Gestaltung: Alex Papadopoulou/Tobias Rehberger
Abbildung: S. 187

Nr. 78
Tobias Rehberger — Galerie Bärbel Grässlin
Hrsg: Galerie Bärbel Grässlin, Frankfurt am Main
1994
31 Seiten
Gestaltung: Alex Papadopoulou/Tobias Rehberger

Nr. 79
Tobias Rehberger — Ausstellung der Stipendiaten
der Frankfurter Künstlerhilfe e.V.
Frankfurt am Main 1994
18 Seiten
Gestaltung: Rahlwes/Rehberger
Abbildung: S. 186/187

Nr. 80
Tobias Rehberger/Jorge Pardo — Garnish
and Landscape
Verlag/Hrsg: Gesellschaft für Gegenwartskunst
Augsburg, Augsburg 1997
30 Seiten
Gestaltung: Pae White/Jorge Pardo/
Tobias Rehberger

Nr. 81
Tobias Rehberger
Moderna Museet Projekt — JP005 (Model for a Film)
Hrsg: Maria Lind — Moderna Museet, Stockholm
1997
36 Seiten
Gestaltung: Tomato London, Standard Rad.,
Frankfurt am Main/Tobias Rehberger
Beiträge: Ulrike Groos
ISBN: 91-7100-593-5

Nr. 82
Fama & Fortune Bulletin Heft 20 — Tobias
Rehberger, *2.6.66* (1984-1989)
Verlag: Pakesch & Schleebrügge, Wien 1997
Hrsg: Kasper König
46 Seiten
Gestaltung: Florian Waldvogel/Tobias Rehberger
Beiträge: Florian Waldvogel

Nr. 83
Tobias Rehberger — Kunsthalle Basel
Verlag: Schwabe & Co. AG, Basel 1998
Hrsg: Peter Pakesch
48 Seiten
Beiträge: Maria Lind
ISSN: 1421-1726

Nr. 84
Frankfurter Positionen 2001 — Tobias Rehberger
Hrsg: Florian Waldvogel; Portikus, Frankfurt am
Main, 2001
36 Seiten
Gestaltung: Tobias Rehberger
ISBN: 3-928071-53-X
Abbildung: S. 186/187

Nr. 85
Tobias Rehberger — 005-000 (Pocket Dictionary)
Verlag: Hatje Cantz Verlag, Ostfildern-Ruit 2001
Hrsg: Florian Matzner
100 Seiten
Gestaltung: Gabriele Sabolewski
Beiträge: Pier Luigi Tazzi, Daniel Birnbaum,
Markus Müller
ISBN: 3-7757-9046-2
Abbildung: S. 186

Nr. 86
Tobias Rehberger — treballant/trabajando/arbeitend
Hrsg: Fundacio „la Caixa", Barcelona 2002
40 Seiten
Gestaltung: b2 botey produccions de disseny/
Tobias Rehberger
ISBN: 84-7664-786-7

Nr. 87
Tobias Rehberger — applesandpears
Verlag: Walther König, Köln 2002
Hrsg: Jan Winkelmann, Susanne Gaensheimer u.a.
50 Seiten
Gestaltung: Standard Rad., Frankfurt am Main/
Tobias Rehberger
Beiträge: Jan Winkelmann
ISBN: 3-88375-426-9

Nr. 88
Tobias Rehberger — presçriçoes, descriçoes,
receitas e recibos
Hrsg: Fundaçao Serralves, 2002
24 Seiten
Gestaltung: Alex Papadopoulou, Standard Rad.,
Frankfurt am Main/Tobias Rehberger
Beiträge: Joao Fernandes, Maria de Lourdes
Modesto
ISBN: 972-739-105-2
Abbildung: S. 184

Nr. 89
Tobias Rehberger — Geläut — bis ichs hör...
Verlag: DuMont Literatur und Kunst Verlag Köln
Hrsg: Götz Adriani, 2002
240 Seiten
Gestaltung: Alex Papadopoulou/Tobias Rehberger
Beiträge: Ralph Melcher, Penelope Curtis
ISBN: 3-8321-7209-2

Nr. 90
Tobias Rehberger — Artist Book
Hrsg: SAMUSO Space for Contemporary Art, Seoul
2004
22 Seiten
Gestaltung: Baan Kim Sung Yeol/
Tobias Rehberger
ISBN: 89—956608—1-3
Abbildung: S. 187

Nr. 91
Tobias Rehberger — Private Matters, Whitechapel
Verlag: JRP Ringier Kunstverlag AG, Zürich 2004
Hrsg: Anthony Spira
57 Seiten
Gestaltung: Gavillet & Rust, Genf/
Tobias Rehberger
Beiträge: Iwona Blazwick, Rirkrit Tiravanija
ISBN: 2-940271-46-1

Nr. 92
Tobias Rehberger – I die every day. 1 Cor. 15, 31
Verlag: Ediciones Aldeasa, Madrid 2005
Hrsg: Ana Martin
192 Seiten
Gestaltung: Double Standards, Berlin/
Tobias Rehberger
Beiträge: Augustin Pérez Rubio, Chus Martinez,
Doris Mampe
ISBN: 84-8026-272-9

Nr. 93
Tobias Rehberger– OnSolo
Verlag: Progetto Prada Arte, Milan 2007
Hrsg: Germano Celant
288 Seiten
Gestaltung: Double Standards, Berlin/
Tobias Rehberger
ISBN: 88-87029-39-3
Abbildung: S. 185

Nr. 94
Tobias Rehberger – 1993-2008
Verlag: Dumont Buchverlag
Köln 2008
Hrsg: Uta Grosenick
260 Seiten
Gestaltung: v.e.r.y., Frankfurt am Main/
Tobias Rehberger
Beiträge: Daniel Birnbaum, Lars Bang Larsen,
Claire Rose
ISBN: 978-3-8321-9126-9
Abbildung: S. 185

Nr. 95
Public – Tobias Rehberger 1997-2009
Verlag: Wienand Verlag, Köln 2009
Hrsg: Ulrike Lorenz
106 Seiten
Gestaltung: v.e.r.y., Frankfurt am Main/
Tobias Rehberger
ISBN: 978-3-86832-016-9
Abbildung: S. 185

Nr. 96
Tobias Rehberger – COPyBrAIN
Verlag: DuMont Buchverlag, Köln 2009
Hrsg: Staatliche Kunsthalle Baden-Baden
336 Seiten
Gestaltung: v.e.r.y. Frankfurt am Main/
Tobias Rehberger
ISBN: 978-3-9321-9315-7
Abbildung: S. 185

Nr. 97
Paradise – Tobias Rehberger
Verlag: onestar presse, Paris 2009
Hrsg: Christophe Boutin und Mélanie Scarciglia
150 Seiten
Gestaltung: Tobias Rehberger
Abbildung: S. 187

Works on Exhibition
Wall Paintings

No. 1
Children Suffer the Most*
*not always entirely correct
Acrylic, brush
Size variable
Courtesy GGNGrafik Frankfurt
Illustrations: design: pp. 124/125; in the exhibition:
p. 9 (detail), p. 11 (detail), p. 17, p. 24, pp. 26/27,
pp. 28/29

No. 2
New Germany 1
Acrylic, brush and spray paint
2006
Size variable
Courtesy Neugerriemschneider, Berlin
Illustrations: design: pp. 116/117; in the exhibition:
p. 18, pp. 20/21, pp. 30/31, p. 52

No. 3
Two Chairs
Acrylic, brush and spray paint
2006
Size variable
Courtesy Neugerriemschneider, Berlin
Illustrations: design: pp. 118/119; in the exhibition:
pp. 30/31, p. 42, pp. 44/45, p. 47, p. 49 (detail),
p. 57

No. 4
Seven Naked Hermann Hesse Fans
Acrylic, brush and spray paint
2006
Size variable
Courtesy Neugerriemschneider, Berlin
Illustrations: design: pp. 128/129; in the exhibition:
p. 33, pp. 34/35, pp. 36/37, pp. 40/41,
pp. 42/43, p. 45 (detail)

No. 5
I Don't Like Music I Have No Sense of Humour and
To Be Honest Social Injustices Don't Particularly
Bother Me
Acrylic, brush and spray paint
2006
Size variable
Courtesy GGNGrafik Frankfurt
Illustrations: design: pp. 126/127; in the exhibition:
p. 35, pp. 38/39

No. 6
Horrible Flute Player
Acrylic, brush and spray paint
2006
Size variable
Courtesy Neugerriemschneider, Berlin
Illustrations: design: pp. 120/121; in the exhibition:
p. 15 (detail), p. 16, pp. 18/19, p. 31 (detail),
pp. 32/33, p. 34, p. 50 (detail)

No. 7
Oranges from Eden
Acrylic, brush and spray paint
2006
Size variable
Courtesy Neugerriemschneider, Berlin
Illustrations: design: pp. 122/123; in the exhibition:
pp. 12/13, p. 14 (detail), p. 33, p. 34, p. 46,
pp. 48/49, pp. 50/51, p. 55, pp. 56/57 (detail)

No. 8
Translator
Acrylic and spray paint
2002
Size variable
Illustrations: in the exhibition: pp. 14/15, p. 16
(detail)

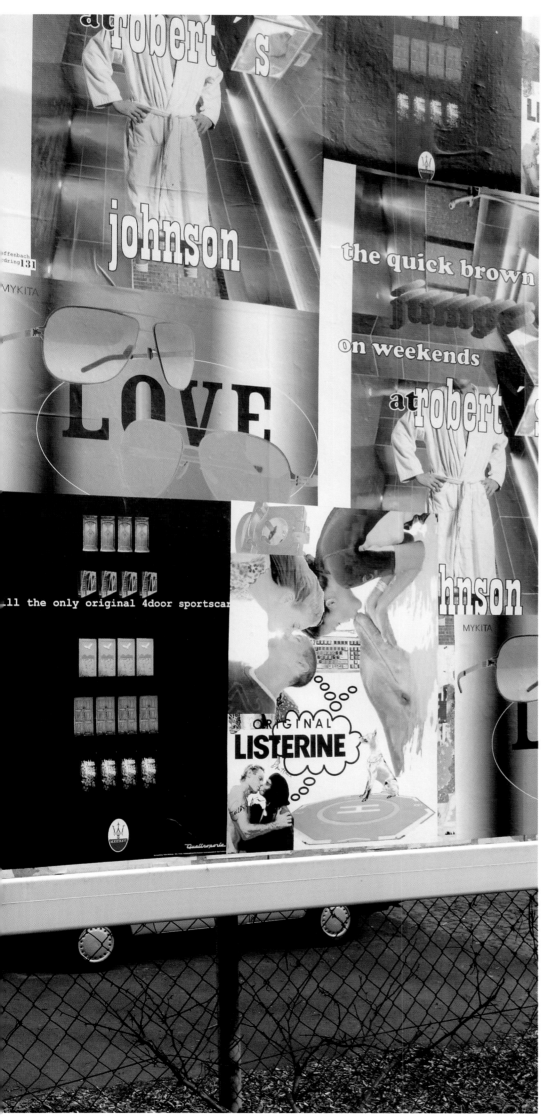

Wallpaper

No. 9
Wallpaper of the installation
UP On 1–5
Digital print
2004
Courtesy Neugerriemschneider, Berlin
Illustrations: in the exhibition: p. 8, p. 10, p. 54,
pp. 56–59, p. 61, p. 84

Posters

No. 10
Highrises, Rocks, Rudis
Berufsverband Bildender Künstler, Stapelhaus,
Cologne
Silkscreen
1990
49.8 x 69.8 cm
Illustrations: p. 86; in the exhibition:
p. 56 (detail), pp. 58/59, p. 61

No. 11
Cancelled Projects
Museum Fridericianum Kassel
Offset
1995
DIN A1
Illustrations: p. 88; in the exhibition: p. 60, p. 63

No. 12
Suggestions from the Visitors of the Shows #74
and #75
Portikus, Frankfurt am Main
Offset
1996
DIN A1
Illustrations: p. 92; in the exhibition: p. 60, p. 63

No. 13
Bar Münster
Digital print
1997
DIN A1
Illustrations: p. 104; in the exhibition: p. 60, p. 63

No. 14
Standard Rad.
Transmission
Gallery Glasgow
Offset
1999
DIN A2
Illustrations: p. 94; in the exhibition: p. 61, p. 84

No. 15
Ringing Until I Hear It ...
MNK Karlsruhe 2003
Offset
2003
DIN A1
Illustrations: p. 93; in the exhibition: p. 60, p. 63

No. 16
Don't Work Too Much
Offset
2003
DIN A1
Illustrations: p. 105; in the exhibition: p. 60, p. 63

No. 17
90 Minutes
Offsetdruck
2004
97 x 66.4 cm
Illustrations: p. 107; in the exhibition: p. 61

No. 18
Please Thank You
Galerie der Stadt Stuttgart
Offset
2004
DIN A1
Illustrations: p. 106; in the exhibition: p. 63

No. 19
Cooperation Tobias Rehberger and Chris Rehberger
The Chicken-and-Egg-No-Problem Wall-Painting
Stedelijk Museum Amsterdam
Offset tbc
2008
DIN A2
Illustrations: p. 132; in the exhibition: p. 61

No. 20
Cooperation Tobias Rehberger and Chris Rehberger
The Chicken-and-Egg-No-Problem-Wall-Painting
Museum Ludwig
Offset tbc
2008
DIN A1
Illustrations: p. 133; in the exhibition: p. 58, p. 61

No. 21
My Time Is Not Your Time
Kunstraum Innsbruck
Offset
2009
DIN A1
Illustrations: p. 155; in the exhibition: p. 56, p. 59,
p. 61

No. 22
Paradise Bookshelf
Offset
2009
DIN A1
Illustrations: p. 142; in the exhibition: p. 84

No. 23
Cooperation Tobias Rehberger and Chris Rehberger
Talks on Art, Leipzig Fair
25 October
Offset tbc
1995
DIN A1
Illustration: p. 89

No. 24
Cooperation Tobias Rehberger and Chris Rehberger
Talks on Art, Leipzig Fair
18 December
Offset tbc
1995
DIN A1
Illustration: p. 87

No. 25
Cooperation Tobias Rehberger and Chris Rehberger
Talks on Art, Leipzig Fair
21 May
Offset tbc
1995/1996
DIN A1
Illustration: p. 90

No. 26
Cooperation Tobias Rehberger and Chris Rehberger
Talks on Art, Leipzig Fair
17 January
Offset tbc
1995/1996
DIN A1
Illustration: p. 91

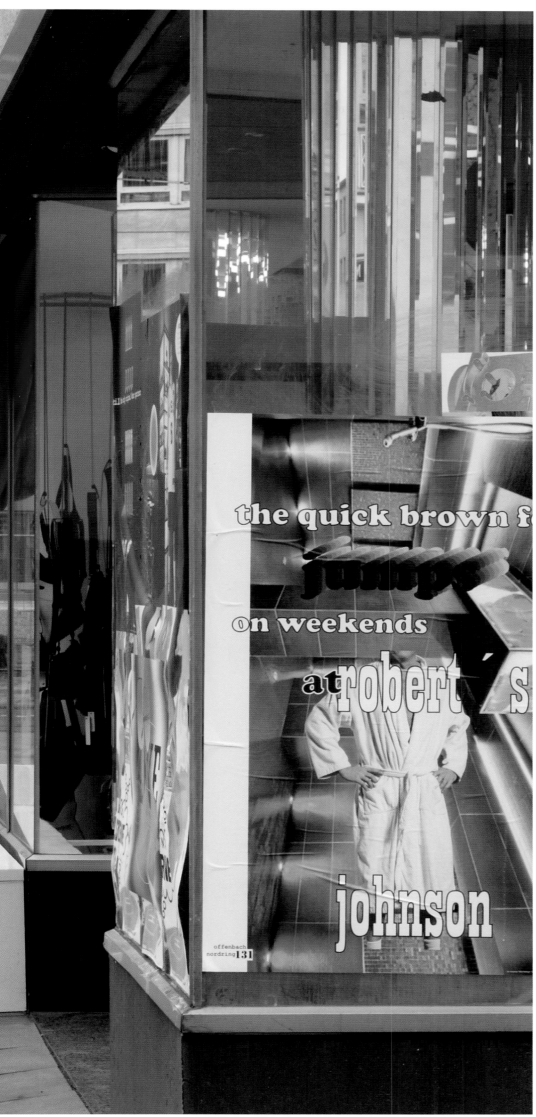

On Otto

No. 27
On Otto
(Poster as first production step in art project)
2007
Offset
DIN A0
Courtesy Fondazione Prada Mailand
Illustrations: p. 131; in the exhibition: p. 68, p. 70

No. 28
Cooperation Tobias Rehberger and
Chris Rehberger
On Otto
Exhibition poster Fondazione Prada Mailand
2007
Offset
199.4 x 138.7 cm
Illustrations: p. 130; in the exhibition: p. 68, p. 70

No. 29
Cooperation Tobias Rehberger and Florian Markl
On Otto
Titles
Digital print on photo rag
2009
100 x 70 cm
Courtesy Edition Schellmann
Illustrations: p. 144; in the exhibition: p. 64

No. 30
Cooperation Tobias Rehberger and Florian Markl
On Otto
Sound
Digital print on photo rag
Druck Recom Art, Ostfildern
2009
100 x 70 cm
Courtesy Edition Schellmann
Illustrations: p. 146; in the exhibition: p. 64,
p. 67 (detail)

No. 31
Cooperation Tobias Rehberger and Florian Markl
On Otto
Music
Digital print on photo rag
Druck Recom Art, Ostfildern
2009
100 x 70 cm
Courtesy Edition Schellmann
Illustrations: p. 152; in the exhibition: p. 64

No. 32
Cooperation Tobias Rehberger and Florian Markl
On Otto
Editing
Digital print on photo rag
Druck Recom Art, Ostfildern
2009
100 x 70 cm
Courtesy Edition Schellmann
Illustrations: p. 154; in the exhibition: p. 62, p. 65

No. 33
Cooperation Tobias Rehberger and Florian Markl
On Otto
Cinematography
Digital print on photo rag
Druck Recom Art, Ostfildern
2009
100 x 70 cm
Courtesy Edition Schellmann
Illustrations: p. 153; in the exhibition: p. 67

No. 34
Cooperation Tobias Rehberger and Florian Markl
On Otto
Actors
Digital print on photo rag
Druck Recom Art, Ostfildern
2009
100 x 70 cm
Courtesy Edition Schellmann
Illustration: p. 148

No. 35
Cooperation Tobias Rehberger and Florian Markl
On Otto
Production Design
Digital print on photo rag
Druck Recom Art, Ostfildern
2009
100 x 70 cm
Courtesy Edition Schellmann
Illustrations: p. 147; in the exhibition: p. 62, p. 65

No. 36
Cooperation Tobias Rehberger and Florian Markl
On Otto
Costume Design
Digital print on photo rag
Druck Recom Art, Ostfildern
2009
100 x 70 cm
Courtesy Edition Schellmann
Illustration: p. 151

No. 37
Cooperation Tobias Rehberger and Florian Markl
On Otto
Story Board
Digital print on photo rag
Druck Recom Art, Ostfildern
2009
100 x 70 cm
Courtesy Edition Schellmann
Illustrations: p. 145; in the exhibition: p. 64

No. 38
Cooperation Tobias Rehberger and Florian Markl
On Otto
Script
Digital print on photo rag
Druck Recom Art, Ostfildern
2009
100 x 70 cm
Courtesy Edition Schellmann
Illustrations: p. 150; in the exhibition: p. 62, p. 65

No. 39 — No. 47
Nine poster motifs for the 2009 Venice Art
Biennale/Bar Cafeteria Palazzo delle Esposizioni
Giardini, offset print on coloured and white poster
paper, DIN A1 or DIN A0
Illustrations: pp. 134-41; in the exhibition:
pp. 82-85

Ads

No. 48
First Ads
Bauer Mann
Offset
2001
107.2 x 77.4 x 2.9 cm
Illustrations: p. 102; in the exhibition:
p. 75 (detail), p. 76

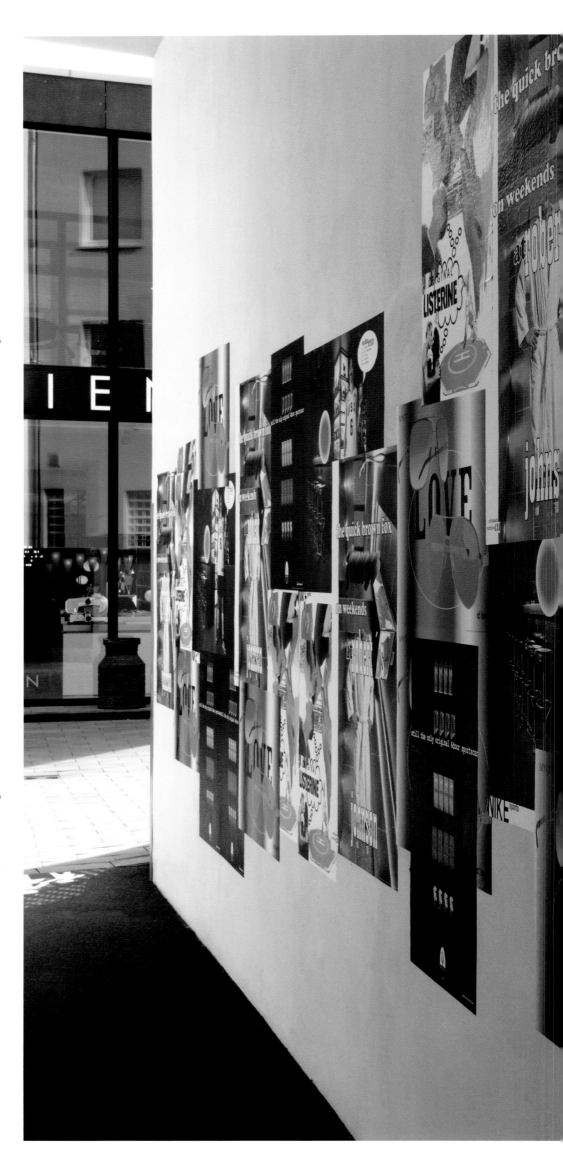

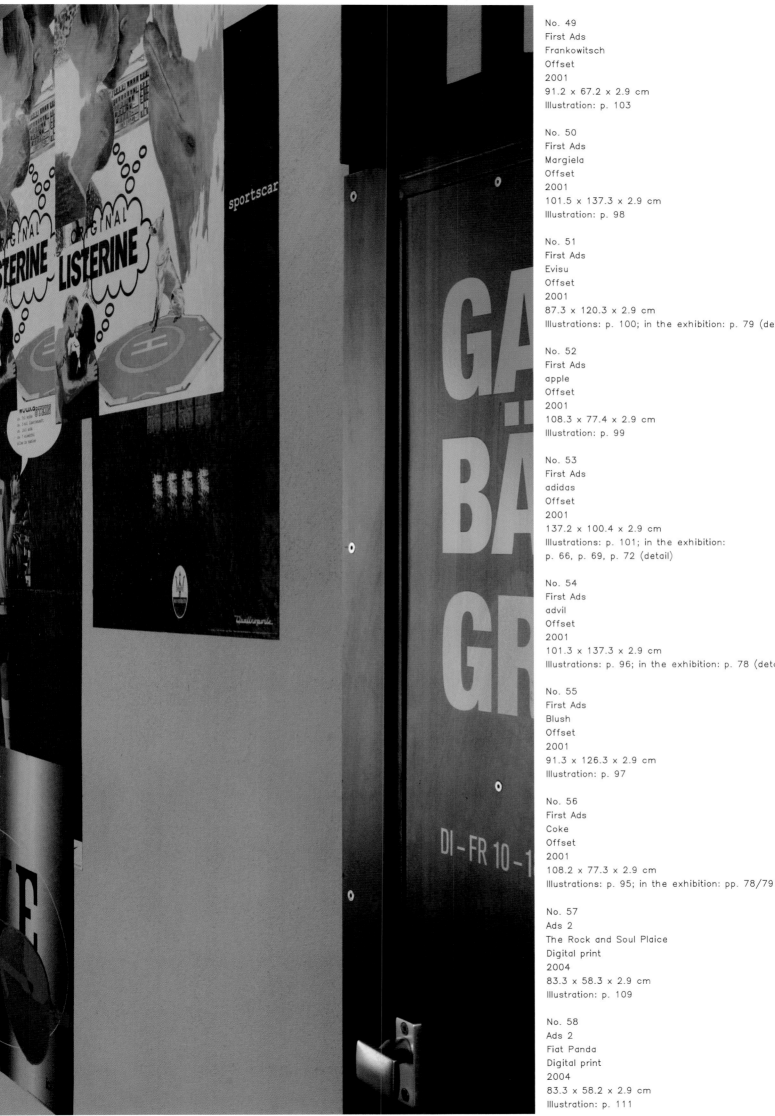

No. 49
First Ads
Frankowitsch
Offset
2001
91.2 x 67.2 x 2.9 cm
Illustration: p. 103

No. 50
First Ads
Margiela
Offset
2001
101.5 x 137.3 x 2.9 cm
Illustration: p. 98

No. 51
First Ads
Evisu
Offset
2001
87.3 x 120.3 x 2.9 cm
Illustrations: p. 100; in the exhibition: p. 79 (detail)

No. 52
First Ads
apple
Offset
2001
108.3 x 77.4 x 2.9 cm
Illustration: p. 99

No. 53
First Ads
adidas
Offset
2001
137.2 x 100.4 x 2.9 cm
Illustrations: p. 101; in the exhibition:
p. 66, p. 69, p. 72 (detail)

No. 54
First Ads
advil
Offset
2001
101.3 x 137.3 x 2.9 cm
Illustrations: p. 96; in the exhibition: p. 78 (detail)

No. 55
First Ads
Blush
Offset
2001
91.3 x 126.3 x 2.9 cm
Illustration: p. 97

No. 56
First Ads
Coke
Offset
2001
108.2 x 77.3 x 2.9 cm
Illustrations: p. 95; in the exhibition: pp. 78/79

No. 57
Ads 2
The Rock and Soul Plaice
Digital print
2004
83.3 x 58.3 x 2.9 cm
Illustration: p. 109

No. 58
Ads 2
Fiat Panda
Digital print
2004
83.3 x 58.2 x 2.9 cm
Illustration: p. 111

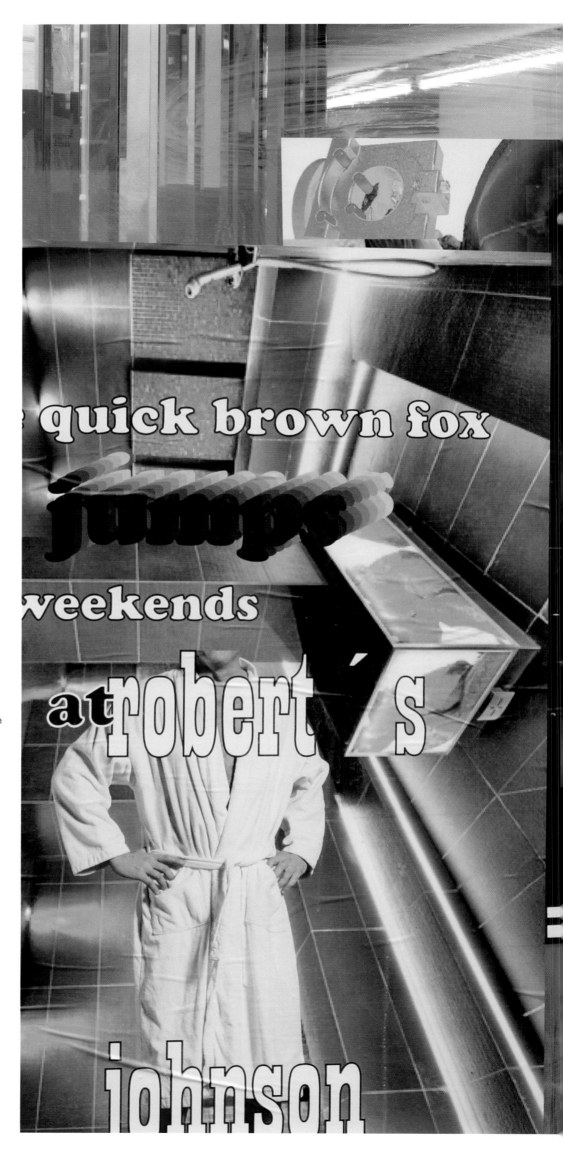

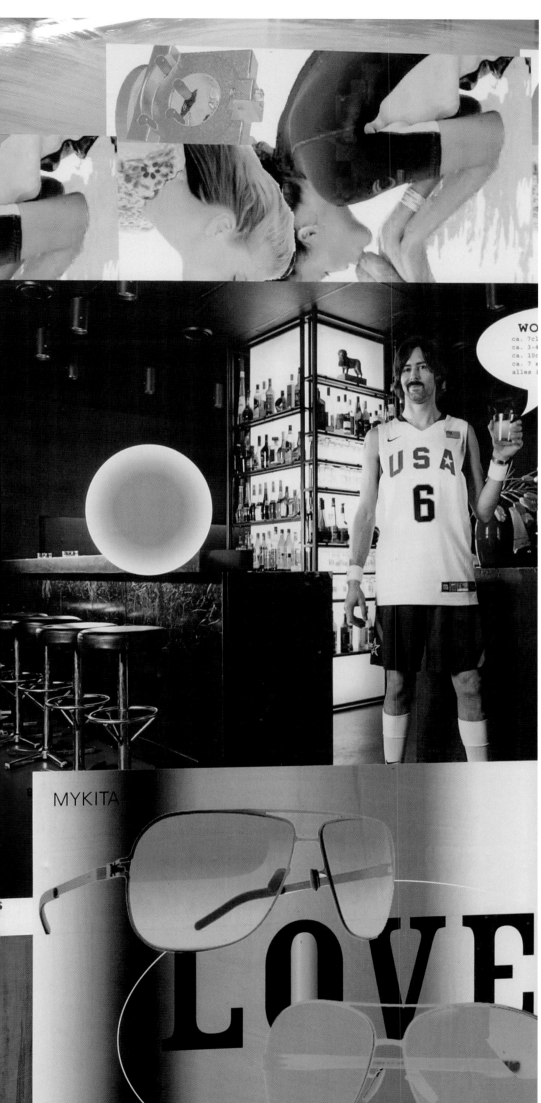

Single-Copy Posters

No. 68
PF!
Marker, ballpoint pen, white-out, tape on poster paper
2009/2010
101.3 x 65.3 x 2.9 cm

No. 69
NIE!
Marker, ballpoint pen, white-out, tape on poster paper
2009/2010
101.2 x 65.3 x 2.9 cm
Illustration: pp. 115

No. 70
NÖ! (red)
Marker, ballpoint pen, white-out, tape on poster paper
2009/2010
94.3 x 67.5 x 2.9 cm

No. 71
ÖH!
Marker, ballpoint pen, white-out, tape on poster paper
2009/2010
101.5 x 65.2 x 2.9 cm
Illustrations: p. 81

No. 72
NÖ! (brown)
Marker, ballpoint pen, white-out, tape on poster paper
2009/2010
101.5 x 65.3 x 2.9 cm
Illustrations: p. 80

No. 73
HM!
Marker, ballpoint pen, white-out, tape on poster paper
2009/2010
101.5 x 65.3 x 2.9 cm
Illustration: p. 80

No. 74
ÄH!
Marker, ballpoint pen, white-out, tape on poster paper
2009/2010
101.5 x 65.3 x 2.9 cm
Illustration: p. 81

Book Art

No. 75
Tobias Rehberger — Highrises, Rocks, Rudis,
Goals, German Shepherds
Publisher: Edition Robert Wilk, Frankfurt am Main,
1990
Editor: Robert Wilk
56 pages
Design: Tobias Rehberger
Contributions: Marko Lehanka, Kasper König

No. 76
Tobias Rehberger — Exhibition at Frankfurter
Sparkasse Forum
Overall production: P. R. Wilk, Friedrichsdorf
4 pages
Year: 1991

No. 77
Tobias Rehberger — Employment Office
Schwäbisch-Gmünd
Editor: O. Schweizer, Frankfurt am Main, 1991
20 pages
Design: Alex Papadopoulou/Tobias Rehberger
Illustration: p. 187

No. 78
Tobias Rehberger — Galerie Bärbel Grässlin
Editor: Galerie Bärbel Grässlin, Frankfurt am Main,
1994
31 pages
Design: Alex Papadopoulou/Tobias Rehberger

No. 79
Tobias Rehberger — Grant Recipients' Exhibition,
Frankfurter Künstlerhilfe e.V.
Frankfurt am Main, 1994
18 pages
Design: Rahlwes/Rehberger
Illustration: pp. 186/187

No. 80
Tobias Rehberger/Jorge Pardo — Garnish and
Landscape
Publisher/editor: Gesellschaft für Gegenwartskunst
Augsburg, Augsburg, 1997
30 pages
Design: Pae White/Jorge Pardo/
Tobias Rehberger

No. 81
Tobias Rehberger
Moderna Museet Projekt — JP005 (Model for
a Film)
Editor: Maria Lind; Moderna Museet, Stockholm, 1997
36 pages
Design: Tomato London, Standard Rad., Frankfurt am
Main/Tobias Rehberger
Contributions: Ulrike Groos
ISBN: 91-7100-593-5

No. 82
Fama & Fortune Bulletin No. 20 —
Tobias Rehberger, *2.6.66* (1984—89)
Publisher: Pakesch & Schleebrügge, Vienna, 1997
Editor: Kasper König
46 pages
Design: Florian Waldvogel/Tobias Rehberger
Contributions: Florian Waldvogel

No. 83
Tobias Rehberger — Kunsthalle Basel
Publisher: Schwabe & Co. AG, Basel, 1998
Editor: Peter Pakesch
48 pages
Contributions: Maria Lind
ISSN: 1421-1726

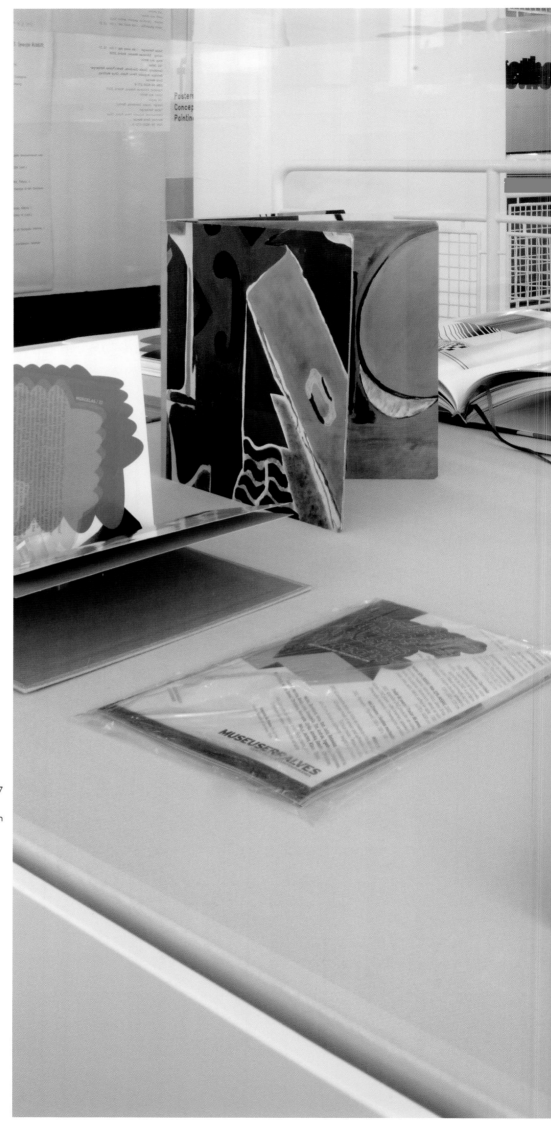

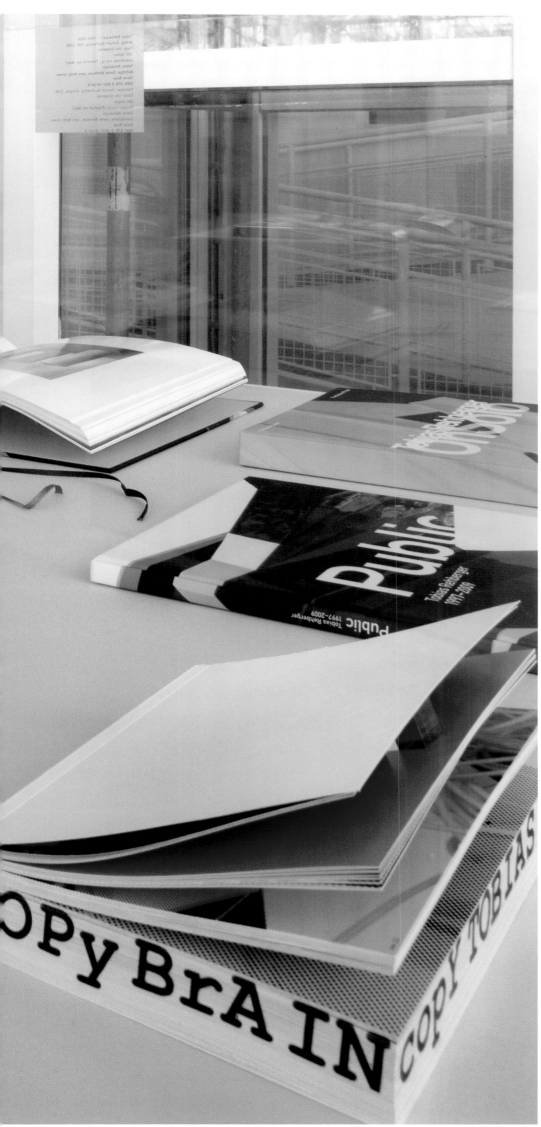

No. 84
Frankfurt Positions 2001 — Tobias Rehberger
Editor: Florian Waldvogel; Portikus, Frankfurt am
Main, 2001
36 pages
Design: Tobias Rehberger
ISBN: 3-928071-53-X
Illustration: pp. 186/187

No. 85
Tobias Rehberger — 005-000 (Pocket Dictionary)
Publisher: Hatje Cantz Verlag, Ostfildern-Ruit, 2001
Editor: Florian Matzner
100 pages
Design: Gabriele Sabolewski
Contributions: Pier Luigi Tazzi, Daniel Birnbaum,
Markus Müller
ISBN: 3-7757-9046-2
Illustration: p. 186

No. 86
Tobias Rehberger —
treballant/trabajando/arbeitend (working)
Editor: Fundacio "la Caixa", Barcelona, 2002
40 pages
Design: b2 botey produccions de disseny/
Tobias Rehberger
ISBN: 84-7664-786-7

No. 87
Tobias Rehberger — applesandpears
Publisher: Walther König, Cologne, 2002
Editor: Jan Winkelmann, Susanne Gaensheimer et al.
50 pages
Design: Standard Rad., Frankfurt am Main/
Tobias Rehberger
Contributions: Jan Winkelmann
ISBN: 3-88375-426-9

No. 88
Tobias Rehberger — presçrições, descrições,
receitas e recibos
Editor: Fundação Serralves, 2002
24 pages
Design: Alex Papadopoulou, Standard Rad.,
Frankfurt am Main/Tobias Rehberger
Contributions: João Fernandes, Maria de Lourdes
Modesto
ISBN: 972-739-105-2
Illustration: p. 184

No. 89
Tobias Rehberger — Ringing Until I Hear It ...
Publisher: DuMont Literatur und Kunst Verlag
Cologne
Editor: Götz Adriani, 2002
240 pages
Design: Alex Papadopoulou/Tobias Rehberger
Contributions: Ralph Melcher, Penelope Curtis
ISBN: 3-8321-7209-2

No. 90
Tobias Rehberger — Artist Book
Editor: SAMUSO Space for Contemporary Art, Seoul,
2004
22 pages
Design: Baan Kim Sung Yeol/Tobias Rehberger
ISBN: 89-956608-1-3
Illustration: p. 187

No. 91
Tobias Rehberger — Private Matters, Whitechapel
Publisher: JRP Ringier Kunstverlag AG, Zurich, 2004
Editor: Anthony Spira
57 pages
Design: Gavillet & Rust, Geneva/
Tobias Rehberger
Contributions: Iwona Blazwick, Rirkrit Tiravanija
ISBN: 2-940271-46-1

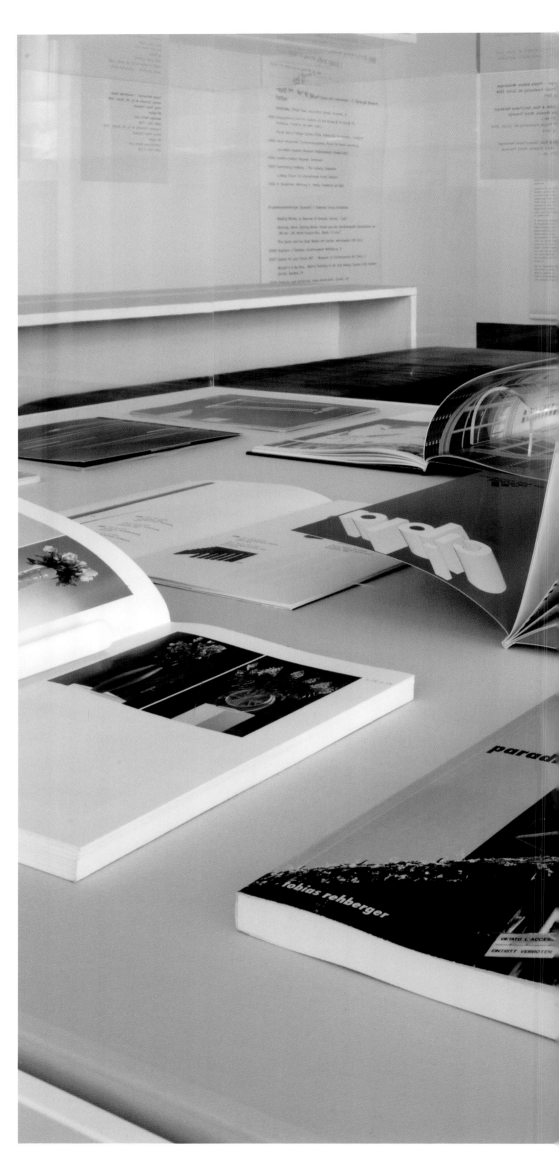

Tobias Rehberger

geboren/born in 1966 Esslingen/Neckar, Germany

Hochschule für Bildende Kunst, Frankfurt am Main, Germany

lebt/lives in Frankfurt am Main, Germany

Einzelausstellungen/Solo Exhibitions

2009
Hector Kunstpreis 2009, Kunsthalle Mannheim, D
Hans Thoma-Preis 2009, Bernau, D
Laying battery, Galeria Pedro Cera, Lissabon, P
I spent a lot of money on booze, birds and fast
cars. The rest I just squandered, Musée
Rochechouart, Rochechouart, F
Cuckoo Clock Shop, Pilar Corrias, London, GB
...my time is not your time, Kunstraum Innsbruck,
Innsbruck, A
Fragments of their pleasant spaces
(in my fashionable version) — the winter collection,
Galerie Bärbel Grässlin, Frankfurt am Main, D

2008
the-chicken-and-egg-no-problem wall-painting,
Stedelijk Museum CS Amsterdam, Amsterdam, NL
Die „Das-kein-Henne-Ei-Problem"-Wandmalerei,
Museum Ludwig, Cologne, D
sceiß nazis, Galería Heinrich Ehrhardt, Madrid, E

2007
On Otto, Fondazione Prada, Milan, I (Cat.)

2006
Ah Non, Je Ne Fais Plus Ça, Dépendance, Brussels, B
Seven Naked Hermann Hesse Fans and other
Gems, Haunch of Venison, London, GB
American Traitor Bitch, Friedrich Petzel Gallery,
New York/NY, USA
Utterances of a quiet, sensitive, religious, serious,
progressive, young man, who presumes from his
deep inner conviction that he is serving a good
cause, Galerie Bärbel Grässlin, Frankfurt am Main, D
Negatives of a Daily Death, Galerie Micheline
Szwajcer, Antwerp, B

2005
I die every day, I Cor. 15,31, Palacio de Cristal,
Museo Nacional Centro de Arte Reina Sofia, Madrid,
E (Cat.)
Nieder mit dem Imperialismus und andere Rahmen
und Sockel.
Entwürfe, Zeichnungen, Modelle, Hospitalhof
Stuttgart, Stuttgart, D (Cat.)
Heaven's Gate 2, Galleria Giò Marconi, Milan, I

2004
Half the Truth, neugerriemschneider, Berlin, D
Private Matters, Whitechapel Gallery, London, GB (Cat.)
Tobias Rehberger, Artsonje Center, Seoul, ROK

2003
Tobias Rehberger: New Works, Galerie Ghislaine
Hussenot, Paris, F
„bitte danke", Arbeiten von Tobias Rehberger aus
der Sammlung Landesbank Baden-Württemberg,
Galerie der Stadt Stuttgart, Stuttgart, D (Cat.)
Karl-Ströher-Preis 2003: Tobias Rehberger,
Museum für Moderne Kunst, Frankfurt am Main, D
Main Interiors, Galerie Micheline Szwajcer, Antwerp, B
Die Zähne sind in Ordnung, aber das Zahnfleisch
geht zurück, Galería Heinrich Ehrhardt, Madrid, E

2002
Prescrições, descrições, receitas e recibos, Museu
Serralves — Museu de Arte Contemporânea, Porto, P
Night Shift, Palais de Tokyo, Paris, F
treballant/trabajando/arbeitend, Sala Montcada,
Fundació „La Caixa", Barcelona, E (Cat.)
Deaddies, Galleria Civica d'Arte Moderna e
Contemporanea, Turine, I (Cat.)
Geläut — bis ichs hör ..., Museum für Neue
Kunst/ZKM, Karlsruhe, D (Cat.)
Mütter innen, von aussen, Galerie Bärbel Grässlin,
Frankfurt am Main, D

2001
Tobias Rehberger. ads, Galerie & Edition Artelier,
Graz, A
Do Not Eat Industrially Produced Eggs, Förderpreis
zum Internationalen Preis des Landes Baden-
Württemberg, Staatliche Kunsthalle, Baden-Baden, D
DIX-Preis 2001, Kunstsammlung Gera — Orangerie,
Gera, D
Tobias Rehberger. Luci diffuse, Viafarini, Milan, I

2000
... (whenever you need me), Westfälischer
Kunstverein, Münster, D (Cat.)
nana, neugerriemschneider, Berlin, D
dusk, Galleria Giò Marconi, Milan, I
The Sun from Above, Museum of Contemporary Art,
Chicago, USA
Tobias Rehberger, Galerie Ghislaine Hussenot,
Paris, F
Seascapes and other portraits, FRAC Nord-Pas de
Calais, Dunkerque, F
Jack Lemmon's Legs and Other Libraries, Friedrich
Petzel Gallery, New York/NY, USA

1999
The Secret Bulb in Barry L., Galerie für
Zeitgenössische Kunst, Leipzig, D (Cat.)
The Improvement of the Idyllic, Galería Heinrich
Ehrhardt, Madrid, E
Sunny-side up, Matrix 180, University of California
Berkeley Art Museum and Pacific Film Archive,
Berkeley/CA, USA
Holiday-Weekend-Leisure, Time-Wombs, Galerie
Micheline Szwajcer, Antwerp, B
fragments of their pleasant spaces (in my
fashionable version), Galerie Bärbel Grässlin,
Frankfurt am Main, D
Standard Rad. Transmission, Gallery Glasgow, UK
Nightprowler, De Vleeshal, Middelburg, NL

1998
MMP: Tobias Rehberger, Moderna Museet,
Stockholm, S (Cat.)
Tobias Rehberger, Kunsthalle Basel, Basle, CH (Cat.)
Waiting Room — Also? Wir gehen? Gehen wir!,
Intervention 13, Sprengel Museum, Hanover, D
On the Desperate and Long Neclected Need for
Small Events, Office Tower Manhattan Project III,
Roomade Office for Contemporary Art, Brussels, B

1997
brâncusi, neugerriemschneider, Berlin, D
anastasia, Friedrich Petzel Gallery, New York/NY,
USA

1996
Suggestions from the Visitors of the Shows #74
and #75, Portikus, Frankfurt am Main, D (Cat.)
Peuè Seèe e Faàgck Sunday Paàe, Kölnischer
Kunstverein, Cologne, D
fragments of their pleasant spaces (in my
fashionable version),
Galerie Bärbel Grässlin, Frankfurt am Main, D

1995
9 Skulpturen, Produzentengalerie, Raum für Kunst,
Hamburg, D

Wo man is gout loogy luckie, Hammelehle +
Ahrens, Stuttgart, D
cancelled projects, Kunsthalle Fridericianum,
Kassel, D (Cat.)
one, neugerriemschneider, Berlin, D

1994
Rehbergerst, Galerie Bärbel Grässlin, Frankfurt am
Main, D (Cat.)
Tobias Rehberger, Galerie Luis Campaña, Cologne, D
Tobias Rehberger, Galerie & Edition Artelier, Graz, A
Tobias Rehberger, Goethe-Institut Yaoundé,
Cameroon, CM

1993
Sammlung Goldberg/The Iceberg Collection, Ludwig
Forum für Internationale Kunst, Aachen, D

1992
9 Skulpturen, Wohnung Kasper König, Frankfurt am
Main, D

1991
Tobias Rehberger, Forum der Stadtsparkasse
Frankfurt, Frankfurt am Main, D

1990
Hochhäuser, Felsen, Rudis, Berufsverband
Bildender Künstler, Stapelhaus, Cologne, D (Cat.)

Gruppenausstellungen/Group Exhibitions

2009
FAX, Drawing Center and ICI (Independent Curators
International), New York, USA (Cat.)
just what it is..., ZKM I Museum für Neue Kunst,
Karlsruhe, D
Licht!, Gesellschaft für Gegenwartskunst e.V.,
Toskanische Säulenhalle im Zeughaus, Augsburg, D
Entre deux actes — Loge de Comédienne,
Staatliche Kunsthalle Baden-Baden, Baden-Baden, D
RETREAT, KunstFort Asperen, Beesd, NL
Fare Mondi, La Biennale die Venezia, 53.
Esposizione Internazionale d'Arte, Venedig, I
Sechzig Jahre. Sechzig Werke. Kunst aus der
Bundesrepublik Deutschland von '49 bis '09,
Martin-Gropius-Bau, Berlin, D (Cat.)
The Quick and the Dead, Walker Art Center,
Minneapolis, USA (Cat.)
Instant Melancholia — Zum Abschied vom
Polaroidfoto, Raum 121, Frankfurt am Main, D
Modellstück, arp museum Bahnhof Rolandseck,
Remagen, D
Extended. Sammlung Landesbank Baden-
Württemberg, ZKM, Museum für neue Kunst,
Karlsruhe, D
KölnSkulptur 5, Skulpturenpark Köln, Cologne, D
Social Sculpture, Whitechapel Gallery, London, GB
Yellow and Green, Museum für Moderne Kunst,
Frankfurt am Main, D

2008
Wouldn't It Be Nice ... Wishful Thinking in Art and
Design, Museum für Gestaltung, Zurich, CH

2007
Winter Palace, De Ateliers, Amsterdam, NL
Signs and Messages from Modern Life, Kate MacGarry,
London, UK
Serralves Foundation Collection Sculpture, Museu
Serralves — Museu De Arte Contemporanea, Porto, P

Space for your Future, MOT — Museum of Contemporary Art, Tokyo, JPN
Wouldn't It Be Nice ... Wishful Thinking in Art and Design, Centre d'Art Contemporain, Geneva, CH
Tomorrow, Artsonje Center, Seoul, ROK
Existencias, MUSAC — Museo de Arte Contemporáneo de Castilla y Leon, Leon, E
La Città Che Sale, ARCOS — Museo di Arte Contemporanea Del Sannio, Benevento, I
MACRO FUTURE — Museo d'Arte Contemporanea Roma, Rome, I
Disorder in the House, VanhaerentsArtCollection, Brussels, B
Design for Living, Initial Access, Wolverhampton, GB
Verlorene Liebesmüh, Westfälisches Landesmuseum für Kultur und Kulturgeschichte, Münster, D
Deutsche Geschichten, Galerie für Zeitgenössische Kunst, Leipzig, D
Modelle für Morgen, European Kunsthalle Köln, Cologne, Köln, D (Cat.)
Dependance at Galerie Neu, Galerie NEU, Berlin, D

2006
ON/OFF, Saarlandmuseum, Saarbrücken, D (Cat.)
Einmal Empire und zurück, Westfälischer Kunstverein, Münster, D
Personal Affairs. Neue Formen der Intimität, Museum Morsbroich, Leverkusen, D (Cat.)
Mathilda is calling, Institut Mathildenhöhe, Darmstadt, D (Cat.)
Ordnung und Verführung, Haus Konstruktiv — Stiftung für konstruktive und konkrete Kunst, Zurich, CH
Kunst lebt! Die Welt mit anderen Augen sehen, Kunstgebäude Stuttgart, Stuttgart, D (Cat.)
Drive. Cars in Contemporary Art, Galleria d'Arte Moderna, Bologna, I
Dialog Skulptur. Zeichnungen und Skulpturen aus der Sammlung Deutsche Bank, Kunstverein Ludwigshafen, Ludwigshafen, D, and Mannheimer Kunstverein, Mannheim, D
Folkwang Atoll. Kunst & Energie, Whitebox, Kultfabrik, Munich, D
Franz West sense Franz West, Centre d'Art Santa Mònica, Barcelona, E
Mapping the Studio, The Land Foundation, Stedelijk Museum CS Amsterdam, Amsterdam, NL
H2. Die Sammlung I, Zentrum für Gegenwartskunst im Glaspalast, Augsburg, D
Kunst und Fußball im Deutschen Bundestag, Kunst-Raum im Deutschen Bundestag, Berlin, D
Anstoß Berlin. Kunst Macht Welt, Haus am Waldsee, Berlin, D (Cat.)
Drive-In. Kutschen, Oldtimer + Kunst, Ludwig Forum für Internationale Kunst, Aachen, D
HyperDesign, 6. Shanghai Biennale, Shanghai Art Museum, Shanghai, CN (Cat.)
FASTER! BIGGER! BETTER! Signetwerke der Sammlungen, Museum für Neue Kunst/ZKM, Karlsruhe, D (Cat.)
Anonimous, Schirn Kunsthalle Frankfurt, Frankfurt am Main, D

2005
Lichtkunst aus Kunstlicht, Museum für Neue Kunst/ZKM, Karlsruhe, D (Cat.)
paralleles leben, Frankfurter Kunstverein, Frankfurt am Main, D (Cat.)
Ways of Living, Kettle's Yard, University of Cambridge, Cambridge, GB (Cat.)
ARTE ALL' ARTE 10, Arte Architettura Paesaggio, San Gimignano, I (Cat.)
Here Comes The Sun, Magasin 3, Stockholm Konsthall, Stockholm, S (Cat.)
Rauminszenierungen 2005, Schlosspark Wendling-hausen, Garten-Landschaft OstWestfalenLippe, D
Extreme Abstraction, Albright-Knox Art Gallery, Buffalo/NY, USA (Cat.)
Light Lab. Alltägliche Kurzschlüsse, MUSEION — Museo d'arte moderna e contemporanea, Bolzano, I

Luna Park. Fantastic Art, Villa Manin, Centro d'Arte Contemporanea, Codroipo, I (Cat.)
Post Notes, Midway Contemporary Art, Minneapolis/MN, USA
Cohabitats, Galerie Ghislaine Hussenot, Paris, F
Colors — Stripes — Lines, Galerie Wolfgang Exner, Vienna, A
Present Perfect, Friedrich Petzel Gallery, New York/NY, USA
El estado de las cosas — El objecto en el arte desde 1960 hasta nuestros dias, Artium de Iva, Centro-Museo Vasco de Arte Contemporáneo, Victoria-Gasteiz, E (Cat.)
Just do it! Die Subversion der Zeichen von Marcel Duchamp bis Prada Meinhof, Lentos Kunstmuseum Linz, Linz, A (Cat.)
Fuori Tema/Italian Feeling, XIV Esposizione Quadriennale d'Arte, Galleria Nazionale d'Arte Moderna, Rome, I (Cat.)
What's new Pussycat?, Museum für Moderne Kunst, Frankfurt am Main, D
Der Kunst ihre Räume, Bonner Kunstverein, Bonn, D
Blancanieves y los siete enanitos: una exposición sobre la presencia del bianco acompañado de un poco de rojo y una pizca de negro, Fundación Marcelino Botín, Santander, E (Cat.)
Fünfundzwanzig Jahre Sammlung Deutsche Bank, Deutsche Guggenheim, Berlin, D (Cat.)
Bidibidobidiboo, Fondazione Sandretto Re Rebaudengo, Guarene d'Alba, I
Les Grands Spectacles. 120 Jahre Kunst und Massenkultur, Museum der Moderne Salzburg, Salzburg, A (Cat.)
Generation X. Junge Kunst aus der Sammlung, Kunstmuseum Wolfsburg, Wolfsburg, D
BYO. Bring Your Own. Opere delle collezione Teseco, Museo d'arte della Provincia di Nuoro, Nuoro, I (Cat.)
Dionysos Hof 1:1, Museum Ludwig, Cologne, D (Cat.)
Official Art Posters for the 2006 FIFA World Cup TM, Art Beatus, Hong Kong, CN
Rundlederwelten. Fußball: Kunst, Martin-Gropius-Bau, Berlin, D (Cat.)
Drive. Automobili nell'Arte Contemporanea, Galleria d'Arte Moderna, Bologna, I (Cat.)

2004
Schöner Wohnen, Kunst van heden voor alle dagen, BE-PART — Platform voor actuele kunst, Waregem, B (Cat.)
Jorge Pardo. Tobias Rehberger, Galeria Graça Brandão, Porto, P
1. International Biennial of Contemporary Art Seville, Seville, E (Cat.)
Delays and Revolutions, Albergo delle Povere, Palermo, I
Nizza Transfer, Kulturstiftung des Bundes/Städelschule, Frankfurt am Main, D
70/90 Engagierte Kunst, Neues Museum — Staatliches Museum für Kunst und Design in Nürnberg, Nuremberg, D (Cat.)
Porträt ohne Antlitz. Abstrakte Strategien in der Bildniskunst, Kunsthalle Kiel, Kiel, D (Cat.)
Trafic d'influences: Art & Design, Collection FRAC Nord-Pas de Calais, Tri postal, Lille, F
Braunschweig Parcours, Kulturinstitut Braunschweig, Brunswick, D (Cat.)
Garten Eden, Galerie Bärbel Grässlin, Frankfurt am Main, D (Cat.)
Group show, Dépendance, Brussels, B
Kunst ein Kinderspiel, Schirn Kunsthalle Frankfurt, Frankfurt am Main, D (Cat.)
Suburban House Kit, Deitch Projects, New York/NY, USA

Werke aus der Sammlung Boros, Museum für Neue Kunst/ZKM, Karlsruhe, D (Cat.)
Neue Arbeiten, Österreichischer Skulpturenpark, Unterpremstätten, A
Over de grens, Museum Dhondt-Dhaenens, Deurle, B
Support 2 — Die Neue Galerie als Sammlung. 1950 — heute, Neue Galerie Graz, Graz, A (Cat.)
Chasm, Busan Biennial 2004, Busan Museum of Modern Art, Busan, ROK
BABY-LON-CITY — Kinderspiele, Österreichisches Museum für angewandte Kunst, Vienna, A
La alegría de mis sueños, 1. Bienal Internacional de Arte Contemporáneo, Monasterio de la Cartuja de Santa María de las Cuevas, Sevilla, E (Cat.)
Wer bietet mehr? — Fünfzehn Jahre Deichtorhallen Hamburg, Deichtorhallen Hamburg, Hamburg, D
Jahresgaben 2004-2005, Kunstverein Braunschweig, Brunswick, D
Minimal Concepts. Werke aus der Sammlung des Kunstmuseums Wolfsburg, Kunstmuseum Wolfsburg, Wolfsburg, D

2003
Grazie, Hochschloss, Stiftung Schloss Dyck, Jüchen, D (Cat.)
Echigo — Tsumari Art Triennial, Matsudai Town, J (Cat.)
Plastik, Plüsch und Politik. Reflexe der 70er Jahre in der Gegenwartkunst, Städtische Galerie, Nordhorn, D (Cat.)
Outlook, „The Factory", Athens School of Fine Arts, Athens, GR (Cat.)
Add to it. Louise Lawler (pictures), Olafur Eliasson & Zumtobel Staff (light), Tobias Rehberger (space), Portikus im Leinwandhaus, Frankfurt am Main, D
Form-Specific, Moderna Galerija, Ljubljana, SLO (Cat.)
Micro-Utopias, 1. Bienal de Valencia, Valencia, E
Cover Theory. Contemporary Art As Re-Interpretation, Officina della Luce, Ex Centrale Emilia, Piacenza, I (Cat.)
Soziale Fassaden u.a., Städtische Galerie im Lenbachhaus und Kunstbau, Munich, D (Cat.)
Dreams and Conflicts — The Viewer's Dictatorship, La Biennale di Venezia, Venice, I (Cat.)
actionbutton. Neuerwerbungen Sammlung der Bundesrepublik Deutschland, Hamburger Bahnhof — Museum für Gegenwart, Berlin, D (Cat.)
Spuren im Schnee. Siebdrucke, Galerie Wolfgang Exner, Galerie für junge und aktuelle Kunst, Vienna, A
Killing Time and Listening Between the Lines, Colección Jumex, Ecatepec de Morelos, MEX
Das lebendige Museum, Museum für Moderne Kunst, Frankfurt am Main, D
Somewhere Better than this Place: Alternative Social Experience in the Spaces of Contemporary Art, Contemporary Arts Center, Cincinnati/OH, USA (Cat.)
La Ciudad ideal, 1. Bienal de Valencia, Los Atarazanas del Puerto de Valencia, Valencia, E (Cat.)
Gyroscope, Hirshhorn Museum and Sculpture Garden, Washington D.C., USA
Editionen, Galerie Markus Nohn, Frankfurt am Main, D
Game, New York Gallery, Ferragamo Flagship Store, New York/NY, USA
No Art — No City! Stadtutopien in der zeitgenössischen Kunst,
Städtische Galerie im Buntentor, Bremen, D (Cat.)
Thisplay, Colección Jumex, Ecatepec de Morelos, MEX

2002
the object sculpture, The Henry Moore Institute, Leeds, GB (Cat.)
EU2, Stephen Friedman Gallery, London, GB
do it, www.e-flux.com, Electronic Flux Corporation, New York/NY, USA (Cat.)
40 Jahre Fluxus und die Folgen, Nassauischer Kunstverein und Projektbüro des Stadtmuseums Wiesbaden, Wiesbaden, D

Hossa. Arte Alemán del 2000, Centro Cultural
Andratx, Mallorca, E
The Theory of Leisure, Colección Jumex, Ecatepec
de Morelos, MEX
Hell, neugerriemschneider, Berlin, D
Art and Economy, Deichtorhallen Hamburg,
Hamburg, D (Cat.)
Skandal und Mythos. Ein neuer Blick auf die
Documenta 5 (1972), Kunsthalle Wien, Vienna, A
(Cat.)
Schwarzwaldhochstraße. Aktuelle Kunst in und aus
Baden-Württemberg, Staatliche Kunsthalle, Baden-
Baden, D (Cat.)
Von Zero bis 2002. Zeitgenössische Kunst aus den
Sammlungen Siegfried Weishaupt, Froehlich, FER
und Grässlin, Museum für Neue Kunst/ZKM,
Karlsruhe, D
Shopping. 100 Jahre Kunst und Konsum, Schirn
Kunsthalle Frankfurt, Frankfurt am Main, D (Cat.)
Kleine Kleinigkeit, Kunsthalle Basel, Basle, CH
French Collection, Musée d'art moderne et
contemporain, Geneva, CH (Cat.)
Come-in. Interieur als Medium der zeitgenössischen
Kunst in Deutschland, IFA Institut für Auslands-
beziehungen, Stuttgart, D (Cat.)
Home Made, WHDG, Stichting Voorheen De Gemeente,
Leeuwarden, NL
Einblick in die Werkstatt für Kunstsiebdruck der
Galerie Edition Andreas Stalzer, Galerie Lisi Hämmerle,
Bregenz, A
Glassfab, Gandy Gallery, Prague, CZ (Cat.)

2001

Utopien heute? Kunst zwischen Vision und Alltag,
Kunstverein Ludwigshafen, Ludwigshafen am Rhein
and Wilhelm-Hack-Museum, Ludwigshafen am
Rhein, D (Cat.)
Mínim Denominador Común, Sala Montcada de la
Fundació „La Caixa", Barcelona, E
Come-in, Institut für Auslandsbeziehungen,
Stuttgart, D (Cat.)
Televisions, Kunst sieht fern, Kunsthalle Wien, Vienna, A
Präsentation der Jahresgaben, Westfälischer
Kunstverein, Münster, D
New Heimat, Frankfurter Kunstverein, Frankfurt am
Main, D (Cat.)
ads, Galerie & Edition Artelier, Graz, A
Artifical Natural Networks, de Verbeelding,
Zeewolde, NL
Frankfurter Positionen, Portikus, Frankfurt am Main,
D (Cat.)
ambiance magasin, Centre d'art contemporain,
Meymac, F (Cat.)
Electrify me, Friedrich Petzel Gallery, New York/NY, USA
Frankfurter Kreuz, Schirn Kunsthalle Frankfurt,
Frankfurt am Main, D (Cat.)
Arbeit (erster Teil der Triologie Arbeit Essen Angst)
Kokerei Zollverein, Essen, D (Cat.)
Serigrafien 1994-2001, Galerie Edition Stalzer,
Vienna, A
Plug in. Einheit und Mobilität, Westfälisches
Landesmuseum für Kunst- und Kulturgeschichte,
Münster, D (Cat.)
Freestyle, Werke aus der Sammlung Boros, Museum
Morsbroich, Leverkusen, D (Cat.)
Hommage an Olle Baertling, Kunsthalle Kiel, Kiel, D
(Cat.)
No Return. Positionen aus der Sammlung Haubrok,
Städtisches Museum Abteiberg, Mönchengladbach,
D (Cat.)

Opening, Colección Jumex, Ecatepec de Morelos, MEX
Comfort: Reclaiming Place in a Virtual World,
Cleveland Center for Contemporary Art,
Cleveland/OH, USA (Cat.)
Vom Eindruck zum Ausdruck — Grässlin Collection,
Deichtorhallen Hamburg, Hamburg, D (Cat.)
Musterkarte. Modelos de pintura en Alemania 2001,
Centro Cultural Conde Duque, Galería Elba Benitez
and Galería Heinrich Ehrhardt, Madrid, E
Target Art in the Park 2001, Madison Square Park,
The Public Art Fund, New York/NY, USA
Update #3. What Looks Good Today ...,
Kunstmuseum Wolfsburg, Wolfsburg, D (Cat.)
Platea dell'umanità Plateau of Humankind Plateau
der Menschheit Plateau de l'umanité (with Olafur
Eliasson and Rikrit Tiravanija), 49. Esposizione
Internazionale d'Arte, La Biennale di Venezia,
Venice, I (Cat.)
Untragbar. Mode als Skulptur, Museum für
Angewandte Kunst, Cologne, D (Cat.)
Copy Right. Inspiration or Copying, Kunstindustrimuseet,
Copenhagen, DK (Cat.)
Man in the Middle — Menschenbilder. Sammlung
Deutsche Bank, Museum Moderner Kunst —
Stiftung Wörlen, Passau, D (Cat.)

2000

Finale di Partita, Chiostro di Ognissanti, Biagiotti
Progetto Arte, Florence, I
more works about buildings and food, Fundição de
Oeiras, Hangar K7, Oeiras, P (Cat.)
pinturas amuebladas — furnished paintings, Galería
OMR, Mexico City, MEX
Project #0004, Friedrich Petzel Gallery, New York/
NY, USA
Berlin — Binnendifferenz, Galerie Krinzinger, Vienna, A
Circles '2: Dribbdeabcja (Zakynthos), Museum für
Neue Kunst/ZKM, Karlsruhe, D
Art For a Better Life, Lothringer13, Städtische
Kunsthalle, Munich, D
Face-À-Face, Kunstpanorama, Lucerne, CH
Raumkörper. Netze und andere Gebilde, Kunsthalle
Basel, Basle, CH (Cat.)
waiting, mjellby konstgård, Halmstad, S (Cat.)
ein/räumen — Arbeiten im Museum. 60 aktuelle
Projekte in der Hamburger Kunsthalle, Hamburger
Kunsthalle, Hamburg, D (Cat.)
Sensitive — Printemps de Cahors, Fondation Cartier
pour l'Art Contemporain, Cahors, F (Cat.)
The Sky is the Limit, Taipei Biennial 2000, Taipei
Fine Arts Museum, Taipei, CN (Cat.)
Skulptur als Möbel — Möbel als Skulptur, Objekte
und Graphiken aus der Sammlung der Neuen
Galerie Graz, Kloster Frohnleiten, A
Micropolitiques, MAGASIN — Centre National d'Art
Contemporain, Grenoble, F (Cat.)
Wechselkurs. 1995-2000. Fünf Jahre
Neuerwerbungen des Museums Abteiberg,
Städtisches Museum Abteiberg, Mönchengladbach, D
Against Design, ICA Institute of Contemporary, Art,
University of Pennsylvania, Philadelphia/PA, USA
(Cat.)
Landschaften eines Jahrhunderts. Aus der
Sammlung Deutsche Bank, Museum Moderner
Kunst — Stiftung Wörlen, Passau, D (Cat.)
Tänk om — Konst på gränsen till architektur och
design, Moderna Museet, Stockholm, S
Home/Homeless, Bo 01, City of Tomorrow:
European Building Exhibition, Malmö, S (Cat.)
In Between. Das Kunstprojekt der Expo 2000, Expo
2000, Hanover, D (Cat.)
Artwaresmart, Portfolio Kunst AG, Vienna, A
Kunstwegen — De Vechte folgen, Städtische
Galerie Nordhorn, Nordhorn, D (Cat.)
KUNSTmatige Natuurlijke Netwerken, De Verbeelding
kunst landschap natuur, Zeewolde, NL (Cat.)

1999

Blown Away, 6th Caribbean Biennial, The Golden
Lemon Inn, Saint Kitts, Caribbean Islands (Cat.)

Piensa dos Veces: Escultura Internacional, Galería
OMR, Mexico City, MEX
German Open 1999. Gegenwartskunst in
Deutschland, Kunstmuseum Wolfsburg, Wolfsburg, D
(Cat.)
Tableaux et Sculptures, Galerie Ghislaine Hussenot,
Paris, F
Die Schule von Athen, Municipality of Athens —
Technopolis, Athens, GR (Cat.)
kraftwerk BERLIN, Aarhus Kunstmuseum, Aarhus,
DK (Cat.)
Arte All'Arte, Arte Continua, Colle di Val d'Elsa, I
(Cat.)
zoom. Ansichten zur deutschen Gegenwartskunst,
Sammlung Landesbank Baden-Württemberg,
Stuttgart, D; Städtisches Museum Abteiberg,
Mönchengladbach, D; Kunsthalle Kiel, Kiel, D (Cat.)
Skulptur Biennale 1999, Münsterland, D (Cat.)
wonder world — notes for a solid collection,
Newsantandrea, Savona, I
les deux saules pleureurs/cube without a corner-
gerät, KW Kunst-Werke — Institute for
Contemporary Art, Berlin, D
am Azonas Künstlerbücher, Villa Minimo, Hanover, D
Ain't Ordinarily So, Casey Kaplan, New York/NY, USA
Who, if not we?, Elizabeth Cherry Contemporary Art,
Tuscon/AZ, USA
Further Fantasy, Galleria Giò Marconi, Milan, I
de coraz(i)on, Centre d'Art Tecla Sala, Barcelona, E
(Cat.)
Konstruktionszeichnungen, KW Kunst-Werke —
Institute for Contemporary Art, Berlin, D
Rethinking Representation, Galerie Andreas Binder,
Munich, D
To Design for: Angela Bulloch/Mathieu Mercier/
Tobias Rehberger/François Trocquet, Le Spot,
Centre d'Art Contemporain, Le Havre, F
Comfort Zone: Furniture by Artists, Paine Webber
Art Gallery, New York/NY, USA (Cat.)
Neue Editionen, Portfolio Kunst AG, Vienna, A
Unternehmen Kunst. Positionen zeitgenössicher
Kunst aus der Sammlung Landesgirokasse, Villa
Merkel — Galerie der Stadt Esslingen, Esslingen am
Neckar, D
Tang (Domesticating the Industrial Aesthetic
Looking Back to the Future), Turner & Runyon,
Dallas/TX, USA
Independence Day, KW Kunst-Werke — Institute for
Contemporary Art, Berlin, D
Sommeraccrochage, KW Kunst-Werke — Institute
for Contemporary Art, Berlin, D
Caledar 2000, Center for Curatorial Studies, Bard
College, Annandale-on-Hudson/NY, USA
KölnSkulptur 2: zeitgenössische Bildhauer im
Skulpturenpark Köln, Cologne, D (Cat.)
Around and Around, Galerie Achim Kubinski, Berlin,
D; Galerie Peter Herrmann, Stuttgart, D
Das XX. Jahrhundert — ein Jahrhundert Kunst in
Deutschland, Kupferstichkabinett, Berlin, D (Cat.)

1998

Dad's Art, neugerriemschneider, Berlin, D
„——, 1994untitled, 1994 (meettim & burkhard)
brâncusi, 1997", Grazer Kunstverein, Graz, A
Round About Waves, Ujadowski Castle, Warsaw, P
(Cat.)
weather everything, Galerie für Zeitgenössische
Kunst, Leipzig, D
Minimalismus. Rezeptionsformen des Minimalismus
in der Kunst der 90er Jahre, Akademie der Künste,
Berlin, D
[Collection 98], Galerie für Zeitgenössische Kunst,
Leipzig, D
Stephen Prina & Tobias Rehberger, Friedrich
Petzel Gallery, New York/NY, USA
Manifesta 2, European Biennial for Contemporary
Art, Luxemburg, L (Cat.)
A Noir — Nero. Le identità di un colore
contemporaneo, Triennale di Milano, Milan, I (Cat.)
Lebensraum, Arkipelag, Stockholm — Europas

Kulturhuvudstad 1998, Nordiska Museet,
Stockholm, S (Cat.)
Kunst und Papier auf dem Laufsteg, Deutsche
Guggenheim, Berlin, D
Kunst für die Bundestagsneubauten, Deutscher
Bundestag, Berlin, D
Berlin/Berlin, 1. Berlin Biennale für
Zeitgenössische Kunst, Berlin, D (Cat.)
Geschenkpapiere. 60 ausgesuchte Arbeiten auf
Papier von Pablo Picasso bis Tobias Rehberger,
Galerie Karl Pfefferle, Munich, D
Selbstportraits, Galerie Bärbel Grässlin, Frankfurt
am Main, D
Global Fun: Kunst und Design von Mondrian, Gehry,
Versace and Friends, Museum Morsbroich,
Leverkusen, D
Mostrato, Fuori Uso '98, Mercati Ortofrutticoli,
Associazione Culturale Arte Nova, Pescara, I (Cat.)
The Happy End of Franz Kafka's 'Amerika', Works
On Paper Inc., Los Angeles/CA, USA

1997
Kunst für Bundestagsneubauten, Deutscher
Bundestag, Berlin, D
Kunst und Papier auf dem Laufsteg, Deutsche
Guggenheim, Berlin, D
Lebensraum, (ARKIPELAG), Stockholm, S
Dramatically different, MAGASIN — Centre National
d'Art Contemporain, Grenoble, F (Cat.)
Kunst ... Arbeit, Sammlung Südwest LB, Stuttgart, D
(Cat.)
M&M, Fondazione Re Rebaudengo, Turine, I
Heaven: Public View, Private View, P.S.1
Contemporary Art Center, New York/NY, USA
Beyond the auratic object, Philomene Magers,
Cologne, D
Time Out, Kunsthalle Nürnberg, Nuremberg, D (Cat.)
Frankfurt-Kassel-Münster, Galerie Bärbel Grässlin,
Frankfurt am Main, D
Truce: Echoes of Art in an Age of Endless
Conclusions, Site Santa Fe's 2nd International
Biennial, Santa Fe/NM, USA (Cat.)
assuming positions, Institute of Contemporary Art,
London, GB (Cat.)
future-present-past/Futuro Presente Passato,
La Biennale di Venezia, I (Cat.)
Dieci Artisti Tedeschi per Verona, Verona, I
skulptur.projekte Münster '97, Westfälisches
Landesmuseum für Kunst und Kulturgeschichte,
Münster, D (Cat.)
Franz Ackermann: 5%, Michel Majerus: Qualified,
Tobias Rehberger: Water-colour, Galleria Giò
Marconi, Milan, I
garnish and landscape, (Tobias Rehberger & Jorge
Pardo), Gesellschaft für Gegenwartskunst,
Augsburg, D (Cat.)
Home Sweet Home, Deichtorhallen Hamburg,
Hamburg, D (Cat.)
Rooms with a View: Environments for Video,
Guggenheim Museum SoHo, New York/NY, USA
Fort! Da!, Villa Merkel — Galerie der Stadt Esslingen,
Esslingen am Neckar, D (Cat.)

1996
Campo 6, The Spiral Village, Bonnefantenmuseum,
Maastricht, NL (Cat.)
Heetz, Nowak, Rehberger, Städtisches Museum
Abteiberg, Mönchengladbach, D
Campo 6, Fondazione Sandretto Re Rebaudengo
per l'Arte, Galleria Civica d'Arte Moderna e
Contemporanea di Torino, Turine, I (Cat.)
nach weimar, Kunstsammlungen zu Weimar,
Weimar, D (Cat.)
Alle Neune, ACC Galerie, Weimar, D
almost invisible/fast nichts, Umspannwerk Singen,
Singen am Hohentwiel, D (Cat.)
Manifesta 1, European Biennial of Contemporary
Art, Rotterdam, NL (Cat.)
Dites-le avec des fleurs, Galerie Chantal Crousel,
Paris, F

something changed, Helga Maria Klosterfelde,
Hamburg, D
Der Umbau Raum, Künstlerhaus Stuttgart,
Stuttgart, D
Cruise, Friedensallee 12, Hamburg, D
Kunst in der neuen Messe Leipzig, Leipzig, D (Cat.)
Zum Gebrauch bestimmt, Galerie Sophia Ungers,
Cologne, D
Sammlung Speck, Museum Ludwig, Cologne, D
(Cat.)

1995
Regal, Regal, Forum der Frankfurter Sparkasse,
Frankfurt am Main, D
Kulturprämie, Städelschule im BASF-
Feierabendhaus, Ludwigshafen am Rhein, D;
Lindenau-Museum Altenburg, Altenburg, D (Cat.)
Bed & Breakfast, Ifor Evans Hall, University
College, London, GB
filmcuts, neugerriemschneider, Berlin, D (Cat.)
Villa Werner, Offenbach, D
... kommt mit seinen Gaben, Städtisches Museum
Abteiberg, Mönchengladbach, D
Alles was modern ist, Galerie Bärbel Grässlin,
Frankfurt am Main, D

1994
Stipendiaten der Frankfurter Künstlerhilfe e.V.,
Galerie ak, Frankfurt am Main, D (Cat.)
WM Karaoke, Portikus, Frankfurt am Main
Die Bücher der Künstler: Publikationen und
Editionen seit den sechziger Jahren in Deutschland,
International touring exhibition of the IFA Institut
für Auslandsbeziehungen, Berlin, D (Cat.)

1993
Men's World, Künstlerkreis Ortenau, Kunstverein
Offenburg-Mittelbaden, Offenburg, D
Stadt/Bild, Karmeliterkloster, Frankfurt am Main, D
(Cat.)
Backstage, Kunstmuseum Luzern, Lucerne, CH;
Hamburger Kunstverein, Hamburg, D (Cat.)
Es ist eine Zeit hereingebrochen, in der alles
möglich sein sollte, Villa Franck — Kunstverein
Ludwigsburg, Ludwigsburg, D

1992
Dealing with Art, Künstlerwerkstatt Lothringer
Straße, Munich, D (Cat.)
SS.SS.R., Galerie Bärbel Grässlin, Frankfurt am
Main, D
Virtuosen vor dem Berg, Galerie Grässlin/Ehrhardt,
Frankfurt am Main, D (Cat.)
Spielhölle, Ästhetik und Gewalt, Frankfurt am Main, D
Qui, quoi, où?, Musée d'Art Moderne de la Ville de
Paris, Paris, F (Cat.)

1991
Zwischen Dürer und Holbein, Städelschule, Frankfurt
am Main, D (Cat.)
Give me a hand before I call you back, Galerie
Bleich-Rossi, Graz, A (Cat.)
Virtuosen ihrer Zeit, 91. Virtuosen vor dem Berg,
Galerie Grässlin/Ehrhardt, Frankfurt am Main, D
Tobias Rehberger, Arbeitsamt Aalen, Dienststelle
Schwäbisch Gmünd, D (Cat.)

1990
Kunststudenten stellen aus, Bonner Kunstverein,
Bonn, D (Cat.)
Kunstpreis Ökologie, AEG Hausgeräte, Nuremberg,
D (Cat.)

Eva Linhart

Tobias Rehberger

flach

flat

Plakate,

Plakatkonzepte und

Wandmalereien

Posters, Poster

Concepts

and Wall Paintings

Impressum

Diese Publikation erscheint anlässlich der Ausstellung „Tobias Rehberger — flach. Plakate, Plakatkonzepte, Wandmalereien" im Museum für Angewandte Kunst Frankfurt vom 7. März bis zum 2. Mai 2010.

This book is published on the occasion of the exhibition "Tobias Rehberger — flat. Posters, Poster Concepts and Paintings" at the Museum für Angewandte Kunst Frankfurt from 7 March until 2 May 2010.

Herausgegeben vom Museum für Angewandte Kunst Frankfurt, Eva Linhart, Kuratorin Buchkunst und Graphik

Edited by Museum für Angewandte Kunst Frankfurt, Eva Linhart, Curator Book Art and Prints

Ausstellungskonzeption und Buch/Exhibition concept and book: Eva Linhart, Ulrich Schneider in Kooperation mit/ in cooperation with Tobias Rehberger/Studio Tobias Rehberger

Redaktion/Editing: Eva Linhart, Sabine Huth, Esther Klippel, Saskia Jung, Johannes Yong Böhm (deutsche Version und Schlussredaktion/German version and copy editing); English German Language Service, Judith Rosenthal, Frankfurt am Main (englische Version/English version)

Konservatorische Betreuung der Ausstellung/ Conservational supervision of the exhibition: Barbara Hassel

Ausstellungsgrafik/Exhibition graphics: VIER5, Christiane Riemann

Buchgestaltung/Book design: VIER5, Paris in Kooperation mit/in cooperation with Tobias Rehberger

Layoutassistenz/Layout assistance: Leonard Herrmann

Fotografie/Photography: Axel Schneider, Frankfurt am Main

Gesamtherstellung/Production: freiburger graphische betriebe (fgb)

Vertrieb/Distribution: GESTALTEN, Berlin
www.gestalten.com
sales@gestalten.com

ISBN 978-3-942405-00-3
Printed in Germany

Erschienen im/Published by: DISTANZ Verlag, Berlin
www.distanz.de